A city in pictures

LONDON

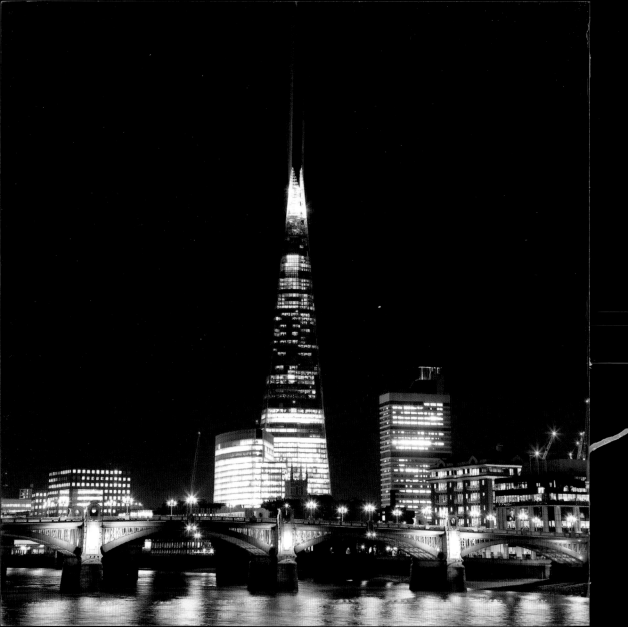

A city in pictures
LONDON

AMMONITE
PRESS

PRESS
ASSOCIATION
Images

First Published 2011 by
Ammonite Press
an imprint of AE Publications Ltd,
166 High Street, Lewes, East Sussex, BN7 1XU

This edition 2016

Text © AE Publications Ltd
Images © Press Association Images
Copyright © in the work AE Publications Ltd

ISBN 978-1-78145-236-3

While every effort has been made to obtain permission
from the copyright holders for all material used in
this book, the publishers will be pleased to hear from
anyone who has not been appropriately acknowledged,
and to make a correction in future reprints.

British Cataloguing in Publication Data. A catalogue
record of this book is available from the British Library.

Editor: Ian Penberthy
Managing Editor: Richard Wiles
Picture Research: Press Association Images
Design: Adam Carter
Colour Reproduction by GMC Reprographics
Printed in China

Shard

Page 2: The Shard stages an
impressive light show in the
run up to New Year's Eve, with
a daily-changing display that
captures the energy, dynamism
and colour of the city.

London Bridge Street, SE1

Big Ben

Right: A golden sun sets on
the Elizabeth Tower, as Big Ben,
the second largest four-faced
chiming clock in the world,
counts away the minutes, as it
has for more than 150 years.

Westminster, SW1

London by Night

Page 6: Amid London's glittering
lights nestles St Paul's Cathedral
with the skyscrapers of the City
of London financial district
behind. The River Thames
snakes westward, spanned
by Blackfriar's Bridge and
Blackfriar's Railway Bridge, the
Millennium Bridge, Southwark
Bridge, Cannon Street Railway
Bridge, London Bridge and
Tower Bridge. In the distance
stands the cluster of skyscrapers
at Canary Wharf.

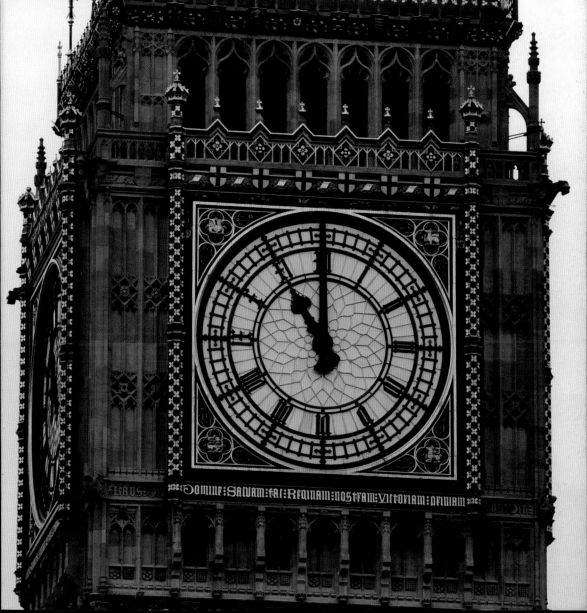

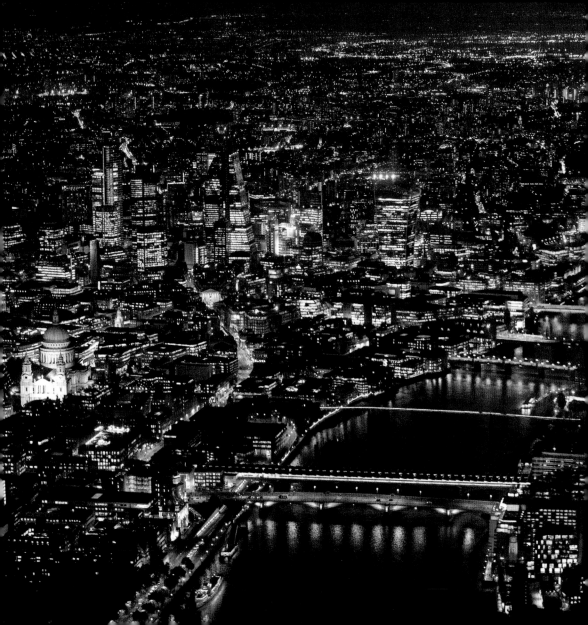

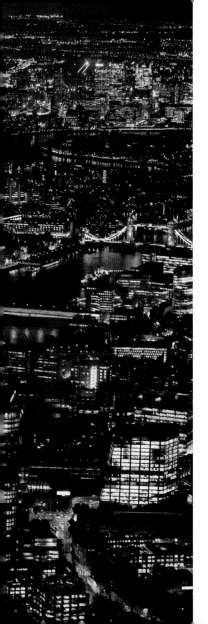

Introduction

"When a man is tired of London, he is tired of life; for there is in London all that life can afford."

—Samuel Johnson

Founded as Londinium by the Romans over 2,000 years ago, London has been a major settlement ever since that time: the seat of kings and queens, the capital of a great nation, once even the hub of an empire that spanned the world and on which the sun never set. Bombed in two world wars and targeted by generations of terrorists, London and Londoners have always stood defiant against tyranny, remaining resolute and unbowed in the face of supreme adversity. It is a city that is rich in history: in its layout and its buildings, in its pomp and its pageantry. No wonder it is the most visited city in the world.

Standing astride 'Old Father Thames', London is one of the world's great cities – a centre of commerce and finance; of tradition and ceremony; of art, fashion and music, and of sporting endeavour. It is a truly multicultural city, with a diverse population of over 8.6 million; always ready to welcome the downtrodden and underprivileged, it has substantial ethnic populations, and some 300 languages are spoken within its boundaries. The city is served by no fewer than five international airports.

Formed in 1868, the Press Association was created by a group of regional newspaper owners as a UK-wide news gathering organisation, but from the very beginning the PA was based in London. Since that time, its skilled photographers have been on hand to record events both momentous and minor in the capital, every day of the week, and in the process have amassed a vast, fascinating archive that depicts the city in all its moods, in all its seasons: its architecture, its landmarks, its open spaces, and its many attractions, from the pageantry of the State Opening of Parliament and the Trooping of the Colour to the excitement of the Cup Final and a ride on the London Eye.

The photographs on the following pages have been carefully selected from the PA archive to show the London of today – a vibrant cosmopolitan city that truly does offer all that life can afford.

London from the Air

A panoramic view of the city, intersected by the snaking River Thames, takes in many of the capital's major tourist attractions, including the London Eye, the Houses of Parliament, Big Ben and Westminster Abbey, Buckingham Palace and St James's Park, the South Bank Centre containing the Royal Festival Hall, the Queen Elizabeth Hall and the Hayward Art Gallery, with the National Theatre. On the left of the picture can be seen the long, glazed train shed of Waterloo railway station. Five of the city's famous bridges can be seen (*left to right*): Vauxhall Bridge, Lambeth Bridge, Westminster Bridge, Hungerford Bridge and Waterloo Bridge.

South Bank, SE1/Westminster, SW1

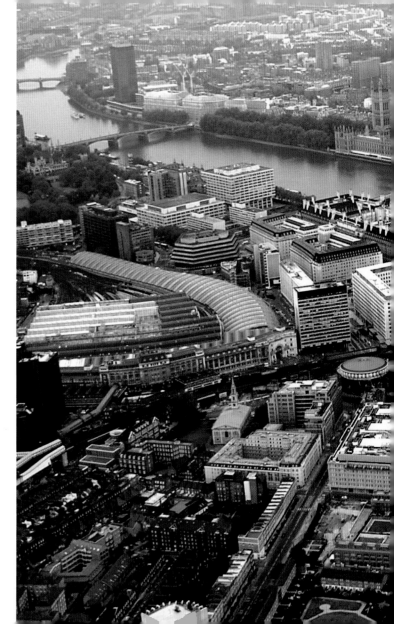

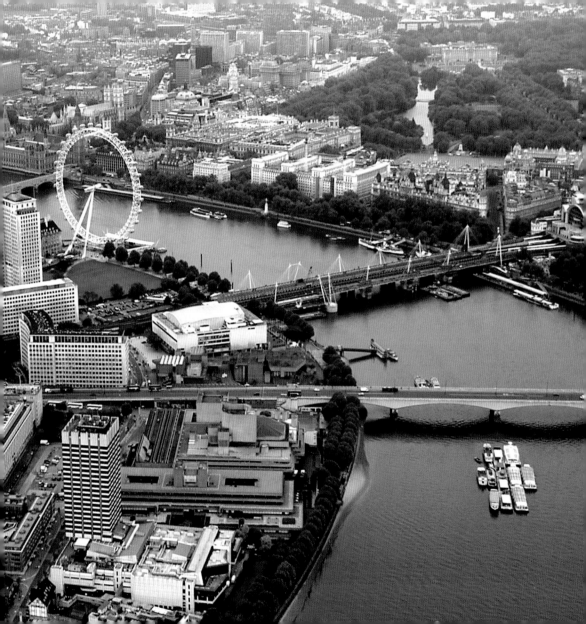

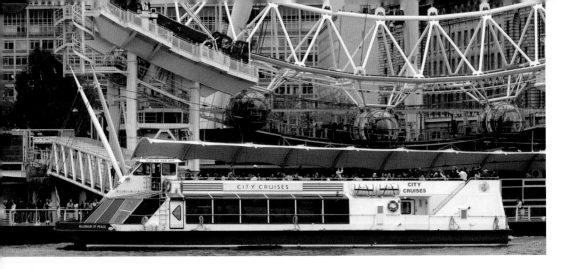

Thames Cruiser

Above: A river cruiser leaves the London Eye Pier on a Thames sightseeing cruise. Passengers can choose from cruises lasting from 30 minutes to three hours. They also have the option of buying tickets that allow them to hop on and off the boats at will.

London Eye Pier, Jubilee Gardens, SE1

London Eye

The spokes and structure of the London Eye (*right*) are thrown into stark relief by a dramatic sunset on a cold December day. The speed of rotation of the eye is slow enough that it does not need to stop to embark and disembark passengers, although this may be done to allow time for the disabled or elderly to get on and off. The tallest Ferris wheel in Europe, it is 135m (443ft) high. Each of the 32 air conditioned pods (*left*) can hold 25 people. A journey on the Eye takes about 30 minutes and offers far-reaching views across the capital.

Belvedere Road, SE1

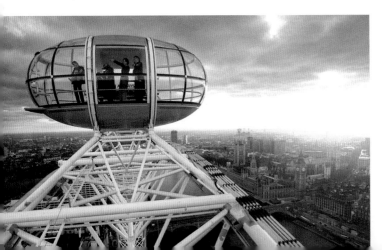

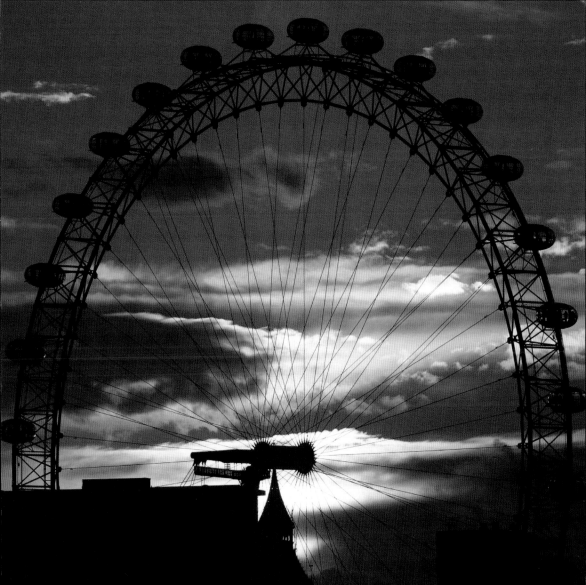

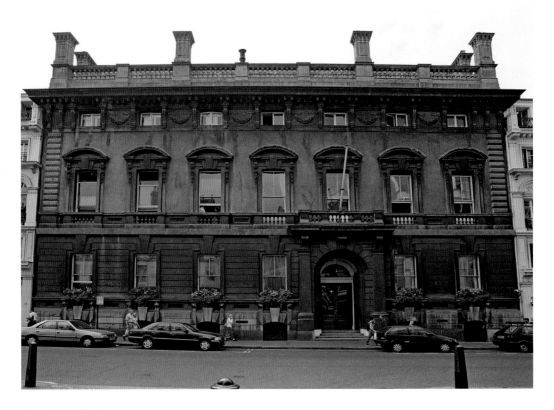

Garrick Club

Formed in 1831 as a private gentlemen's club with the avowed intention to "tend to the regeneration of the drama", the Garrick Club was named after the eminent actor David Garrick, whose work in the 18th century at the Theatre Royal, Drury Lane had by that time come to represent the 'golden age' of British drama. Membership was by invitation only and included a veritable 'who's who' of theatrical types. The club moved to its present premises in 1864 and has around 1,300 members at any one time. It remains a gentlemen's club, however, women only being welcomed as guests of members.

Garrick Street, WC2

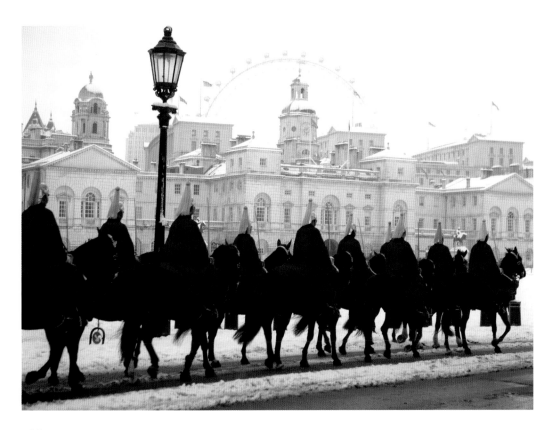

Life Guards

With their scarlet capes standing out against the drab greyness of a snowy winter's day, soldiers of the Life Guards, a regiment of the Household Cavalry, ride across Horse Guards Parade on their way to the Changing of the Guard ceremony.

Horse Guards Parade, Whitehall, SW1

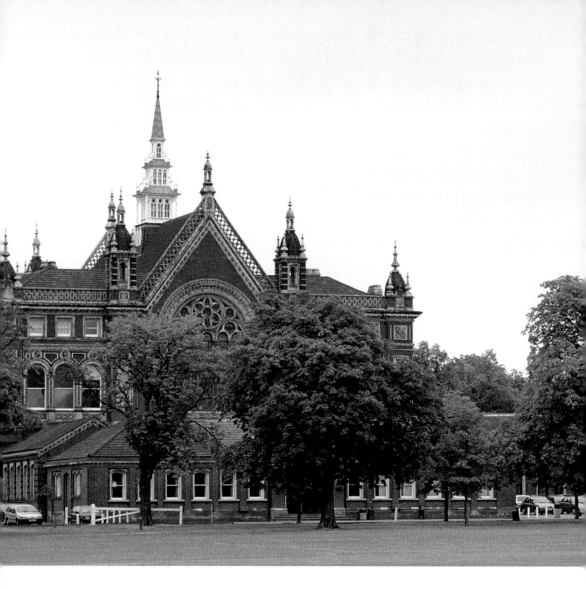

Dulwich College

One of Britain's best known public schools, Dulwich College was founded in 1619 by Edward Alleyn, a renowned Elizabethan actor, as a charitable venture with the purpose of educating poor scholars. It was known originally as the College of God's Gift. Today, it provides places for around 1,600 boys, 120 of whom are boarders, making it one of the largest independent schools in the country.

College Road, SE21

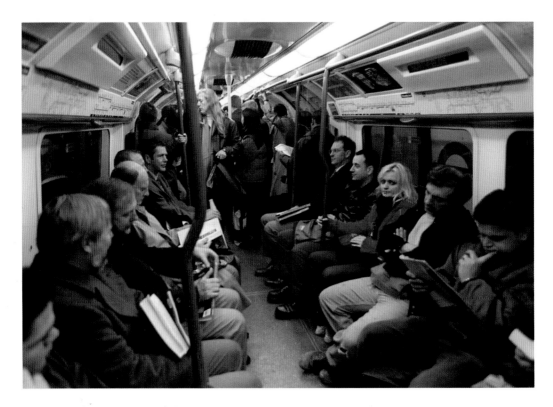

Commuting on the Tube

Commuters pack a rush-hour Underground train. The Underground system covers a wide area of Greater London, and parts of Essex, Hertfordshire and Buckinghamshire, making it a vital transport system for the city. It was the first underground railway in the world, the first section opening in 1863, and it was the first to use electric trains (1890). Originally operated by a number of independent companies, it is a unified entity with 270 stations and around 400km (250 miles) of track. Around three million passenger journeys are made each day on the Tube, as it is popularly known.

St James's Palace

One of London's oldest palaces, St James's Palace was built for Henry VIII on the site of a former leper hospital dedicated to St James the Less. Despite the fact that no monarch has lived in it for over 200 years, it remains the sovereign's official residence and, as such, gives its name to the Royal Court – the Court of St James's. The palace is also the official London residence of Anne, Princess Royal, Princess Beatrice of York, Princess Eugenie of York and Princess Alexandra, the Honorable Lady Ogilvy.

Pall Mall, SW1

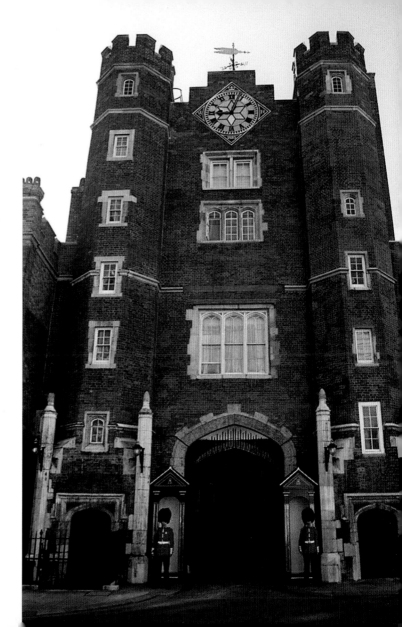

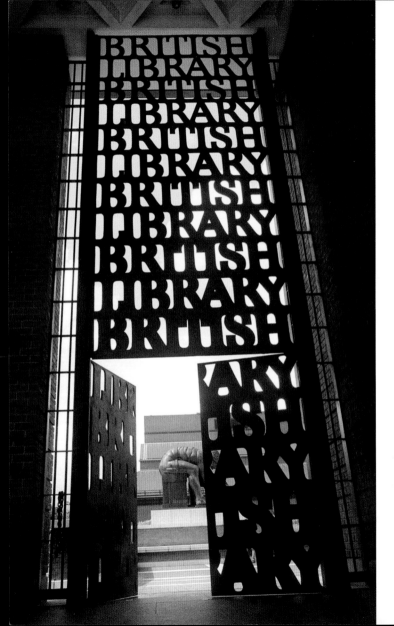

British Library

The gates at the entrance to the British Library in Kings Cross. They were designed by David and Lida Kindersley, the former being a typeface designer and stone letter carver.

With an inventory of over 150 million items in all known languages and formats, including historical artefacts that date back to 300 BC, the British Library is the largest library in the world and one of the world's major research libraries. Prior to 1997, its collections were dispersed to a number of buildings within and outside London. Now, however, the main collection is contained within the new purpose-built library building on Euston Road, the largest public building constructed in the UK during the 20th century.

Euston Road, NW1

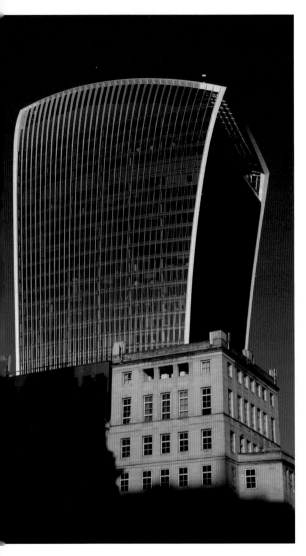

Walkie-Talkie

Taking its official, rather unimaginative name from its address at 20 Fenchurch Street, in the historic City of London financial district, this 34-storey building has been nicknamed, more colourfully, the 'Walkie-Talkie' because of its distinctive top-heavy shape. Designed by Uruguayan architect Rafael Viñoly and costing over £200 million, the building stands 160m (525ft) tall and appears to burst upward and outward.

Sky Garden

The Sky Garden spans the top three floors of the Walkie-Talkie building, and consists of a large viewing deck, terrace, bar and two restaurants. The garden is open free to the public, although tickets must be booked in advance.

Fenchurch Street, EC3

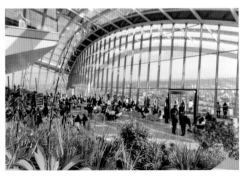

Freemasons' Hall

The Grand Temple of the Freemasons' Hall, which is the headquarters of the United Grand Lodge of England. Three Masonic buildings have stood on this site since 1775, the present one dating from 1933. Displaying distinct Art Deco influences in its design, it was built as a memorial to the 3,225 Freemasons who died on active service during the First World War.

Great Queen Street, WC2

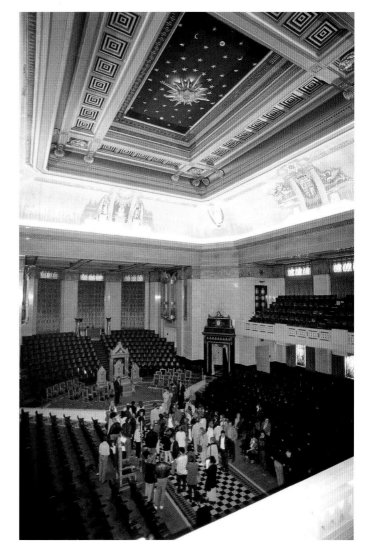

Blind Beggar

Notorious as the pub where East End gangster Ronnie Kray shot and killed George Cornell, a rival gang member, in March 1966, the Blind Beggar pub was also the site of William Booth's first sermon, which led ultimately to the formation of the Salvation Army. The pub's name derives from the legend of nobleman Henry de Montfort, who was blinded at the Battle of Evesham in 1265, lost all his wealth and property, and became the 'Blind Beggar of Bethnal Green'.

Whitechapel Road, E1

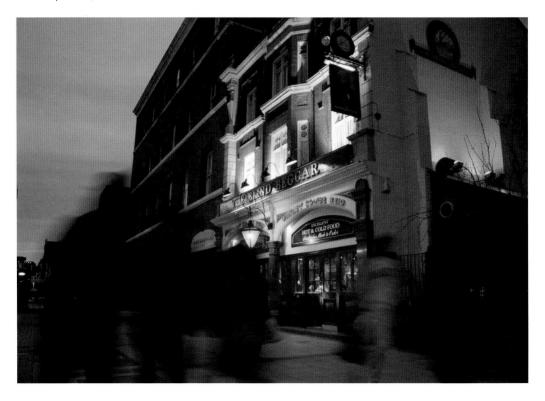

Lloyd's Building

Known popularly as the 'Inside-Out Building', because all of its stairways, lifts, conduits and pipes are on the outside, the Lloyd's building is home to Lloyd's of London, the insurance underwriting institution. The eye-catching structure was designed by Richard Rogers and comprises three main towers with associated service towers around a central well. The site was previously occupied by the first Lloyd's building, which was opened in 1928. The unusual appearance of the building has led to its use as a backdrop in a number of films and TV dramas.

Lime Street, EC3

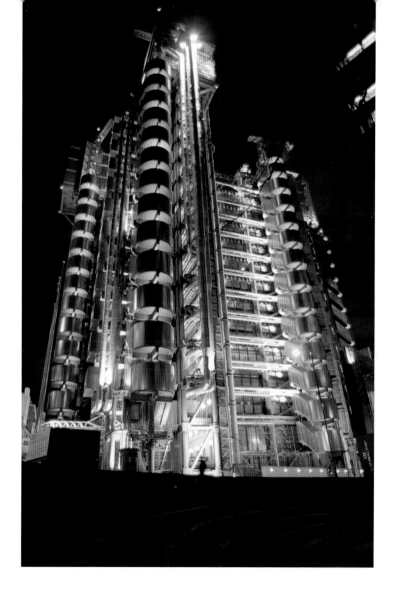

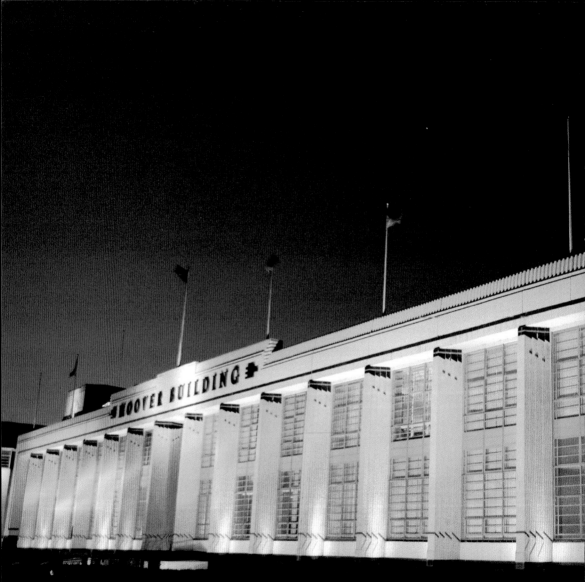

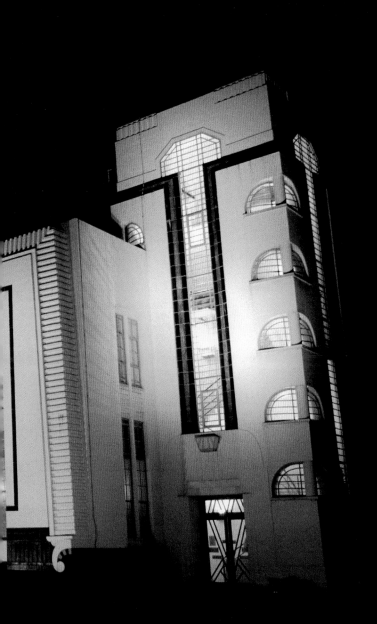

Hoover Building

Its striking Art Deco
architecture accentuated
by dramatic lighting, the
Hoover Building makes
a bold statement against
the deep blue of the night
sky. Built originally as the
headquarters and UK
manufacturing centre for
the Hoover company during
the 1930s, the building was
designed by Wallis, Gilbert
and Partners. During the
Second World War, the plant
made electrical equipment
for tanks and aircraft, the
distinctive building having to
be camouflaged to protect
it from German bombers.
Today, it is a listed building
and owned by supermarket
giant Tesco.

*Western Avenue, Perivale,
Middlesex*

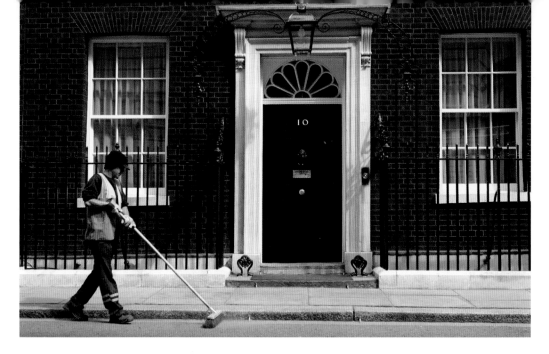

10 Downing Street

Above: A road sweeper cleans the road outside 10 Downing Street in Westminster. The residence of the Prime Minister during term of office, the building has been refurbished many times during the past 300 years, and entirely rebuilt in the 1960s using many of the original building's materials. Originally, it was three houses built around 1683 by Sir George Downing, formerly a spy for Oliver Cromwell.

Right: Gates were installed at both ends of the street during the premiership of Margaret Thatcher due to terrorist threats.

Downing Street, SW1

Vaudeville Theatre

As its name suggests, the Vaudeville Theatre held mostly vaudeville shows and musical reviews during its early days. Opened in 1870, the theatre has been rebuilt twice, the present building dating from 1926. It has a 690-seat auditorium, and contains many rare early stage mechanisms, including thunder drums and lightning sheets.

Strand, WC2

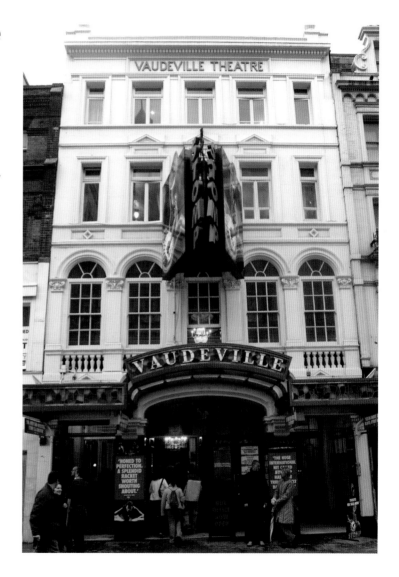

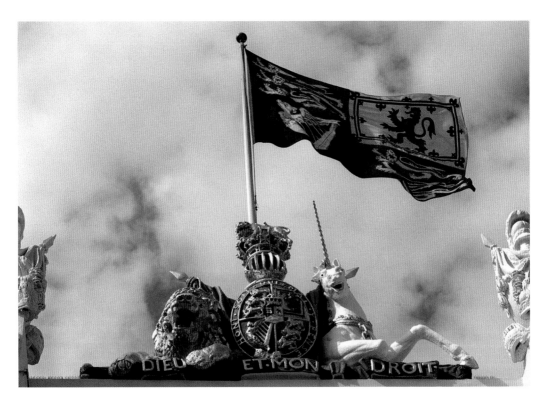

Royal Standard

The Royal Standard flag flies high above the Royal Artillery Barracks in Woolwich during a review of the Royal Horse Artillery by Queen Elizabeth. The standard is always flown on Royal residences when the Queen is present, for example Buckingham Palace, on the Queen's car and on aircraft when on the ground. It may also be flown from any building being visited by the Queen.

Royal Artillery Barracks, Woolwich, SE18

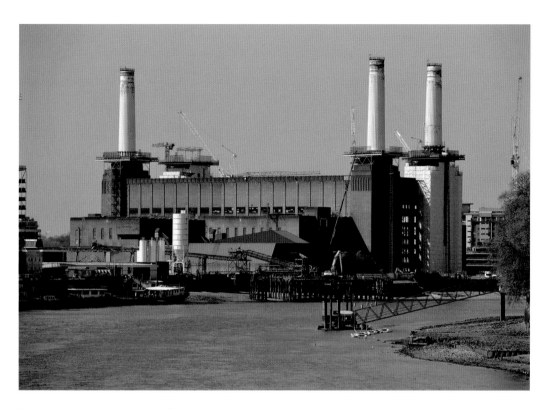

Battersea Power Station

One of the most well-known landmarks in London, Battersea Power Station sits on the south bank of the River Thames. The Art Deco building was designed by Sir Giles Gilbert Scott, creator of the iconic red telephone box. It is actually two identical power stations built side by side. The first was completed in the mid-1930s, while the second was commissioned 20 years later. The subject of a variety of unfulfilled schemes, work began in 2013 on a major redevelopment of the 16-hectare (40-acre) site that would see the Power Station central to a complex of shops, cafés, restaurants, art and leisure facilities, office space and residential accommodation.

Battersea, Wandsworth, SW11

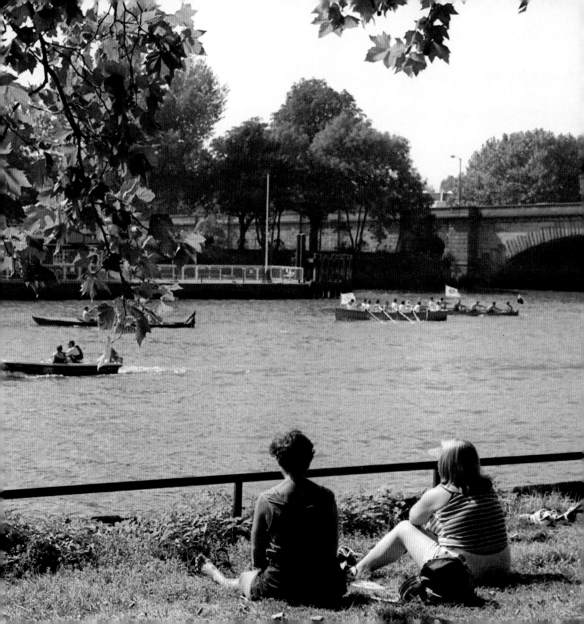

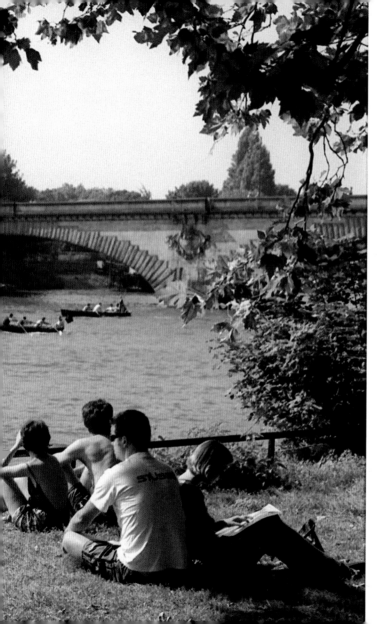

Watching the Great River Race

On a warm day in late summer, spectators watch some of the 300 traditional rowed boats competing in the annual Great River Race on the River Thames at Richmond. The 35km (21½-mile) marathon course starts from London's Docklands and finishes at Ham in Surrey.

Richmond, Surrey

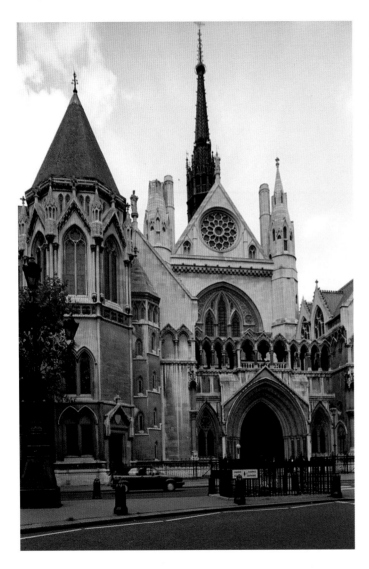

Royal Courts of Justice

Housing the Court of Appeal of England and Wales, and the High Court of Justice of England and Wales, the Royal Courts of Justice in the Strand were opened by Queen Victoria in 1882. In typical Victorian Gothic style, the building was designed by architect George Edmund Street, a former solicitor, who died before its completion. During construction, a strike among the stonemasons led to foreign workers, mostly Germans, being employed. This aroused such hostility that they had to be housed and fed on site.

Strand, WC2

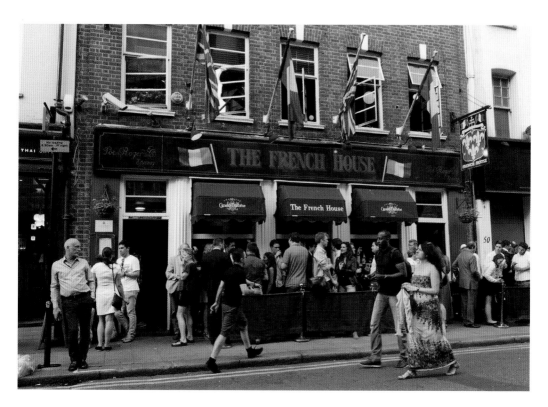

French House

A Grade II listed pub and dining room at 49 Dean Street, Soho, 'the French' is reputed to sell more Ricard than anywhere else in Britain, and only serves beer in half-pints. Opened by a German national named Schmitt in 1891, it passed to his wife on his death in 1911. She ran the pub until 1914, when, on the outbreak of war, she sold it to Belgian Victor Berlemont, whose son Gaston worked there until he retired in 1989. The French was and is popular with artists and writers, including Francis Bacon, Lucian Freud, John Mortimer, and Dylan Thomas, who once left the manuscript of *Under Milk Wood* under his chair.

Dean Street, W1

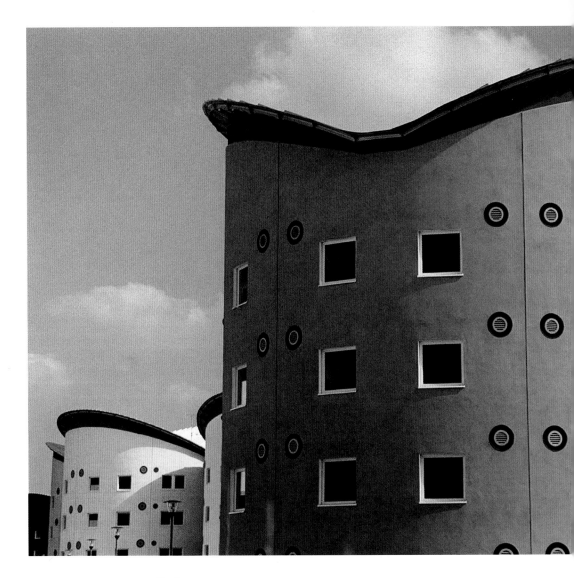

University of East London

Colourful and uniquely designed halls of residence at the Docklands campus of the University of East London, which overlook the Royal Albert Dock. The Docklands campus was London's first university campus to be built in over 50 years. The university was formed in 1970 by the merger of several colleges of higher education. Today, it caters for over 28,000 students spread between its two campuses in Stratford and Docklands.

University Way, E16

Canning Town Underground Station

Automatic entrance barriers and escalators at Canning Town Underground station, designed by architects Troughton McAslan. The station also serves the Docklands Light Railway.

Silvertown Way, E16

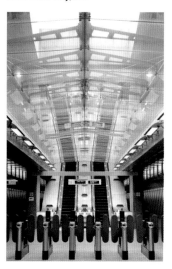

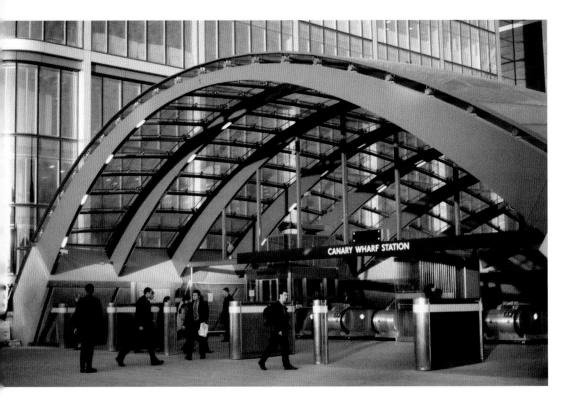

Canary Wharf Underground Station

One of two arched, glazed entrances to Canary Wharf Underground station. The glazing allows daylight to filter down to the ticket hall. The station was opened in 1999, serving the Docklands business district on an extension to the Jubilee Line. Over 40 million people use the station each year, making it the busiest Underground station outside central London, after Stratford.

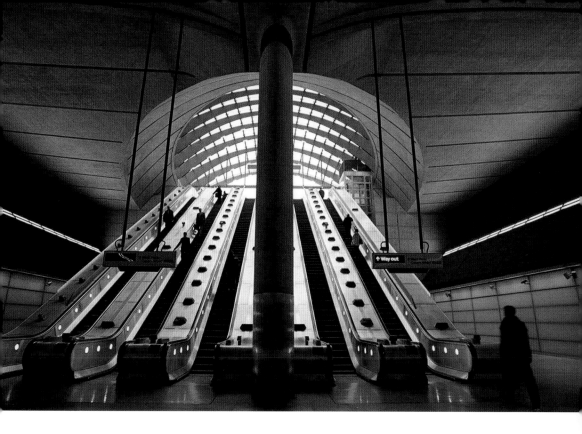

The great glazed entrance roof, vast interior and escalators of the Canary Wharf Underground station. Designed by renowned architect Norman Foster, the station was intended from the outset to be the showpiece of the Jubilee Line Extension. Its cathedral-like interior has even been used for a wedding.

Heron Quays Road, E14

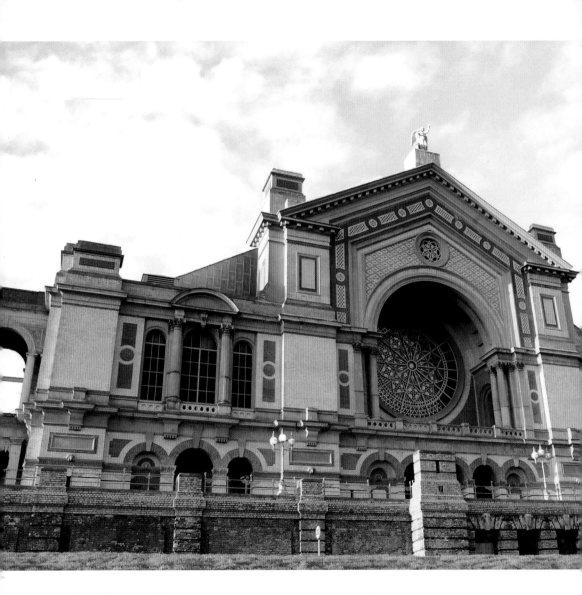

Alexandra Palace

Opened in 1873, Alexandra Palace was intended as a centre for education, entertainment and recreation, a north London equivalent of the Crystal Palace in south London. The building stands in Alexandra Park, named after Princess Alexandra of Denmark, who married Edward, Prince of Wales in 1863. In 1936, Alexandra Palace became the headquarters for the BBC's new television service, and the original transmitter mast (*right*) and studios still survive. Known popularly as 'Ally Pally', the building is mainly used today for exhibitions, music concerts and conferences.

Alexandra Palace Way, N22

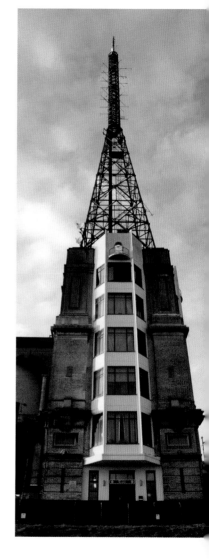

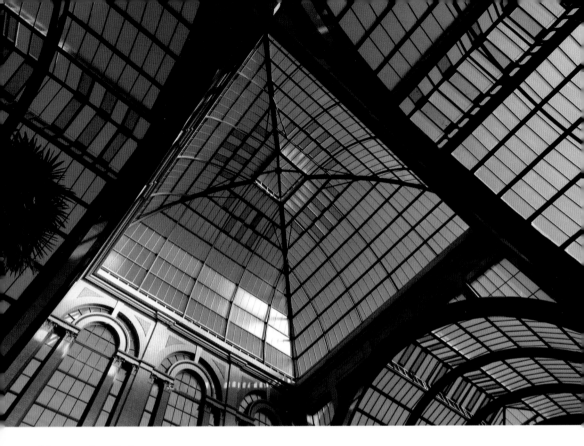

Alexandra Palace

The amazing Victorian iron and glass roof of Alexandra Palace. The building was designed by architect Owen Jones, and construction began in 1865. Tragically, the building burned to the ground 16 days after being opened. Subsequently rebuilt, it was reopened in 1875. A second disastrous fire occurred in 1980, which destroyed half the building.

Alexandra Palace Way, N22

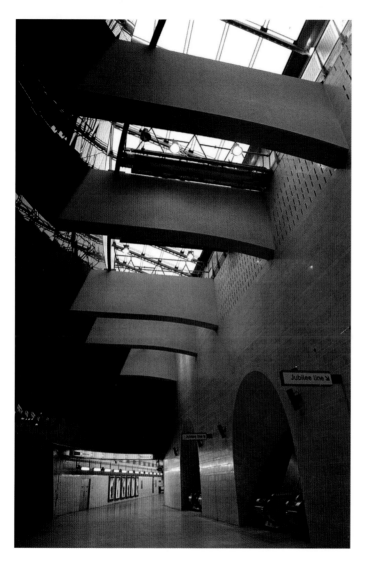

Southwark Underground Station

The intermediate concourse of Southwark Underground station, designed by MacCormac Jamieson Prichard and serving the Jubilee Line Extension, which runs eastward from Green Park to Stratford. Like other stations on the line, Southwark is notable for its striking architecture. The upper concourse has a 40m (131ft) long glass wall made from 660 pieces of blue glass by the artist Alexander Beleschenko, which has won a number of awards.

Blackfriars Road, SE1

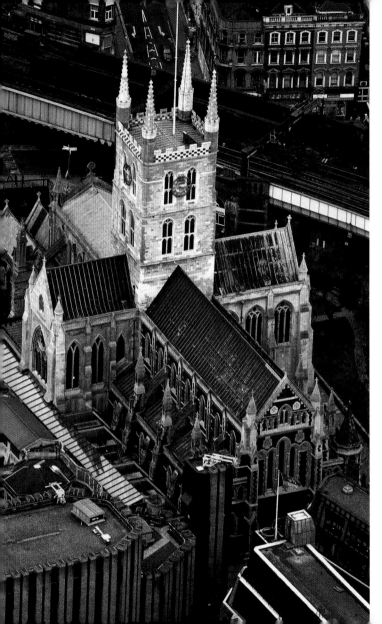

Southwark Cathedral

Left: The site of Southwark Cathedral has been a place of Christian worship for over 1,000 years, although the church was only made a cathedral in 1905, when the Anglican diocese of Southwark was created; the mainly Gothic building dates from 1220 to 1420. It is surrounded by buildings, including Borough Market, and the railway lines that run from London Bridge to Waterloo and Cannon Street.

Right: The great arching, vaulted roof of Southwark Cathedral. The building was the first Gothic church to be constructed in London. It was devastated by fire in the early 13th century and again in the late 14th century. The 15th-century poet John Gower is buried in the cathedral, as is Edmund, brother of William Shakespeare; there is a 19th-century stained-glass window dedicated to the bard.

Montague Close, SE1

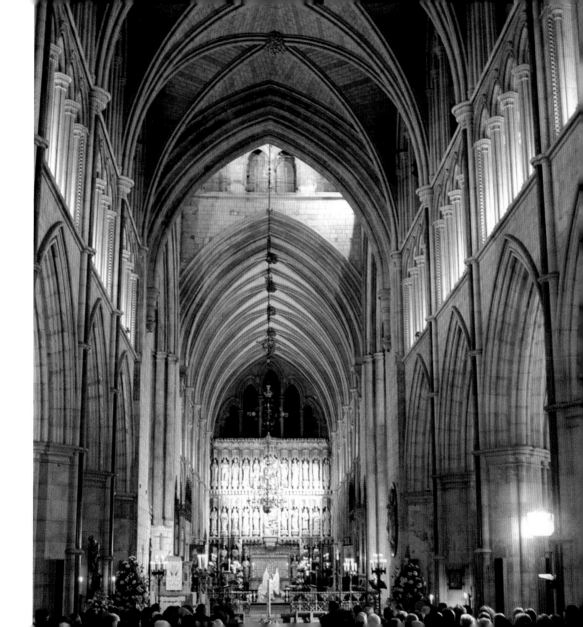

Royal Tank Regiment Memorial

A veteran surveys the Royal Tank Regiment Memorial in Whitehall. The bronze statue, sculpted by Vivien Mallock, depicts the crew of a Second World War Comet tank and is intended to show the comradeship that exists in tank crews. It was unveiled by Queen Elizabeth in 2000.

Whitehall Place, SW1

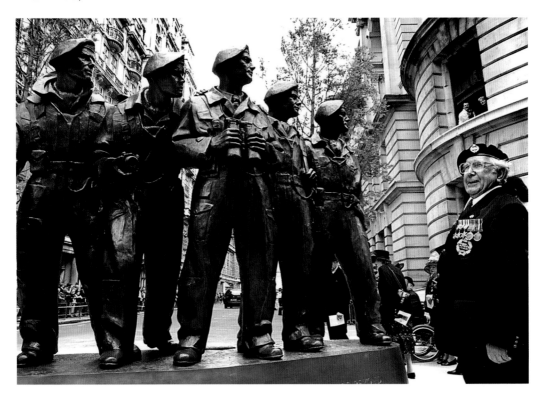

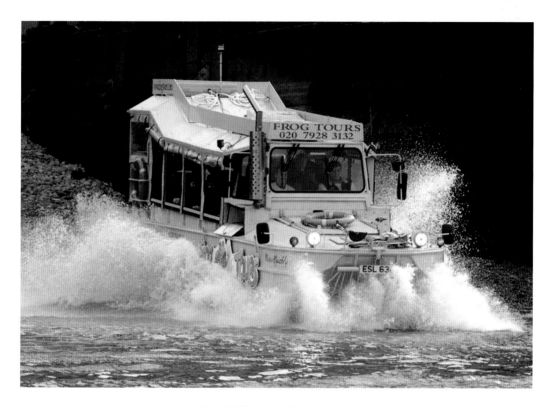

Amphibious River Cruise

A specially adapted Second World War amphibious landing craft is launched into the River Thames at Vauxhall, south London, to provide a unique tourist attraction. Officially known as a DUKW, the six-wheel-drive vehicle takes a 75-minute tour around central London's sights on land and water.

York Road, SE1

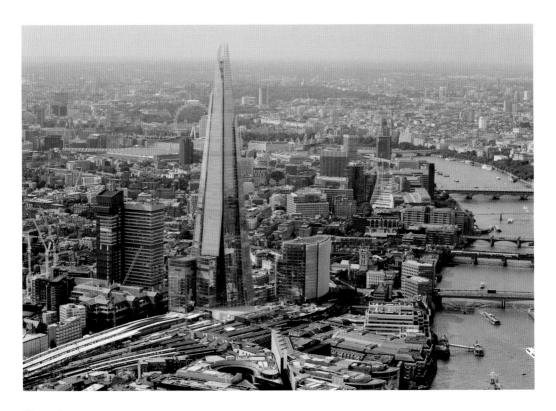

Shard

Piercing the sky over London Bridge Station in Southwark, the Shard is a glass-clad pyramidal tower, which, at 309.6m (1,016ft) high, is the second-tallest freestanding structure in the United Kingdom (after Emley Moor transmitting station in Yorkshire). Construction began in March 2009 and the building – designed by Italian architect Renzo Piano – was topped out on 30th March, 2012. The View from the Shard, a viewing gallery and open-air observation deck on floors 68, 69 and 72 (at 244m/802ft) is open to the public via pre-booked tickets, and offers 360-degree views for up to 64km (40 miles).

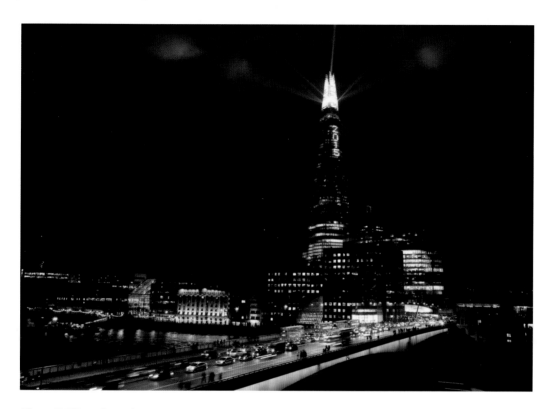

Shard Illuminations

The Shard – conceived as a 'vertical city' containing apartments, offices, restaurants and a hotel – celebrates the arrival of the New Year with a light and laser spectacle in the sky.

London Bridge Street, SE1

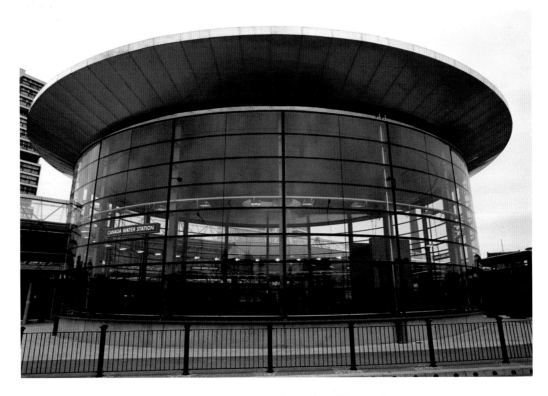

Canada Water Underground Station

The glass 'drum' of Canada Water Underground station allows daylight to reach deep into the station. The station, the first to be constructed on the Jubilee Line Extension, takes its name from a nearby lake created from a defunct dock.

Surrey Quays Road, SE16

London Marathon

Right: Runners in the London Marathon fill The Mall, site of the finish line. The run, which winds through the city around the Thames, from three separate starting points in Blackheath, covers a distance of 42.195km (26 miles, 385 yards) and is the only marathon in the world to be run in two hemispheres, as it crosses the Prime Meridian at Greenwich.

The Mall, SW1

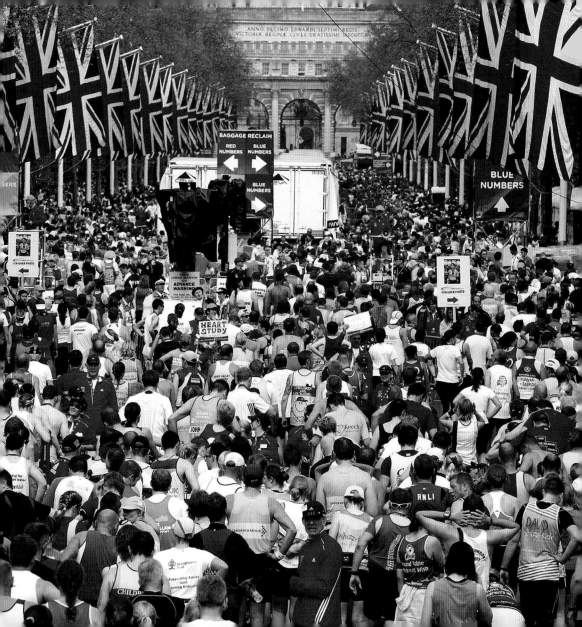

Vauxhall Bridge

The dramatic cascading architecture of apartment and office blocks at St George Wharf provides an eye-catching backdrop for the broad arches of Vauxhall Bridge. Completed in 1906, the bridge, which replaced an earlier bridge, was the first in London to carry trams.

Vauxhall Bridge Road, SW1

Reformers' Tree Sculpture

The Reformers' Tree sculpture in Hyde Park is cleaned. Unveiled by MP Tony Benn in 2000, the sculpture takes the form of a circular mosaic. It is set close to the original tree, where the Reform League held protest meetings in the 19th century.

Hyde Park, W1

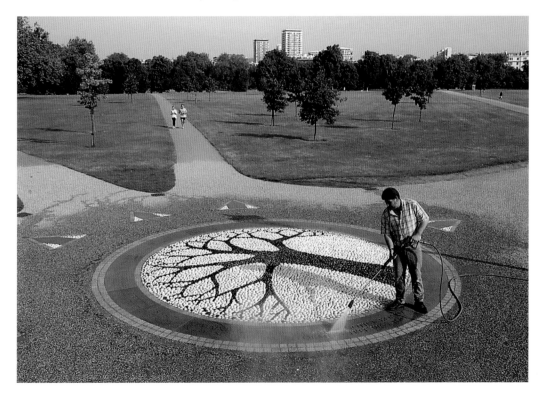

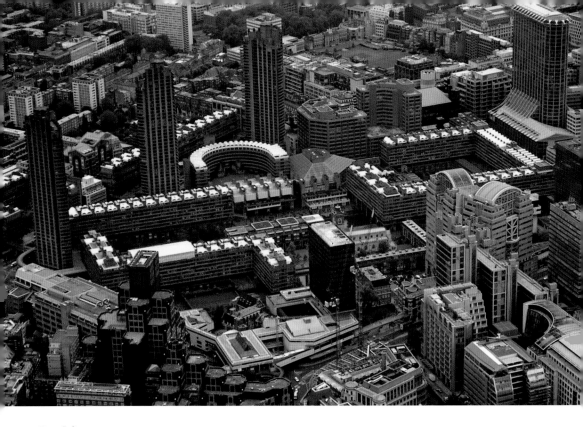

Barbican

Constructed on a site in the Cripplegate area of London, which had been badly bombed during the Second World War, the Barbican complex comprises a residential estate and the Barbican Centre, a venue for arts, drama and business. A prime example of post-war concrete brutalist architecture, the complex includes three of London's highest residential towers.

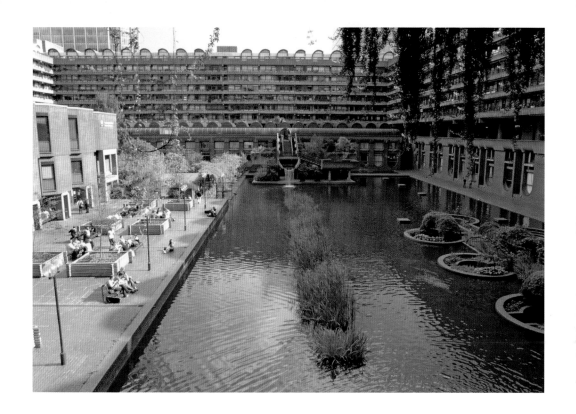

Residents and visitors alike enjoy a sunny day sitting by the lake at the Barbican. The residential complex includes 13 terrace blocks grouped around the lake and green squares. All the blocks are linked by a podium, which provides pedestrian access above street level. Vehicles are not allowed within the estate.

Barbican, EC2

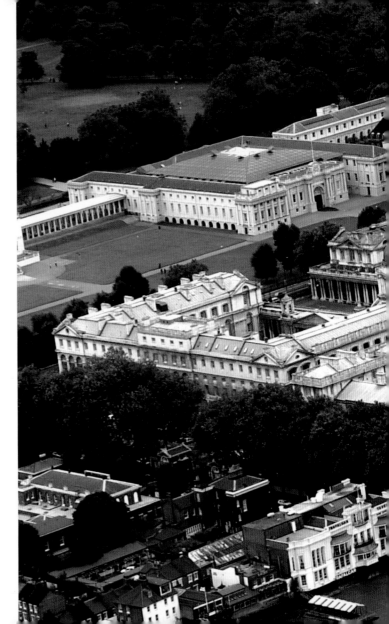

Maritime Greenwich

Described by UNESCO as the "finest and most dramatically sited architectural and landscape ensemble in the British Isles", the former Royal Naval College at Greenwich (*centre*), together with the National Maritime Museum (*top left*), the 17th-century Queen's House and the Royal Observatory (*both not shown*) form the Maritime Greenwich World Heritage Site.

Romney Road, SE10

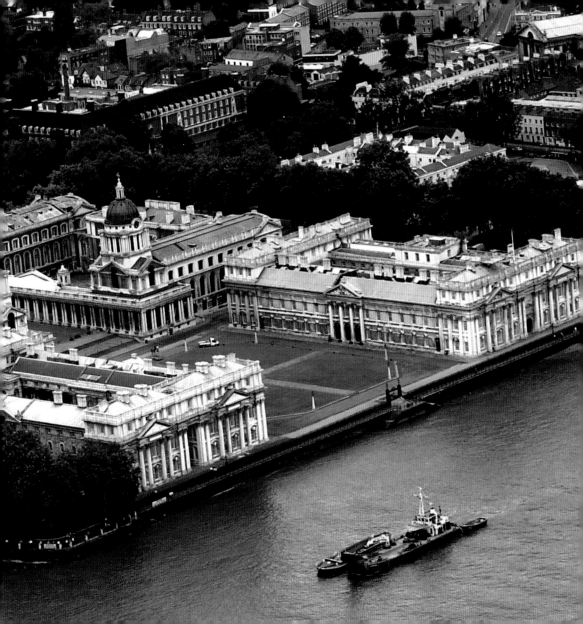

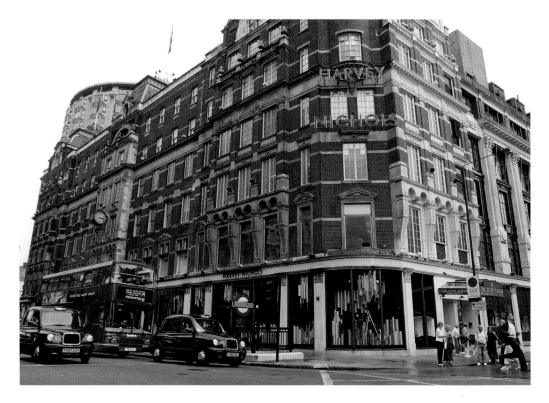

Harvey Nichols

In 1813, Benjamin Harvey opened a linen shop in Knightsbridge, and upon his death in 1820, the business passed to his daughter, on the understanding that she entered into a partnership with a Colonel Nichols to sell carpets, silks and other luxury goods alongside the linens. Today, Harvey Nichols is a well-known, upmarket department store, which has occupied the same building since 1880.

Knightsbridge, SW1

Speakers' Corner

For over 150 years, Speakers' Corner, in the north-east corner of Hyde Park, has provided anyone with an opinion about anything the opportunity to air it in public, and anyone else the opportunity to challenge and debate that opinion, often with lively results. Many renowned figures in history have taken advantage of Speakers' Corner to express their views and philosophies, including Karl Marx, Vladimir Lenin, George Orwell and William Morris.

Hyde Park, W1

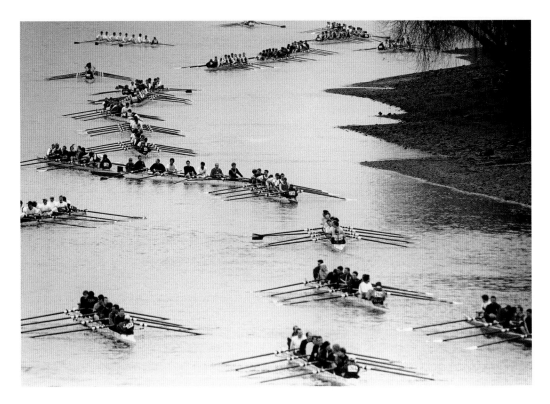

Head of the River Race

Boat crews from rowing clubs across the UK and overseas gather on the River Thames at Putney, in March, for the beginning of the annual Head of the River Race. Established in 1926 by rowing coach Steve Fairbairn, the against-the-clock 'processional' race takes place over a 6.8km (4.25-mile) course between Mortlake and Putney. The race is open to men's eights only and can attract up to 420 crews.

Putney, SW15

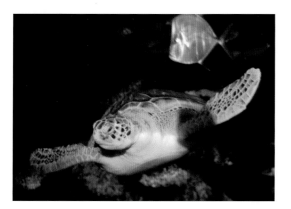

London Aquarium

Boris, a green turtle (*left*) that was named after London Mayor Boris Johnson at the Sea Life Aquarium on the South Bank. The aquarium is housed on the ground floor of County Hall (*below*), former headquarters of the now defunct Greater London Council, and close to the London Eye. Opened in 1997, it is the capital's largest collection of aquatic species.

Westminster Bridge Road, SE17

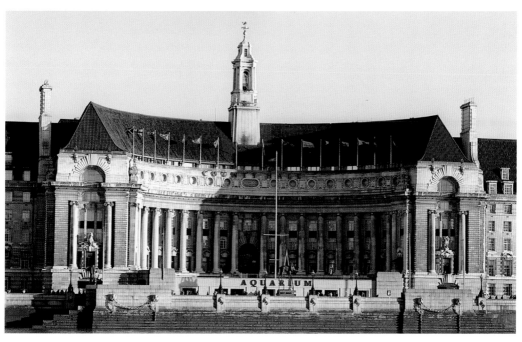

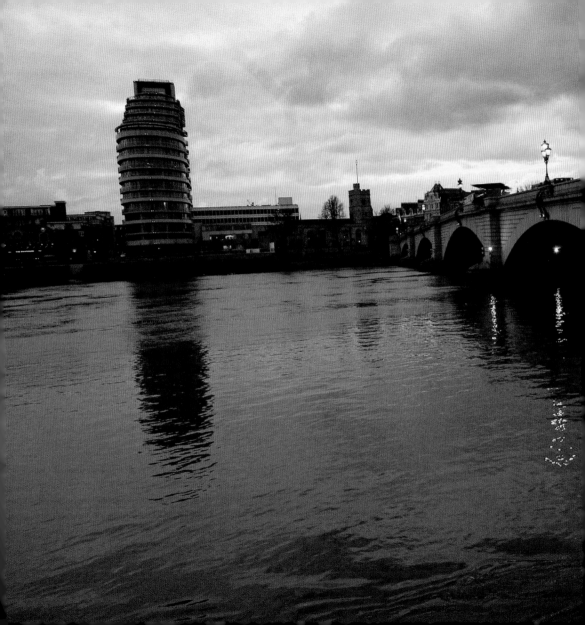

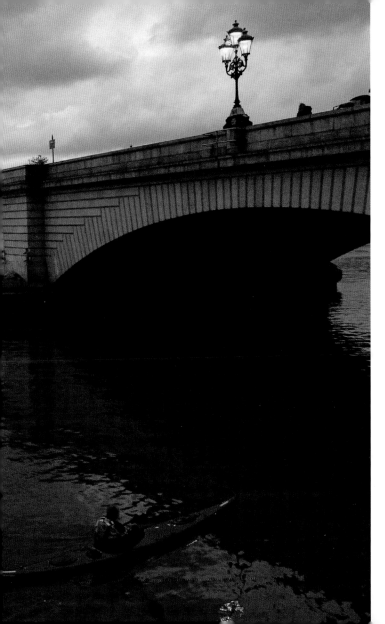

Putney Bridge

As the sun sets on a brisk winter's day in January, a hardy canoeist paddles quietly beneath Putney Bridge on the River Thames. Originally there was a ferry crossing at this point on the river, but it was replaced by a wooden toll bridge in 1729. The present stone bridge was built in 1886, having been designed by renowned civil engineer Joseph Bazalgette. It is the starting point for the annual University Boat Race.

Putney Bridge Approach, SW15

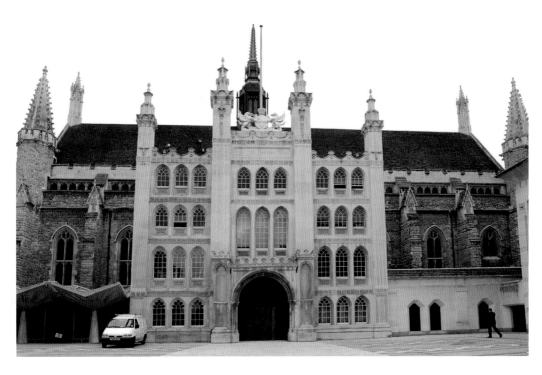

Guildhall

For centuries, the Guildhall has acted as the town hall of the City of London, the historic core of the capital. Today, the historic building, parts of which date from 1411, is used largely for ceremonial purposes for the City of London Corporation and the Lord Mayor. It is the only stone building not belonging to the Church to have survived the Great Fire of London in 1666.

Gresham Street, EC2

Crystal Palace Park

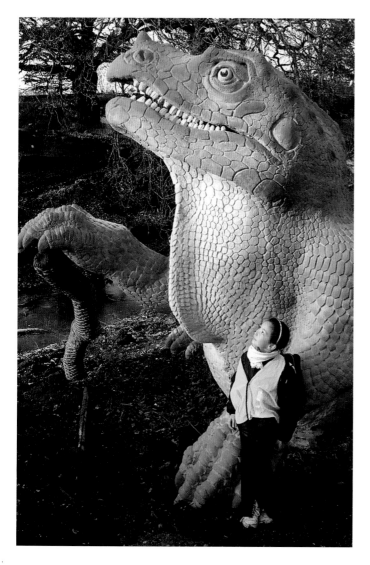

A young enthusiast examines a statue of an Iguanodon at Crystal Palace Park. The statue is one of 29 life-sized representations of prehistoric creatures created by the sculptor Benjamin Waterhouse Hawkins, under the guidance of Professor Richard Owen (who coined the name dinosaur), between 1852 and 1855. It was the world's first dinosaur and prehistoric animal park. Although known to be inaccurate, the statues were renovated in 2002 as part of a £3.6m restoration of the historic park. They form part of a geological time trail, tracing the geological history of Britain over billions of years.

Thicket Road, SE20

Ministry of Defence

Philip Jackson's monument to the Ghurkas stands opposite the Ministry of Defence's headquarters in Whitehall. The neoclassical building was designed by the architect Vincent Harris and was built in stages between 1938 and 1959, originally to house the Air Ministry and the Board of Trade. A complete renovation of the building was completed in 2004 and involved the replacement of 3,600 doors together with the equivalent of eight football pitches of carpet.

Whitehall, SW1

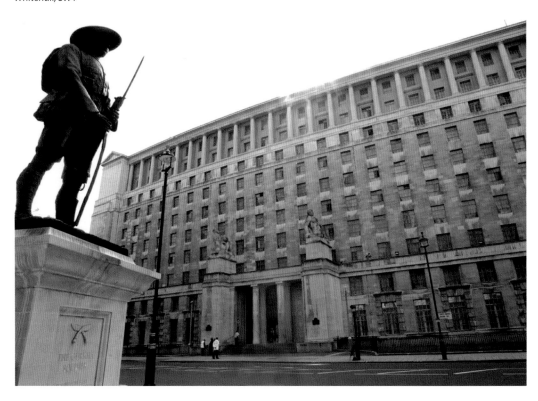

Statue of Peter Pan

Sir George Frampton's statue of Peter Pan, which was donated by the character's creator, J.M. Barrie, to Kensington Gardens in 1912. The spot where the statue stands was mentioned in Barrie's first Peter Pan book, *The Little White Bird*, published in 1902. Barrie arranged for the statue to be erected secretly overnight, publicising its arrival with an announcement in *The Times* that read: "There is a surprise in store for the children who go to Kensington Gardens to feed the ducks in the Serpentine this morning…"

Kensington Gardens, W2

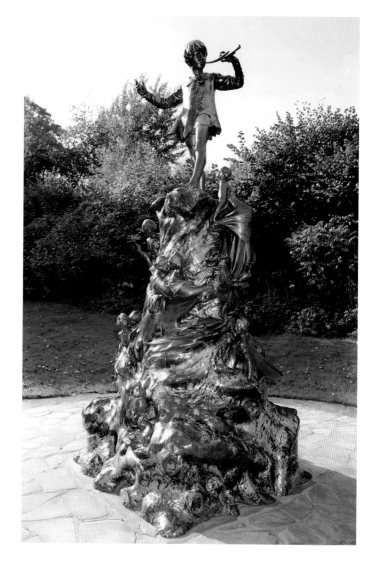

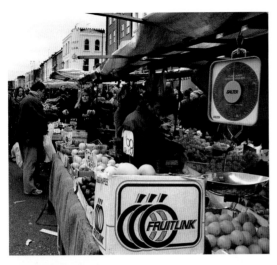

Portobello Road Market

Left: A fruit and vegetable stall in Portobello Road Market, which has a history that dates back to the 19th century. It covers a distance of about 0.8km (half a mile). On Saturdays, the market also contains many stalls selling antiques and it is a popular destination for tourists. Among many other appearances in the media, the market was used as the location for the film, *Notting Hill.*

Portobello Road, W11

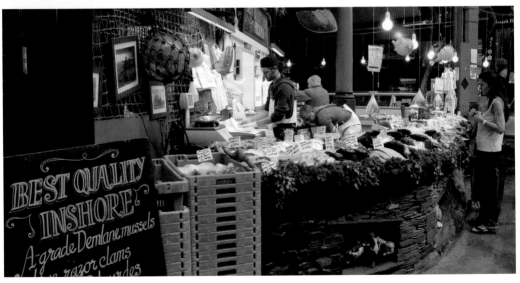

Borough Market

Right and below left: There has been a market on the site of Borough Market in south-east London since at least the middle of the 13th century, and the current market is one of the largest food markets in the world. Borough Market caters for both wholesale and retail shoppers, offering a wide variety of delicacies from around the world. The current buildings of the market date to 1851, but in 1932, an entrance on Southwark Street was erected in the Art Deco style. A programme of refurbishment was undertaken in 2001. The streets around the market have featured in several films, including B*ridget Jones's Diary*, *Lock, Stock and Two Smoking Barrels* and *Harry Potter and the Prisoner of Azkaban.*

Southwark Street/Borough High Street, SE1

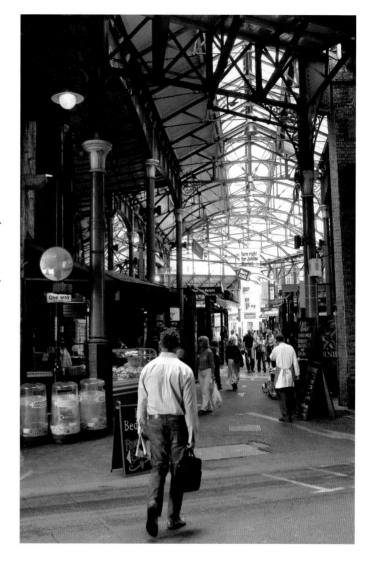

Whitechapel Bell Foundry

A foundryman pours molten metal into a bell mould at the Whitechapel Bell Foundry in east London. The business is the oldest manufacturing company in Britain, dating back to 1570 and possibly earlier. In 1738, the foundry produced the original Bow Bells for St Mary-le-Bow church in Cheapside.

Whitechapel Road, E1

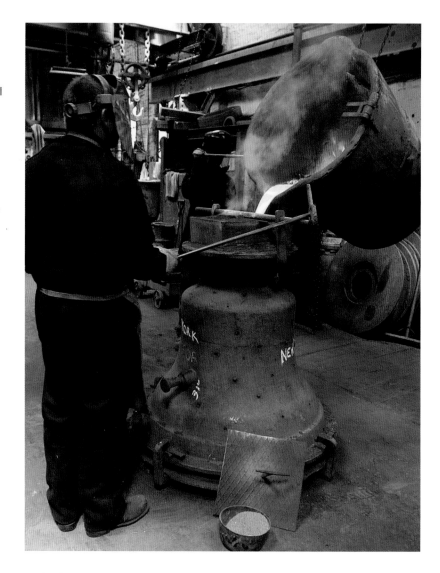

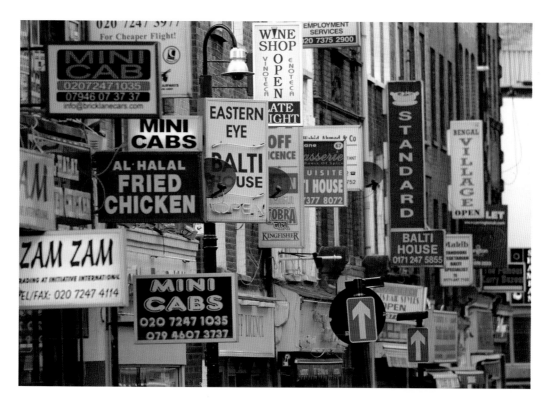

Brick Lane

A proliferation of signs in Brick Lane, east London. A number of ethnic groups have settled in the area over the centuries, such as French Huguenots, Ashkenazi Jews and Bangladeshis. Today, it is the centre of London's Bangladeshi-Sylheti community and is popularly known to many as 'Banglatown'. In recognition of the large Bengali community in the area, local street signs are duplicated in Bengali.

Brick Lane, E1

London Museum of Water & Steam

Opened by the Grand Junction Waterworks Company in 1838, Kew Bridge Pumping Station relied on steam engines to operate its pumps until 1944, when diesel and electric pumps took over. Rather than being scrapped, however, the steam engines were retained and subsequently formed the basis for the Kew Bridge Steam Museum, which was opened on the site in 1975. The museum contains the world's largest collection of Cornish beam engines, including the largest working engine, the Grand Junction 90, which has a cylinder diameter of 228cm (90 inches) and weighs 227 tonnes (250 tons). The museum was rebranded as the London Museum of Water & Steam in early 2014 following a major investment project.

Green Dragon Lane, Brentford, Middlesex

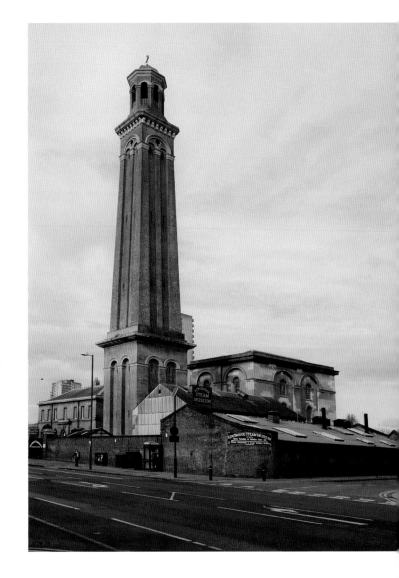

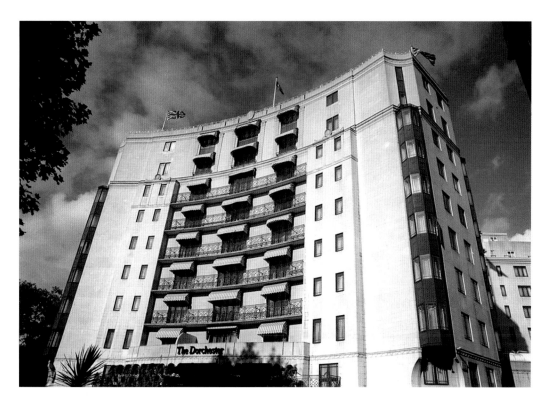

Dorchester Hotel

Opened in 1931, the Dorchester is a luxury hotel that overlooks Hyde Park. Much use was made of reinforced concrete in its construction, allowing large internal spaces without support. This modern method of construction (for its day) earned the hotel the reputation of being a very safe building during the Second World War, and many high-ranking individuals stayed there, including Winston Churchill and General Dwight D. Eisenhower. Today it remains a popular hotel among the rich and famous.

Park Lane, W1

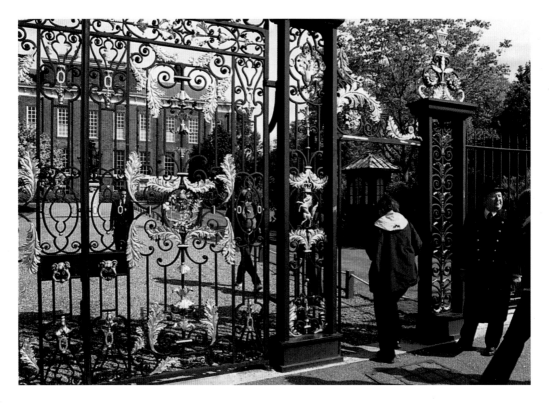

Kensington Palace

Members of the public pass through the Gold Gates on their way to view the state apartments and the Royal Ceremonial Dress Collection at Kensington Palace. The entrance, opened in 2002, enables visitors to see the Rose Garden, which previously was hidden from view. The gates, which are French and were made around 1879, are based loosely on a Louis XV style. They were installed in 1989.

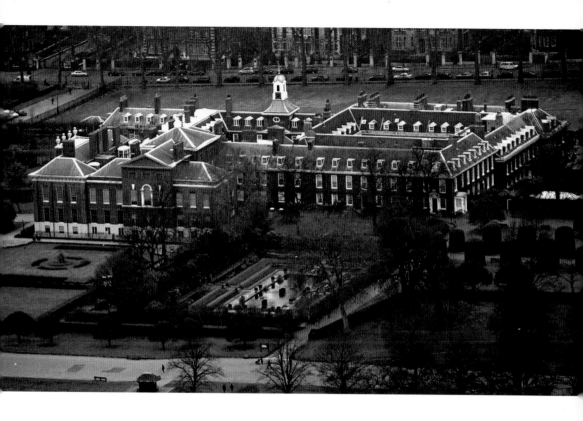

A Royal residence since the 17th century, Kensington Palace was home to Diana, Princess of Wales until her death in 1997. Today the palace accommodates the offices and private apartments of a number of members of the Royal Family, including the Duke and Duchess of Cambridge and Prince Harry. Built originally for the Earl of Nottingham, the palace was improved and extended by Christopher Wren.

Kensington Gardens, W8

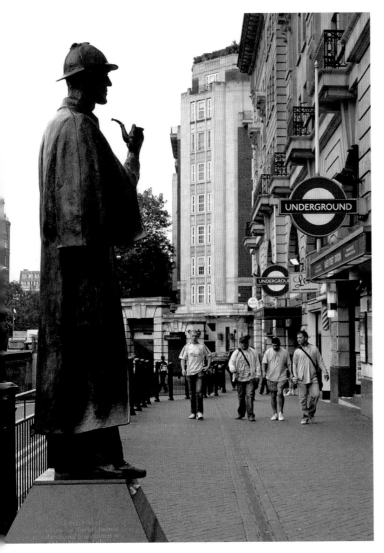

Statue of Sherlock Holmes

Outside the Underground station, a statue of fictional detective Sherlock Holmes watches over Baker Street. The famous sleuth, created by Arthur Conan Doyle in a series of stories published in *The Strand* magazine around the turn of the last century, lived and worked at 221B Baker Street, although this address was also fictional. The statue was sponsored by the Abbey National Building Society, whose offices at 215–229 Baker Street were kept busy answering mail addressed to the great detective, even though he was a fictional character and the stories had been set during Victorian times. Today, Baker Street is home to the Sherlock Holmes Museum, which has been given the 221B address, even though it is out of numerical order.

Baker Street, W1

Baker Street

The Chiltern Court residential flats in Baker Street, where the novelist Arnold Bennett (1867–1931) lived for several years until his death. Baker Street was named after the builder William Baker, who laid out the street in the 18th century. Originally a high-class residential district, today it is largely occupied by commercial premises.

Baker Street, W1

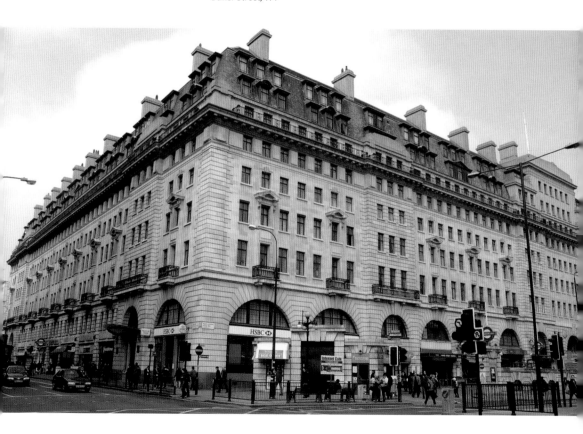

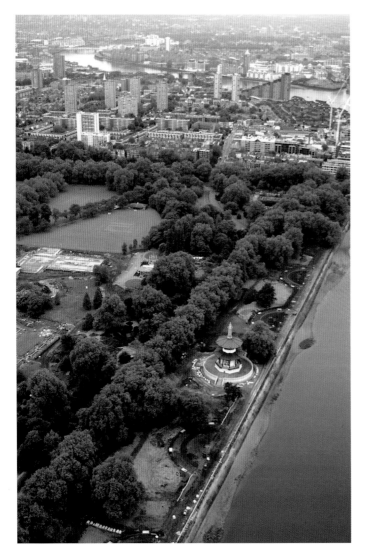

Battersea Park

The 80-hectare (200-acre) Battersea Park, on the south bank of the River Thames, which was opened in 1858. Previously, the site had been known as Battersea Fields and was a popular spot for duelling. In 1829, the Duke of Wellington and Earl of Winchilsea fought a duel there, each deliberately discharging his pistol wide to avoid injuring the other. In 1951, a number of attractions were built in the park to form the popular Festival Gardens, part of the Festival of Britain. The circular structure near the river (*centre*) is the Peace Pagoda, erected in 1985. This Buddhist device is intended to help people focus their thoughts in a search for world peace.

Albert Bridge Road, SW11

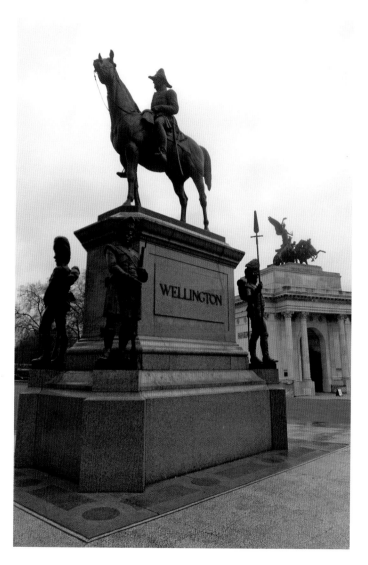

Statue of Duke of Wellington

With Wellington Arch in the background, the statue of the Duke of Wellington at Hyde Park Corner faces Apsley House, once the home of the 'Iron Duke' and now the Wellington Museum. It was created by the sculptor J.E. Boehm in 1888 and is 'guarded' by four figures representing British soldiers from the Napoleonic period.

Grosvenor Place, SW1

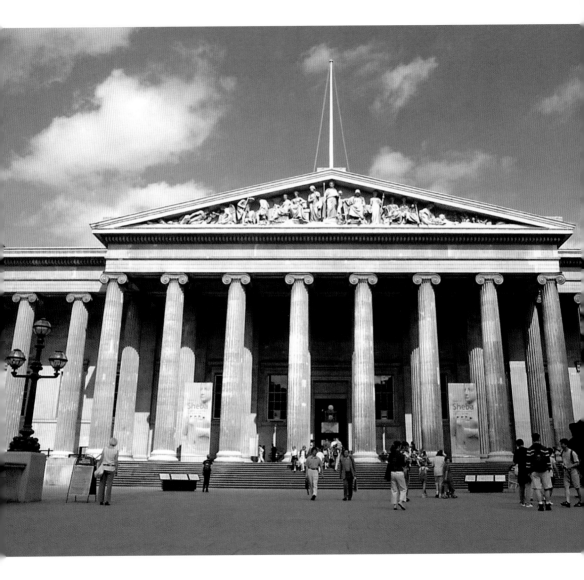

British Museum

Left: Established in 1753, the British Museum is dedicated to human history and culture from their beginnings to the present day, and has collections from around the world that number over eight million objects. The museum was opened to the public in 1759 in Montagu House, on the site of the present museum building, which was erected in the first half of the 19th century.

Right: The Great Court of the British Museum, which was created following the move of the British Library to its own dedicated premises in 1997. The museum's former central quadrangle, containing Sydney Smirke's 1857 round reading room, was redeveloped and covered with a tessellated glass roof designed by Buro Happold, creating the largest covered square in Europe. The Great Court contains shops and cafés, and remains open after the museum itself has closed.

Great Russell Street, WC1

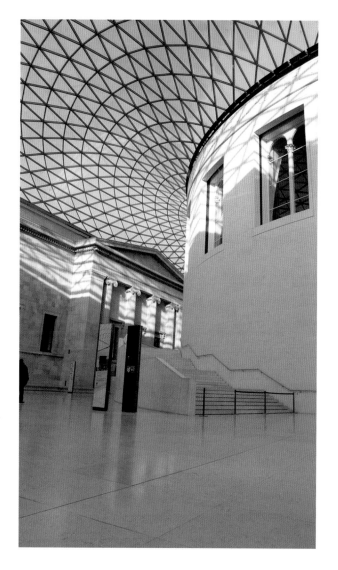

New Bond Street

Exclusive London jewellers, Graff, in New Bond Street. In 2009, jewellery worth nearly £40m was stolen from the shop in an audacious daylight raid by two armed men who had disguised themselves with the aid of an unwitting professional make-up artist (they said it was for a music video). Although the men were soon caught, along with several accomplices, none of the jewellery has ever been recovered.

New Bond Street, W1

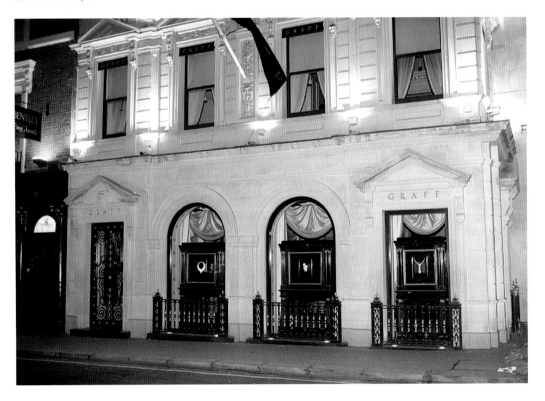

Victoria Memorial

Completed in 1911, the Victoria Memorial stands on a traffic island in front of Buckingham Palace. It was erected in memory of Queen Victoria and unveiled by King George V, her son. The seated statue of Victoria faces The Mall, while the memorial is surmounted by a gilded winged figure of Victory.

The Mall, SW1

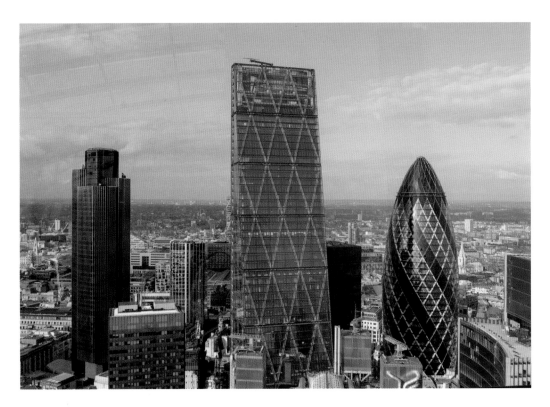

Cheesegrater

Formally known as the Leadenhall Building, but dubbed 'the Cheesegrater' for its distinctive wedge shape, the 737ft (225m) tall commercial skyscraper nestles between Tower 42 (*left*) and 'the Gherkin' (*right*) in the City's financial district. Designed by Rogers Stirk Harbour & Partners, and opened in July 2014, the structure has no central core, with an external frame providing lateral stability.

Leadenhall Street, EC3

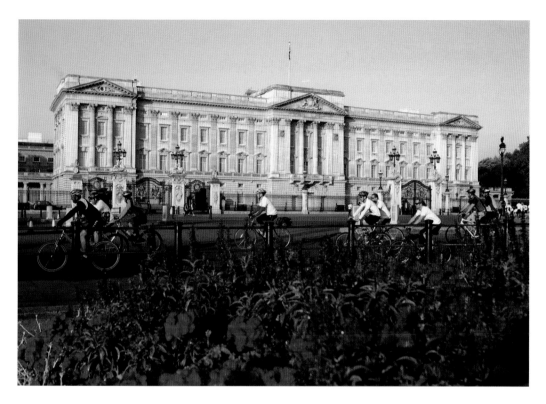

Buckingham Palace

On a bright sunny day in September, a group of cyclists passes in front of Buckingham Palace, the official London residence of Queen Elizabeth. The building at the core of the palace was known originally as Buckingham House and was built for the Duke of Buckingham in 1703. It was acquired by George III in 1761 as a residence for Queen Charlotte and became known as the Queen's House. The building was enlarged in the 19th century and became the official Royal residence in 1837 upon the accession of Queen Victoria.

Buckingham Palace Road, SW1

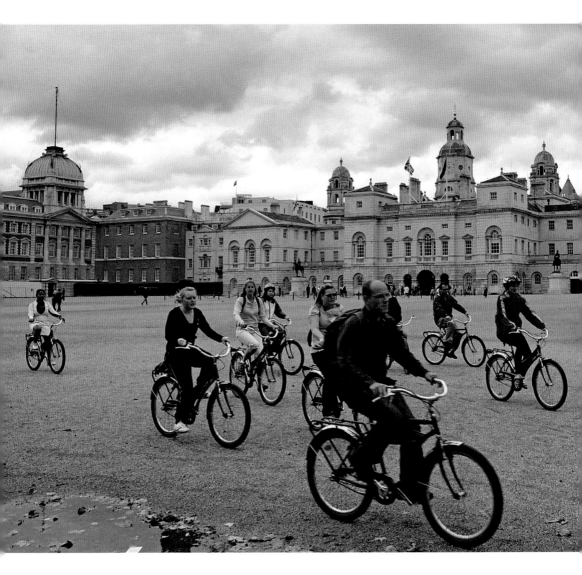

Horse Guards Parade

Originally the site of the Palace of Whitehall's tiltyard, where tournaments were held in the time of Henry VIII, this large parade ground is used for such military ceremonies as Trooping the Colour and Beating the Retreat. The buildings around Horse Guards Parade were once used as the headquarters of the British Army, and the square is ringed with a variety of military statues and monuments.

Horse Guards Parade, SW1

Trooping the Colour

Queen Elizabeth and the Duke of Edinburgh stand on the podium during the annual Trooping the Colour ceremony at Horse Guards Parade. Each year, one of the Household Division's Foot Guards regiments (Grenadier, Coldstream, Scots, Irish or Welsh) parades its colour (flag) through the ranks of the remaining regiments. This is followed by a March Past in front of the sovereign.

Horse Guards Parade, Whitehall, SW1

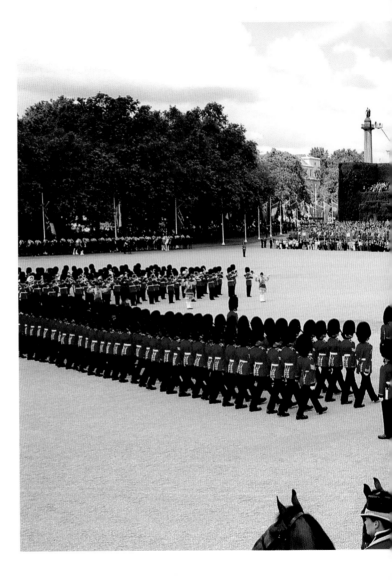

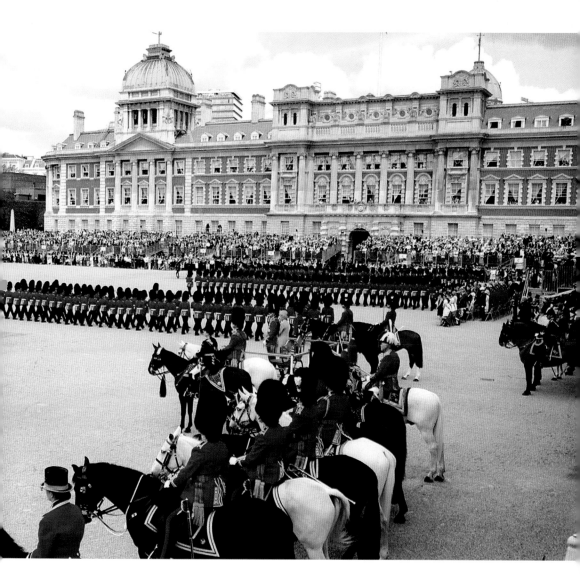

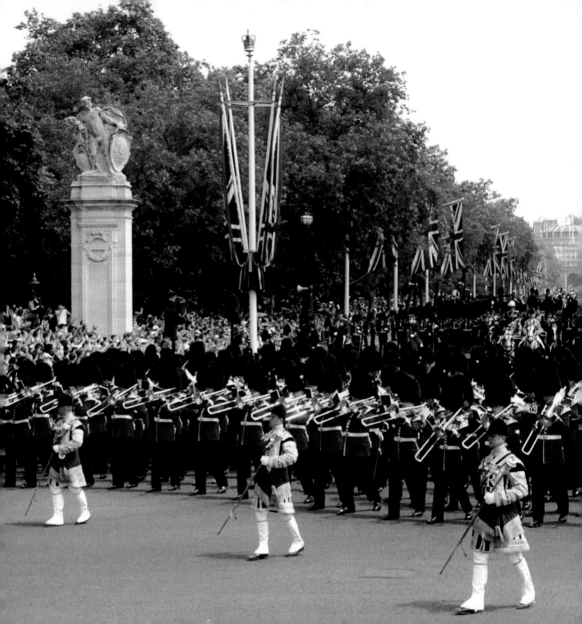

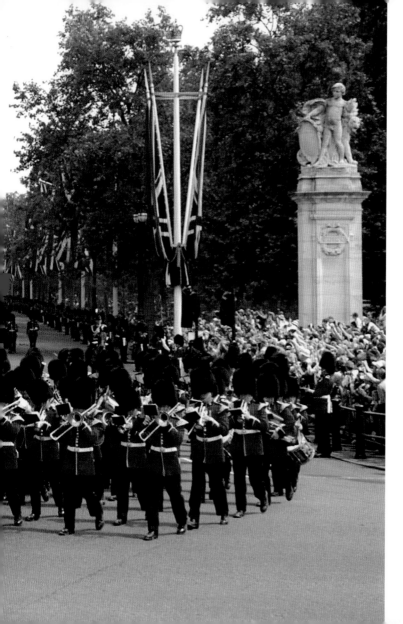

Trooping the Colour

The massed bands of the Guards lead the carriage bearing Queen Elizabeth, followed by the Foot Guards, back to Buckingham Palace following the Trooping the Colour ceremony.

The Mall, SW1

Chelsea Flower Show

Below: Visitors enjoy the attractions of the Chelsea Flower Show. Officially called the Great Spring Show by the Royal Horticultural Society, the annual garden show is the most well-known event of its type in the UK, lasting five days and attracting over 150,000 visitors. With breaks for the First and Second World Wars, it has drawn crowds to the grounds of the Royal Hospital since 1913.

Right: A visitor takes time to enjoy a display of delphiniums and begonias at the show.

Below right: A happy gardening enthusiast carries plants and other bargains home on a rickshaw after the last day of the show. Rickshaws have become an increasingly common sight on the streets of central London, offering a 'green' alternative to a cab or bus for short journeys.

Royal Hospital Road, Chelsea, SW3

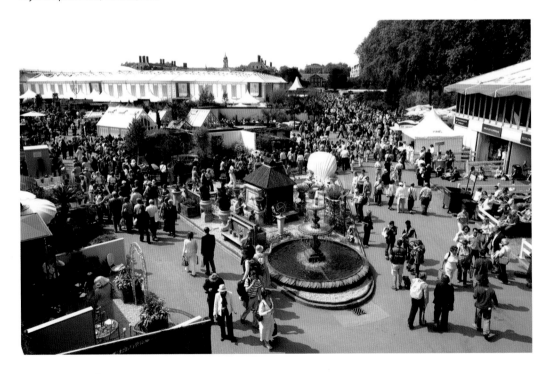

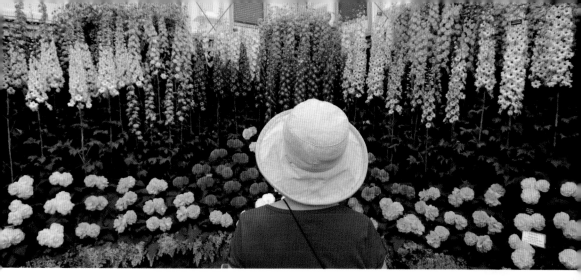

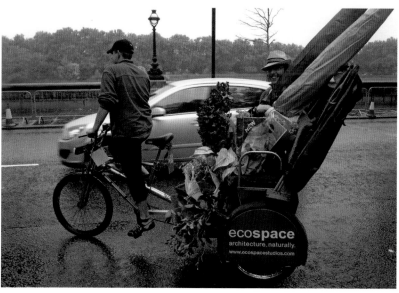

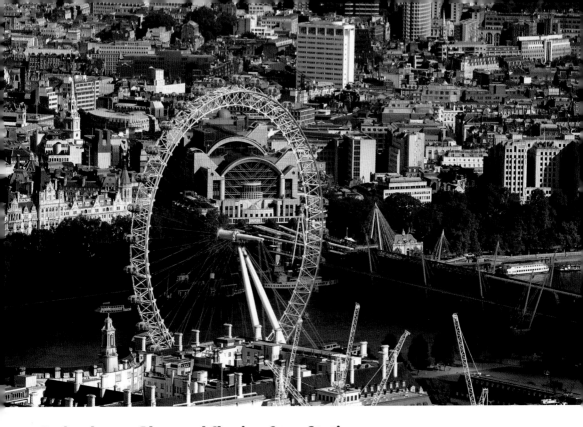

Embankment Place and Charing Cross Station

The London Eye frames the dramatic shapes of Embankment Place, a commercial and shopping complex built over the platforms of Charing Cross railway station, to the north of Hungerford Bridge. Opened in 1990, Embankment Place replaced almost all of the station's previous roof, which had been erected in 1906, following the partial collapse of the original Victorian wrought-iron and glass arched roof. The station itself was opened in 1864 as a terminus for the South Eastern Railway.

Embankment Place, WC2

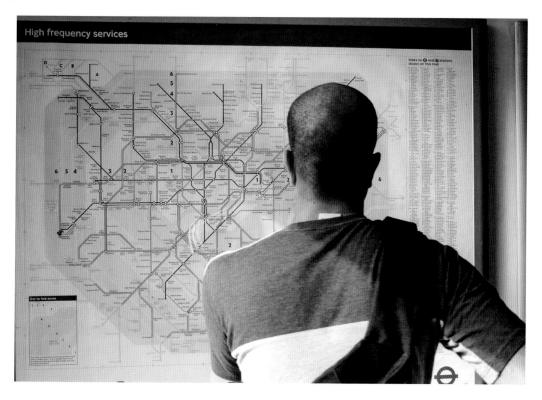

Tube Map

A passenger studies a map of the Underground at Mile End station. Prior to 1933, geographic maps were issued for the Underground, with the lines overlaid on surface features. However, a much clearer diagrammatic map was produced by Underground employee Harry Beck, and this soon proved popular with travellers. Although the map has been revised on many occasions, all the subsequent versions have been rooted very firmly in Beck's original design.

Mile End Road, E3

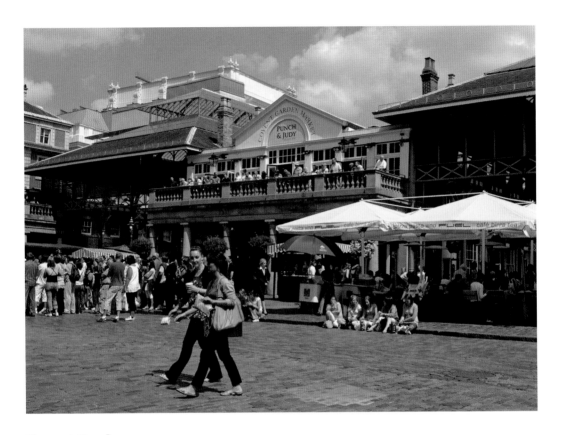

Covent Garden

On a sunny day in August, tourists and shoppers relax at Covent Garden Market. The original fruit and vegetable market was forced to move from the central London location in 1974 due to traffic congestion. In 1980, the neoclassical market hall was reopened as a shopping centre.

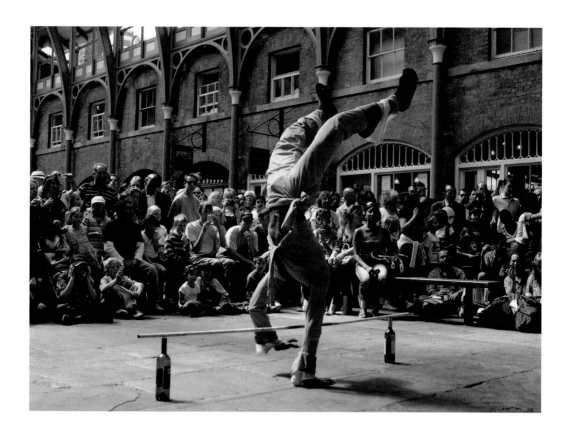

A street performer entertains the crowds in Covent Garden Market. The former fruit and vegetable market hall, which was erected in 1834, is now a popular shopping centre containing cafés, pubs, small shops and a craft market. There is a long tradition of street performance in the Covent Garden area, and today it is the only part of London licensed for such entertainment.

Covent Garden Piazza, WC2

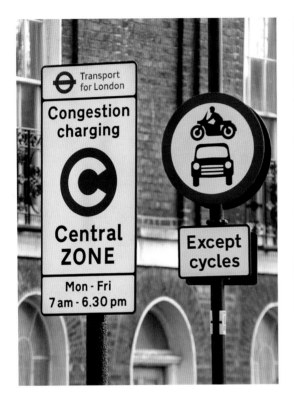
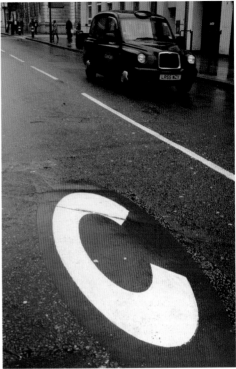

Congestion Charging

Signs and road markings indicating London's congestion charging zone. The congestion charging scheme was introduced for an area of central London in early 2003 and extended to parts of west London in 2007. Its purpose is to reduce traffic congestion and raise funds for London's transport system. Any vehicle that travels within the zone between 7am and 6pm, Monday to Friday, must pay a fee. The system is enforced by means of CCTV cameras and automatic number plate recognition technology.

Central London

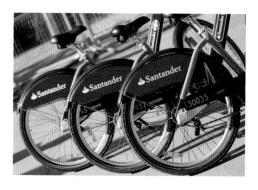

Cycle Hire Scheme

With the addition of 12 new cycle superhighways in central London, the Cycle Hire Scheme, launched in July 2010, was expected to generate 40,000 extra cycle trips a day in the capital, helping to ease congestion. Participants in the scheme can collect and return bicycles at a number of docking stations dotted throughout the city. Santander took over from Barclays as sponsor in April 2015.

Central London

Cycle Superhighway

Cyclists use Cycle Superhighway 7 in Clapham. A network of such cycle routes has been created in conjunction with Santander Cycles to allow cyclists easy passage throughout central London.

Clapham, SW4

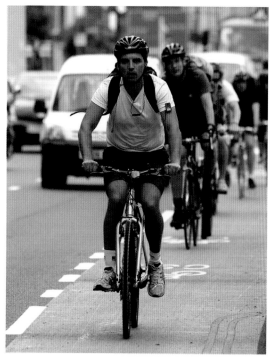

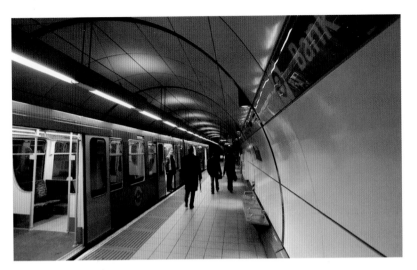

Docklands Light Railway

Passengers leave a Docklands Light Railway (DLR) train at Bank station. Bank is the western terminus of the line, where the DLR shares the station with the Underground. Other parts of the system connect with mainline services.

Above right: In keeping with its ownership by Transport for London, the DLR has a roundel-type logo based on those used for London's buses and Underground.

Facing page: A DLR train leaves the skyscrapers of Canary Wharf behind. Built to serve the redeveloped area of Docklands in east London, the DLR is an automated rail system with branches that stretch north, south, east and west. Opened in 1987, it carries over 60 million passengers annually.

Docklands, east London

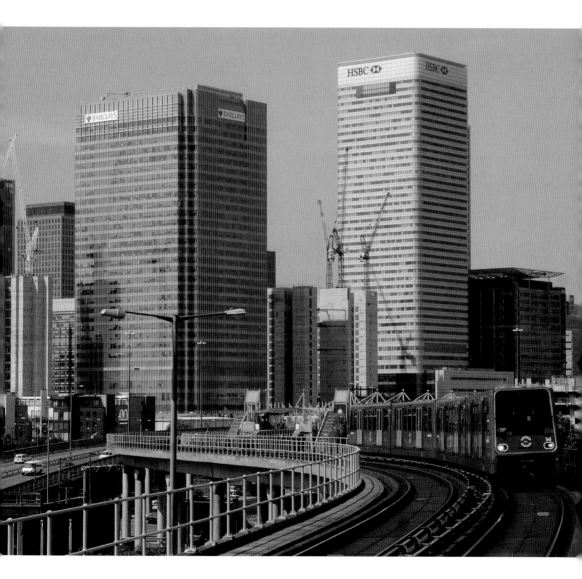

Claridges

Founded in 1812, originally as Mivart's Hotel, Claridges is one of London's grand old hotels, with a clientele that has ranged from royalty to pop stars. During the Second World War, the exiled Peter II of Yugoslavia and his wife lived in the hotel, and in 1945, upon the imminent birth of their son, Crown Prince Alexander, their suite was ceded by the United Kingdom to Yugoslavia for a day so that the prince could be born on Yugoslav soil.

Brook Street, W1

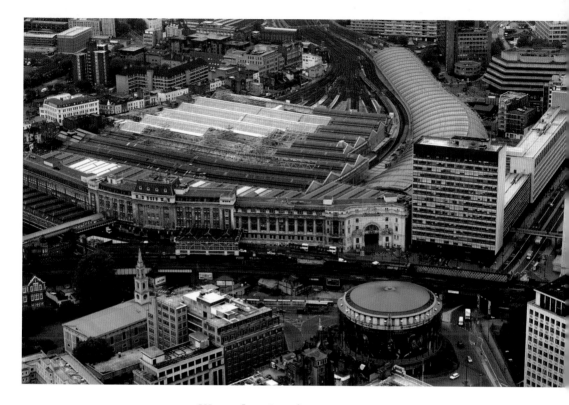

Waterloo Station

In this aerial view, the massive roof and main entrance of Waterloo railway station can be seen (*top left*). The circular building (*bottom right*) is the BFI London IMAX cinema. Because of its situation on a traffic island and the proximity of an Underground line, the cinema, which has the largest screen in Britain, was built on anti-vibration bearings.

Waterloo Station, SE1

Central Hall, Westminster

Constructed between 1905 and 1911 to mark the centenary of John Wesley's death, the Central Hall is not just a working Methodist church, but also an exhibition and conference centre, an art gallery and a tourist attraction. Its Great Hall can seat over 2,300 people, and it is often used for public enquiries.

Storey's Gate, SW1

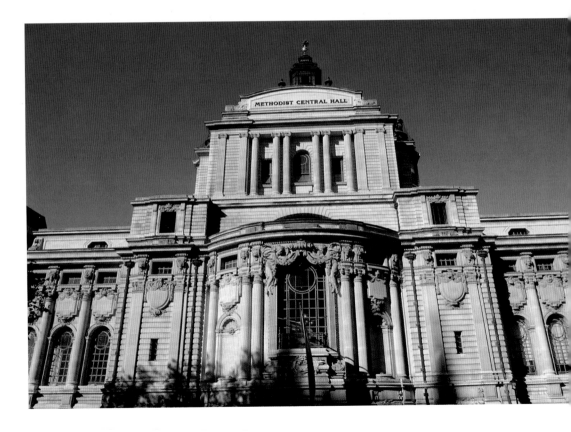

South Bank

This aerial view shows the River Thames and surroundings, looking eastward. In the foreground can be seen Hungerford Bridge carrying the railway tracks into Charing Cross station, beneath the curved roof of Embankment Place. Six other bridges are also visible: Waterloo Bridge, Blackfriars road and rail bridges, Millennium Bridge (pedestrian), Southwark Bridge and Cannon Street Bridge (rail). The National Theatre can be seen on the South Bank (*centre right*), while the dome of St Paul's Cathedral and the office towers of the City of London are also featured (*top left*).

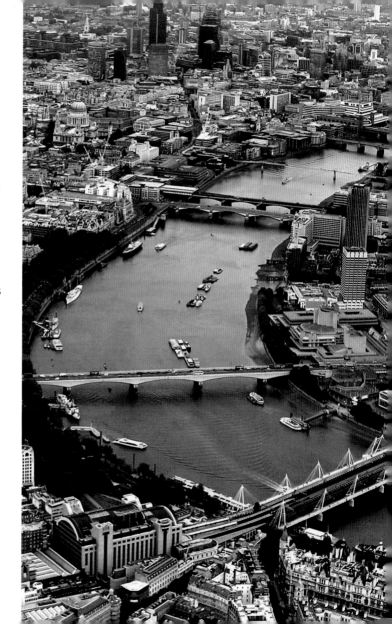

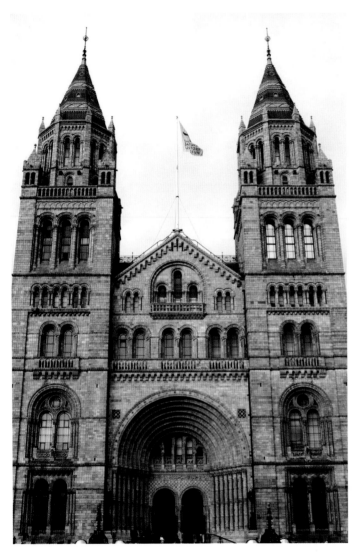

Natural History Museum

Left: Established originally as part of the British Museum in 1756, the Natural History Museum did not complete its move into its present premises until 1880. During its very early years, the maintenance of the collections was dogged by incompetence and deliberate acts of vandalism, such that little remains from that time. It was not until the arrival of Richard Owen as superintendent in 1856 that the museum developed as an efficient institution open to everyone. Today, it holds 80 million objects In five main collections: botany, entomology, mineralogy, palaeontology and zoology.

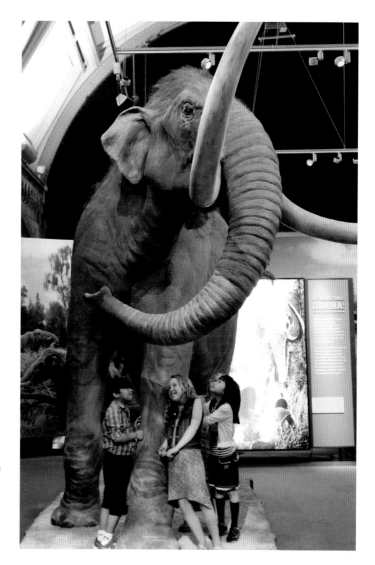

Right: Children make friends with a lofty Columbian Mammoth in the 'Mammoths: Ice Age Giants' 2014 exhibition at the Natural History Museum.

Cromwell Road, SW7

Design Museum

Housed in a former banana warehouse that overlooks the River Thames near Tower Bridge and renovated in the modernist architectural style of the 1930s, the Design Museum was established in 1989. Claimed to be the first museum of modern design, it has exhibits covering product, industrial, graphic, fashion and architectural design.

Shad Thames, SE1

Adelphi Theatre

A theatre has stood on the site of the Adelphi since 1806, the first to open there being known originally as the Sans Pareil, although its name was changed to Adelphi in 1819. In 1858 and again in 1901, new theatres were opened on the site; the present building, with its Art Deco styling, was opened in 1930. For much of its history, the Adelphi has specialised in comedy and musicals, including work by Richard Rodgers and Lorenz Hart, and Noël Coward.

Strand, WC2

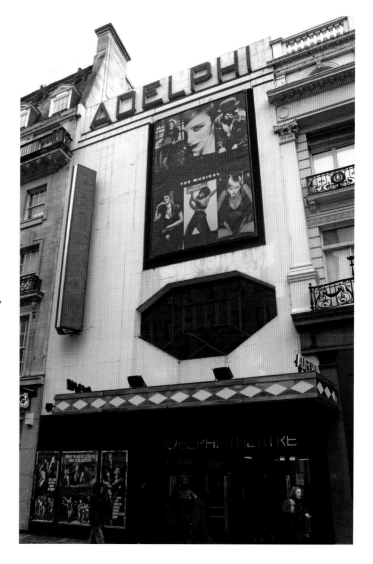

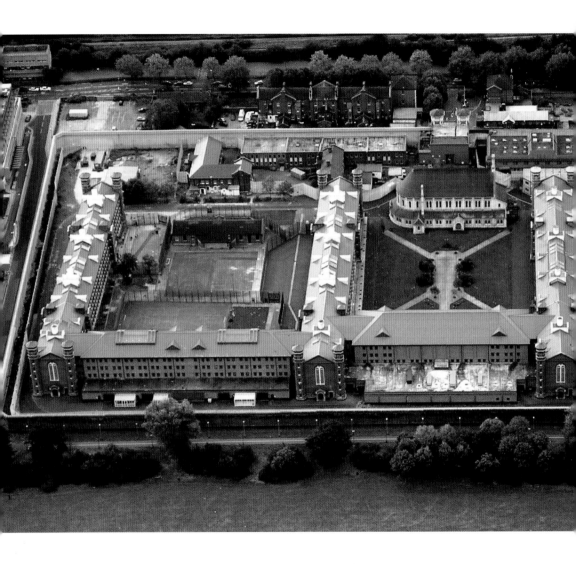

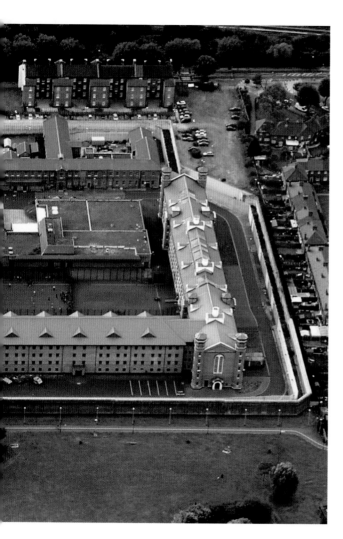

Wormwood Scrubs Prison

Opened in 1891, Wormwood Scrubs prison was built entirely by convict labour, a concept that had been proposed by General Sir Edmund du Cane, who had been inspired by the construction of Sing Sing prison in the USA. Even the bricks for the buildings were manufactured on site. During the Second World War, the prisoners were evacuated and the prison taken over by MI5 and MI8 for secure office space. Today, it houses around 1,270 Category B male prisoners.

Du Cane Road, W12

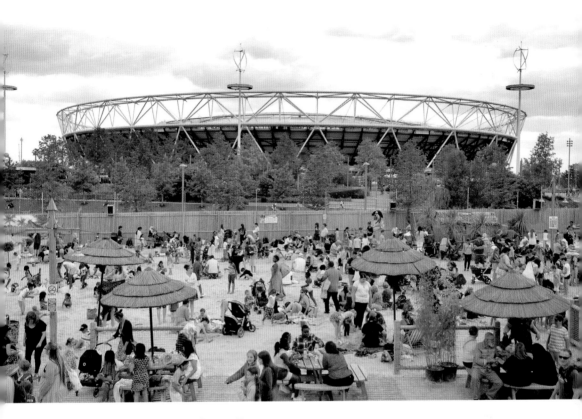

Queen Elizabeth Olympic Park

A large crowd enjoys the summer sunshine on the man-made beach at the Queen Elizabeth Olympic Park in Stratford, east London, with the Stadium in the background. A sporting complex built for the 2012 Summer Olympics and Paralympics, the park contains several venues including the London Aquatics Centre, the Lee Valley VeloPark and the Copper Box Arena multi-sport venue. The Stadium, used intermittently after the Olympics during renovations, will become the home to West Ham United Football Club and British Athletics.

Olympic Park, E20

ArcelorMittal Orbit

Looming over the Olympic Stadium is the writhing red steelwork of ArcelorMittal Orbit, a 115m (376ft) tall observation tower and Britain's largest piece of public art. Designed by Turner Prize-winning artist Sir Anish Kapoor and Cecil Balmond of engineering group Arup, the structure was modified in 2015 to incorporate the world's tallest and longest tunnel slide, 178m (583ft) long and 76m (250ft) high.

Olympic Park, E20

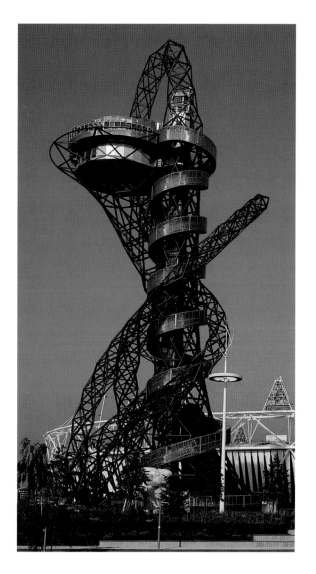

London Aquatics Centre

An undulating wave-like roof of covers the London Aquatics Centre, a facility built for the 2012 Olympic Games, which features two 50m (160ft) swimming pools and a 25m (82ft) diving pool.

Olympic Park, E20

The Velodrome Track

In a scene from day eleven of the 2012 Olympics, Great Britain's Sir Chris Hoy (third right) rides in the Men's Keirin First Round in the Olympic Park's velodrome. The 250m (270yd) track, designed by Ron Webb, who created the tracks for the Sydney and Athens Games, was made with 56km (35 miles) of Siberian Pine and 350,000 nails.

Olympic Park, E20

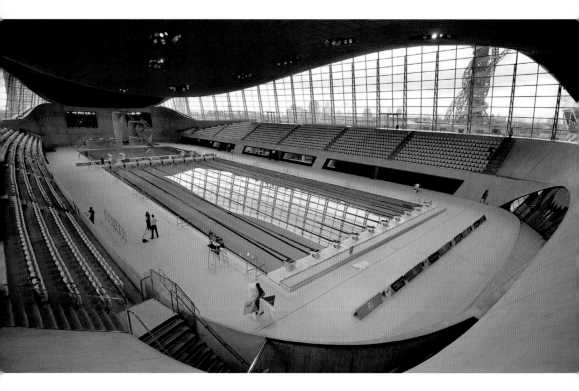

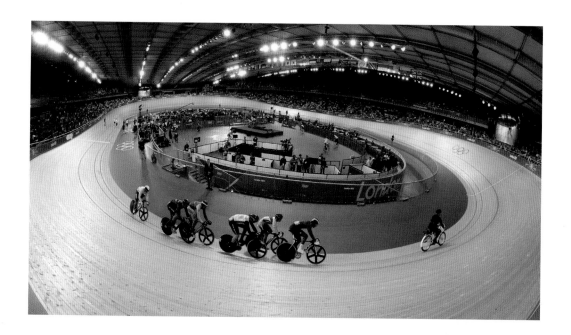

Lee Valley VeloPark

In a facility that houses a BMX racing track, a 1.6km (1-mile) road course and 8km (5 miles) of mountain bike trails, the VeloPark is also home to the Olympic Velodrome. The elegant roof is designed to complement the geometry of cycling while being lightweight and efficient, reflecting a bike. The energy-efficient building's rooflights reduce the need for artificial lighting, and natural ventilation obviates the need for air-conditioning. Rainwater is also collected, reducing the amount of water used from the municipal system.

Olympic Park, E20

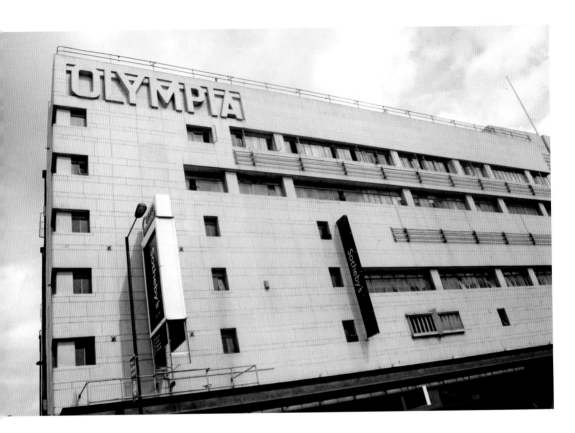

Olympia

Originally known as the National Agricultural Hall, the Olympia exhibition centre opened in 1885. That building, called the Grand Hall today, was typically Victorian with a great curved iron and glass roof. A second, smaller hall (National Hall), in similar style, was added in 1922–3. Then, in 1929–30, by complete contrast, the strikingly modernistic Empire Hall (shown here and known as Olympia Two today) was built.

Right: Olympia's Grand Hall during the British Toy and Hobby Association's 2010 Toy Fair. Derbyshire architect Andrew Handyside created the building, originally called the National Agricultural Hall, in 1885. Since then, it has remained one of the largest and most popular exhibition centres in the UK.

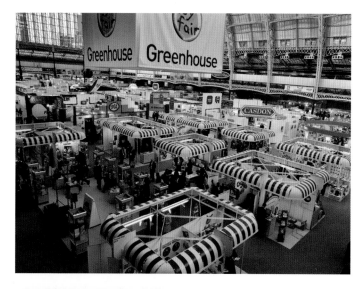

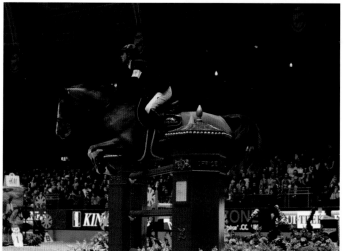

Left: Great Britain's Ben Maher rides Diva II to win the Olympia Grand Prix during the 2014 London International Horse Show at the Olympia Exhibition Centre. Held during the run-up to Christmas, the annual show provides exciting entertainment for all the family, with elegant dressage, a Shetland pony race and dog agility competition among many other events.

Olympia, Hammersmith Road, W14

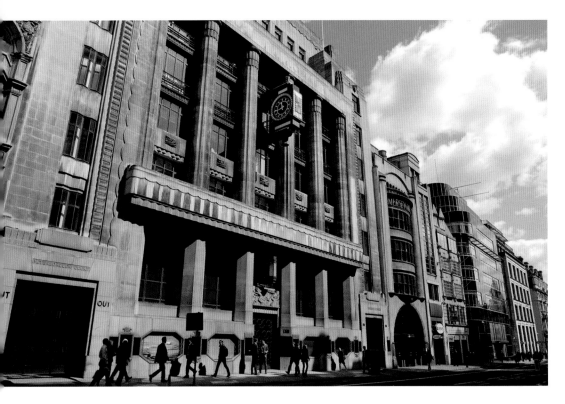

Fleet Street

Buildings in Fleet Street that were once home to some of the nation's great newspaper publishers. Among them are Peterborough Court, the former *Daily Telegraph* building (bearing clock), and the *Daily Express* building with its curved glass fascia. Both are examples of architecture from the Art Deco period of the 1930s. Today they house the offices of the banking house Goldman Sachs.

With its distinctive Art Deco architecture, the former *Daily Express* building on Fleet Street makes a striking statement. At one time, the street was the centre of the national newspaper publishing industry, but the presses behind the impressive facades have long since fallen silent and the businesses have moved away into purpose-built publishing 'factories'.

Fleet Street, EC4

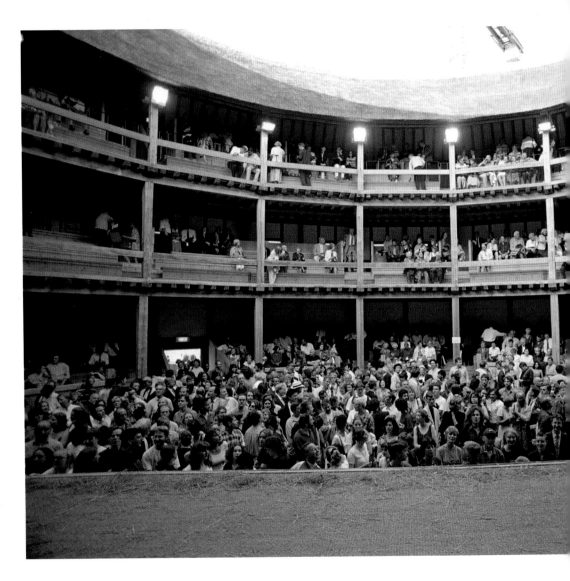

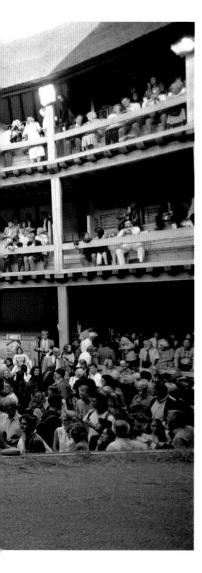

Globe Theatre

Built at a cost of £22m, Shakespeare's Globe is a re-creation of the original Elizabethan Globe Theatre that was erected by the company of actors known as the Lord Chamberlain's Men, to which William Shakespeare belonged. The theatre stands within 228m (750ft) of the site of the original, and the project was spearheaded by actor Sam Wanamaker. Sadly, he died before the theatre was opened in 1997. The Globe is the only building in London to have been allowed a thatched roof since the Great Fire of 1666.

New Globe Walk, SE1

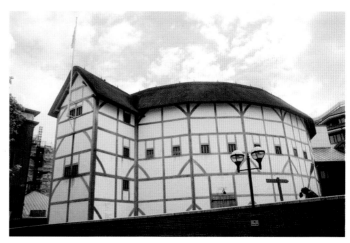

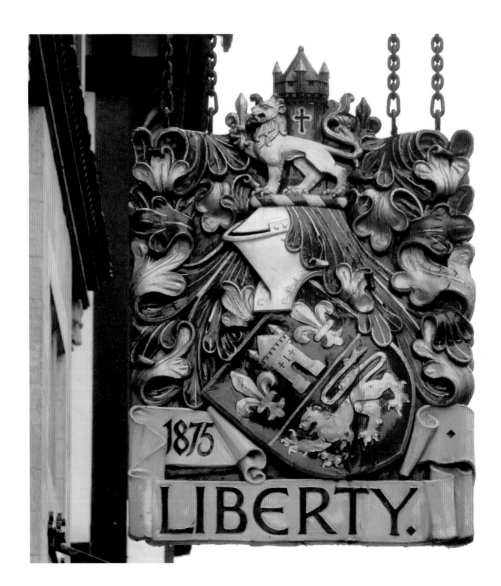

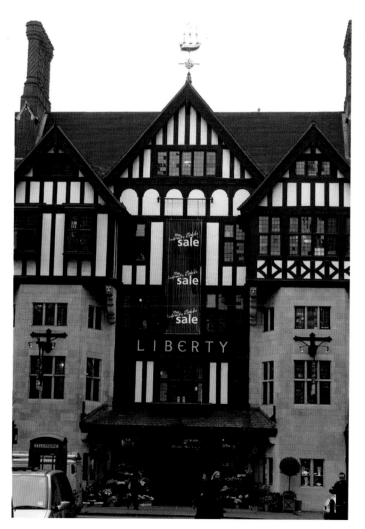

Liberty & Co

The Tudor-style Liberty store on Regent Street. Completed in the early 1920s, the building was designed by Edwin T. Hall and his son, Edwin S. Hall. It utilised the timbers from two decommissioned Royal Navy ships, HMS *Impregnable* and HMS *Hindustan*. It was Arthur Liberty's intention that shoppers would feel as though they were looking around someone's home when they entered the store, so it contained several small rooms with fireplaces. Sadly, he died in 1917 and never saw his ideas come to fruition.

Regent Street, W1

All Souls Church

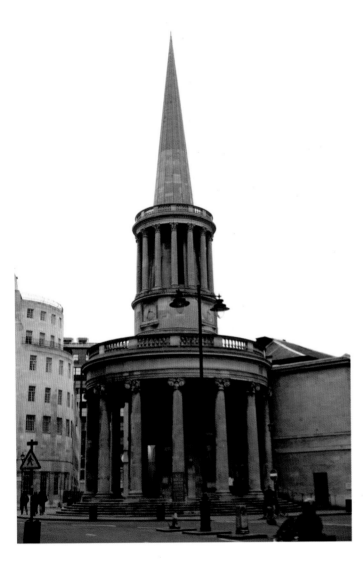

Designed by John Nash and the last surviving church by the great architect, All Souls church was consecrated in 1824 by the Bishop of London. Built of Bath stone, it has a unique spire that features 17 concave sides. Nash's design did not meet with universal approval, however, for some thought its exterior did not display the grandeur required for a church, comparing it instead to a warehouse. In 1940, All Souls was severely damaged by German bombing, the repairs not being completed until 1950.

Langham Place, W1

Crystal Palace Television Transmitter

At one time the tallest structure in London (until the building of the Canary Wharf skyscrapers in the early 1990s), the 219m (719ft) high Crystal Palace television transmitter mast was erected in the mid-1950s on the foundations of the Crystal Palace. The transmitter took over from the BBC's facility at Alexandra Palace as London's main television transmitter. Today, in addition to digital television signals, the mast transmits a variety of FM and digital radio broadcasts.

Crystal Palace Park, SE19

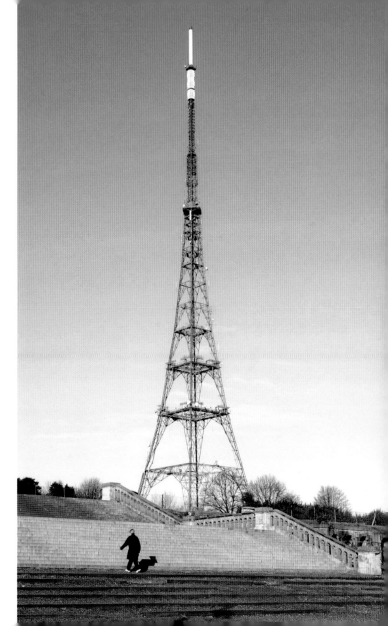

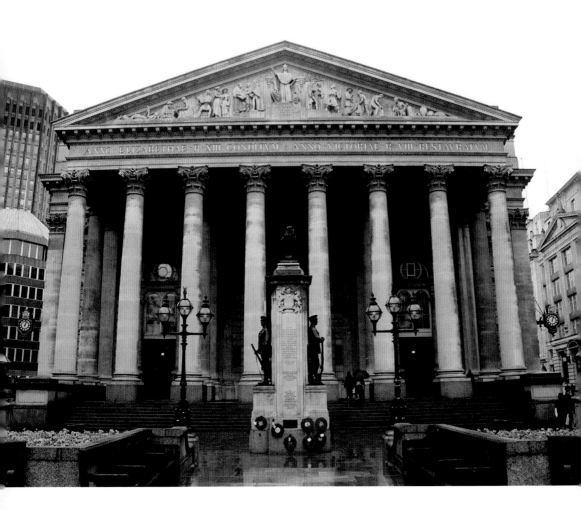

ANNO ELIZABETHAE R. XIII CONDITVM · ANNO VICTORIAE R. VIII RESTAVRATVM

Royal Exchange

Left: Once a centre of commerce for the City of London, the Royal Exchange is now an upmarket shopping centre. The Exchange was founded in 1565 by Sir Thomas Gresham, whose crest, a large gilt grasshopper, forms part of the building's weathervane. The original building was opened officially by Queen Elizabeth I, who conferred upon it the Royal title. The present building is the third to stand on the site, the previous two having been destroyed by fire.

Threadneedle Street, EC3

Leadenhall Market

Right: Dating to the 14th century, Leadenhall Market was created originally for the sale of meat, game and poultry. The current building, however, was erected in 1881 and was designed by Sir Horace Jones; of note is the ornate roof. Today, its shops house cheesemongers, butchers and florists. Leadenhall Market was used as a location for the films *Harry Potter and the Philosopher's Stone* and *The Imaginarium of Doctor Parnassus*.

Leadenhall Market, EC3

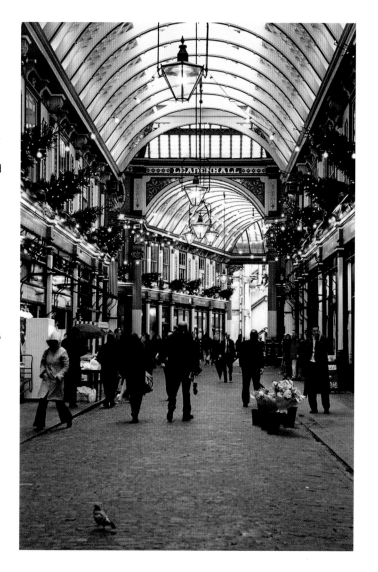

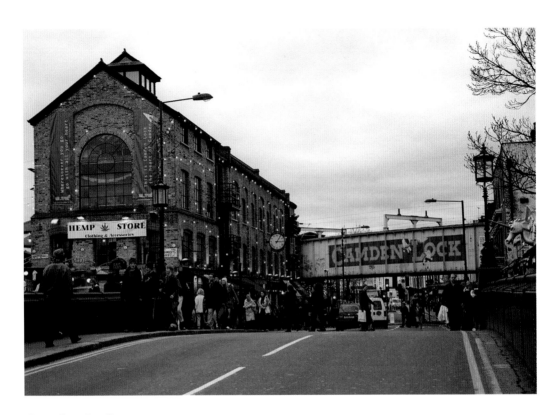

Camden Lock

A bustling shopping street threads through Camden Lock in north-west London. The area is well known for its markets, which sell a wide variety of items, including antiques and fashion, and are a major tourist attraction. The actual lock is part of the Regent's Canal and is in regular use. A waterbus and sightseeing boats operate services from the lock.

Camden Lock, NW1

Old Spitalfields Market

A market has stood on the site of Old Spitalfields Market since 1638, when Charles I authorised its establishment on an area of open ground known as Spittle Fields. In time, it became a wholesale fruit and vegetable market, and the present buildings were completed in 1887. The wholesale market moved to new premises in 1991 and today there is a popular food and general market in its place.

Brushfield Street, E1

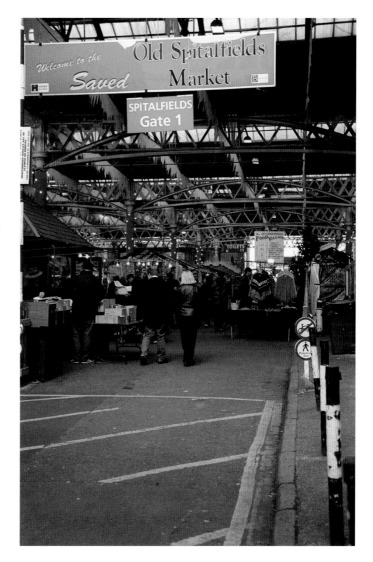

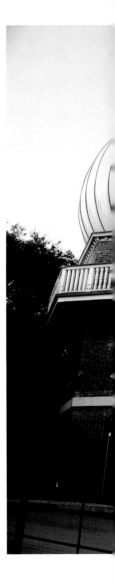

Royal Observatory

Right: Established in 1675 by King Charles II, the Royal Observatory at Greenwich, under the first Astronomer Royal, John Flamsteed, was given the task of studying the heavens to develop stellar tables that would assist global navigation. Subsequently, it was required to keep accurate time, and today Greenwich Mean Time (Universal Time) is used as a datum around the world.

Above left: A time ball that drops at a predetermined time to enable sailors to check their marine chronometers from their boats offshore, sits atop the Octagon Room.

Left: The Prime Meridian acted as the datum for the system of longitude that aids global navigation. It was established by astronomical observation in 1851 and adopted internationally in 1884. For years, it was marked by a brass strip set in the courtyard, but today this has been replaced by stainless steel. At night, it is marked by a green laser that shines northward across London.

Blackheath Avenue, SE10

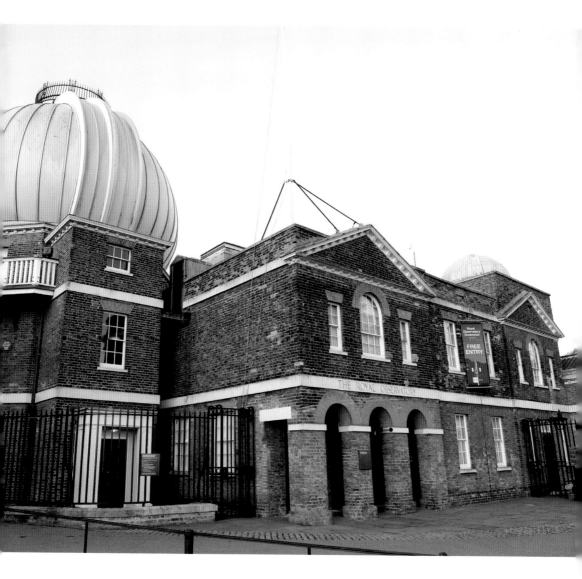

Emirates Air Line

Cable cars snake across the River Thames on three pylons between Greenwich Peninsula (and the 02 Arena) and the Royal Victoria Docks (close to the ExCel exhibition centre). The Emirates Air Line, built by Doppelmayr with sponsorship from the airline Emirates, is operated by Transport for London. A single crossing takes ten minutes (five in rush hour, when the speed is increased). The 1km (0.62-mile) gondola line crosses the river at a height up to 91m (300ft). One crossing is provided every 15 seconds, with a maximum capacity of 2,500 passengers per hour in each direction. Bicycles may be carried, and passengers can pay for their journeys with pay-as-you-go Oyster cards.

Greenwich Peninsula, SE10 – Royal Victoria Docks, E16

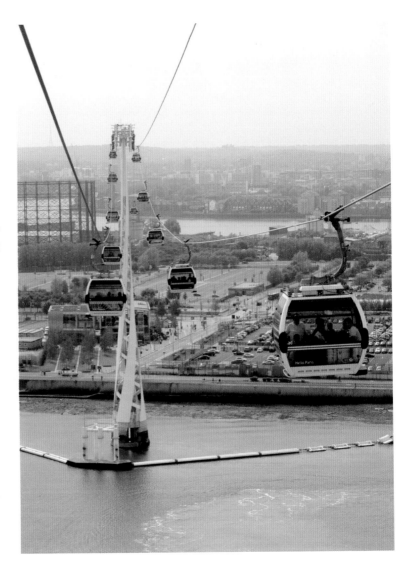

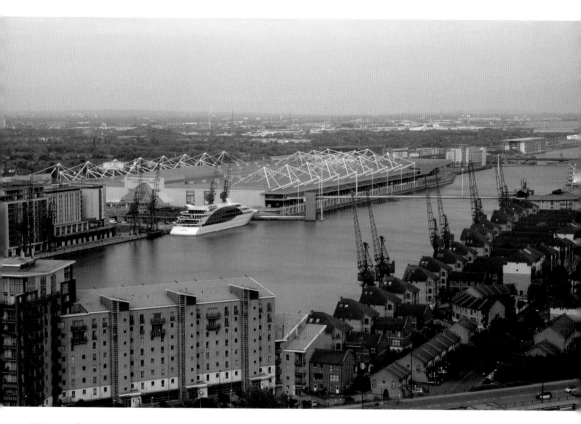

Waterfront Attractions

Viewed from the window of an Emirates Air Line cab is the Royal Victoria Docks (*right*) and the ExCel exhibition centre (*centre*), with the Sunborn London four-star deluxe super yacht hotel moored alongside. The yacht has 136 guest rooms over five floors, including four suites, a reception area, bar and lounge, restaurant, banqueting facilities, auditorium, conference rooms, and an event venue with outdoor terraces.

Royal Victoria Dock, E16

Elephant and Castle

A statue indicating the Elephant and Castle, an area of Southwark in south London that straddles a major road intersection. Originally known as Newington, from the middle of the 18th century, it took its present name from a local coaching inn. The inn had been built on the former site of a blacksmith and cutler, and the coat of arms of the Worshipful Company of Cutlers featured an elephant with a castle on its back, hence the inn's name.

Southwark, SE17

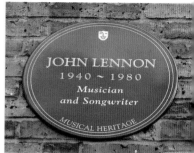

John Lennon Plaque

At the site of the ill-fated Apple shop, opened by The Beatles in 1967, a blue Musical Heritage plaque (*above*) commemorates John Lennon, who was murdered in New York in 1980. The original building, a Georgian town house dating from 1795, was demolished in 1974 and replaced with a neo-Georgian office block. The Apple shop was a financial disaster, losing £200,000, and was closed after eight months.

Baker Street, W1

BBC Broadcasting House

Opened in 1932, Broadcasting House is the headquarters of the British Broadcasting Corporation (BBC). Noted for its Art Deco styling, the building features statuary by Eric Gill and was the work of architect George Val Myer in collaboration with the BBC's own civil engineer, M.T. Tudsbery. A recent renovation and redevelopment programme attracted criticism for it lateness and massive £100m cost overrun.

Portland Place, W1

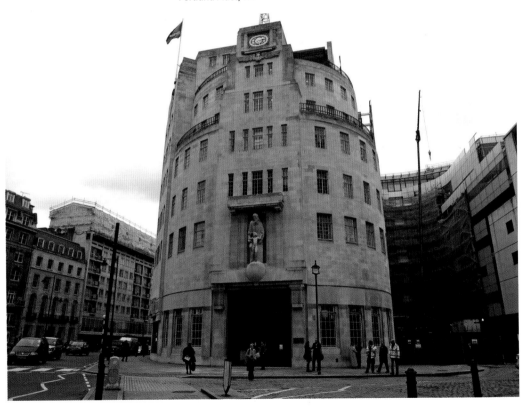

Busking on the Tube

A licensed busker performs at an official busking pitch at Canary Wharf Underground station. Busking has been common at Underground stations for many years, but it was only legalised in 2003. Today, there are 39 official pitches spread among 25 stations in central London.

Canary Wharf Underground station, Heron Quays Road, E14

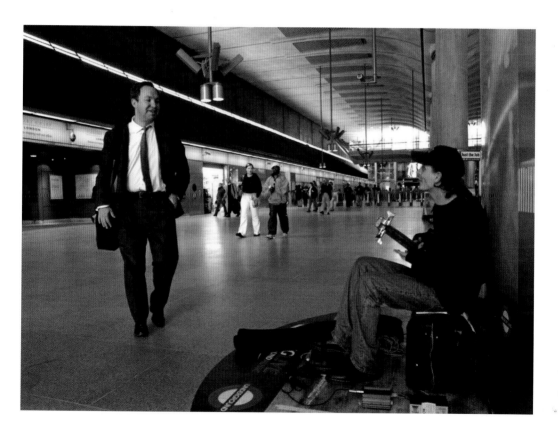

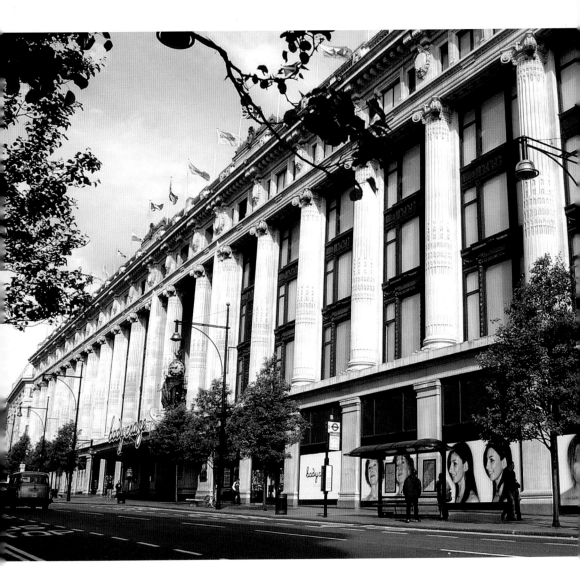

Selfridges

Left: The flagship department store of the Selfridges chain on Oxford Street. Established by American Harry Gordon Selfridge in 1909, the business thrived through his innovative marketing ploys – he aimed to make shopping fun rather than a chore. One way he attracted customers was by installing educational and scientific displays, among them Louis Blériot's cross-Channel monoplane in 1909.

Right: In keeping with Harry Selfridge's desire to make shopping interesting and fun, his store on Oxford Street is noted for its imaginative window displays and architectural features. Among these is the clock over the main entrance, which is carried by the Queen of Time riding on her ship of commerce. The statue is the work of Gilbert Bayes.

Oxford Street, W1

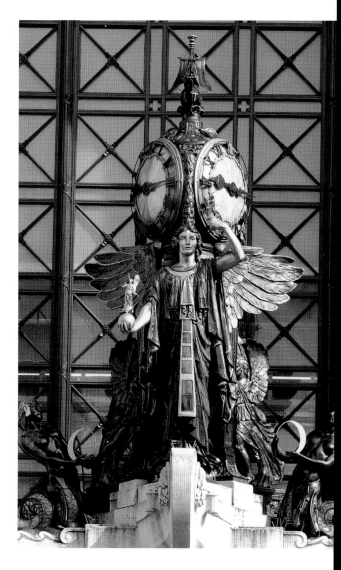

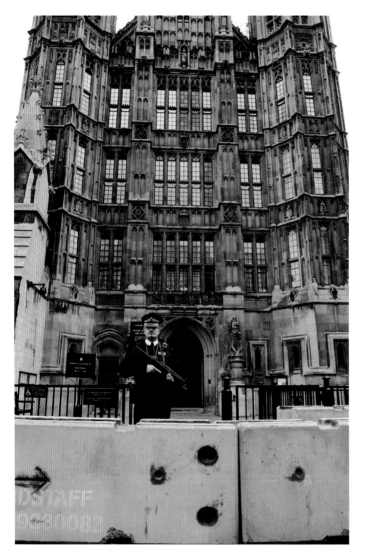

Armed Police

An armed policeman stands behind concrete barriers outside the Palace of Westminster. With the ever-present threat of terrorist attack, particularly from suicide bombers, such measures have become commonplace at high-risk targets in London.

Palace of Westminster, SW1

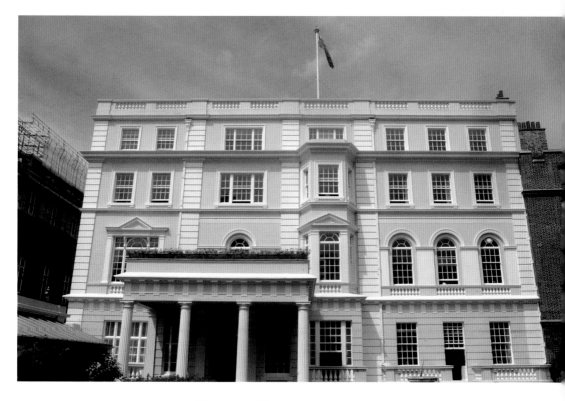

Clarence House

The official London residence of Charles, Prince of Wales and Camilla, Duchess of Cornwall, Clarence House was designed by John Nash and built between 1825 and 1827 for the Duke of Clarence (later King William IV). Over the years, it has been extensively rebuilt, such that little of Nash's original building remains. Between 1953 and 2002, it was the home of Queen Elizabeth, the Queen Mother.

The Mall, SW1

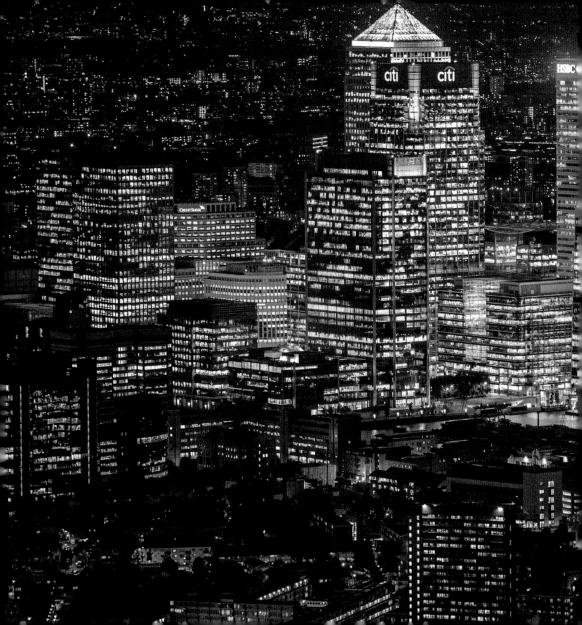

Canary Wharf

The skyscrapers of Canary Wharf illuminated against a backdrop of multi-coloured lights of the surrounding night-time city.

Canary Wharf, E14

9/11 Memorial

The memorial garden in Grosvenor Square was opened in September 2003 by the Princess Royal and dedicated to the memory of those who died when two hijacked passenger jets crashed into the twin towers of New York's World Trade Center on 11 September 2001. The garden of remembrance contains a small pavilion bearing three bronze plaques, listing the names of victims from the UK, UK Overseas Territories and those with dual nationalities. The pavilion carries the inscription: "Grief is the price we pay for love."

Grosvenor Square, W1

Grosvenor House Hotel

Opened in 1929, the Grosvenor House Hotel was built on the site of the former home of the Dukes of Westminster, whose family name is Grosvenor. It contains one of the largest ballrooms in Europe, which is often used for major awards ceremonies and charity balls. Known officially as the Great Room, it was built originally as an ice skating rink.

Park Lane, W1

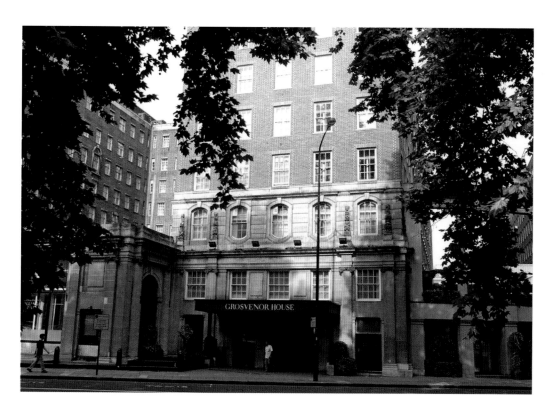

Crimean War Memorial

The Crimean War Memorial, situated in Waterloo Place. The memorial comprises a central Guards' Memorial, dedicated to the 2,152 men of the Brigade of Guards who died in the war against Russia between 1854 and 1856, together with statues of Florence Nightingale and Sidney Herbert, who was Secretary for War during the conflict.

Waterloo Place, SW1

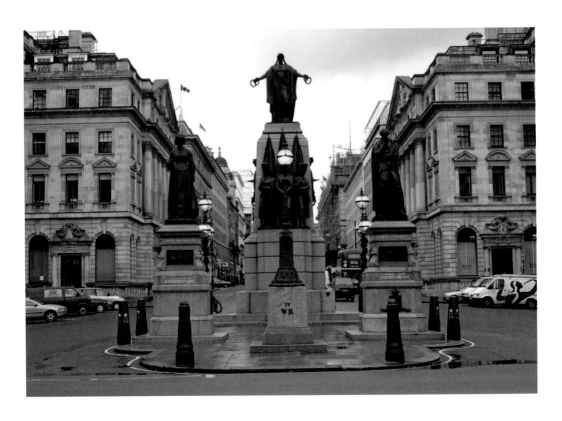

Black Rod's Garden

A January snowstorm gives Black Rod's Garden, at the Palace of Westminster, a magical air. The garden, which acts as a private entrance to the palace, is named after the Gentleman Usher of the Black Rod, an official of the House of Lords who acts as the personal attendant to the Sovereign in the Lords as well as carrying out a number of other ceremonial duties. Black Rod is best known for the role he plays during the State Opening of Parliament, when he summons the Commons to attend the Queen's Speech and leads them to the Lords.

Palace of Westminster, SW1

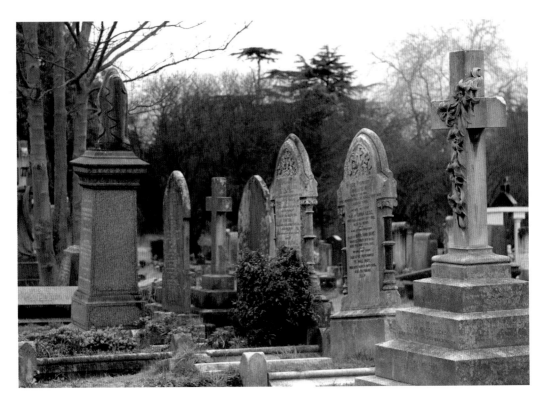

St Pancras and Islington Cemetery

Gravestones and funerary monuments in the St Pancras and Islington Cemetery. The largest cemetery in London, it contains the graves of many notable individuals. Among them are Cora Crippen, wife of murderer Dr Crippen; Henry Croft, the first Pearly King; violinist and conductor Sir Eugene Aynsley Goossens; dance band leader Ken 'Snakehips' Johnson; the Pre-Raphaelite artist Ford Madox Brown; and Mary Shepherd, a tramp who lived in Alan Bennett's driveway.

High Road, N2

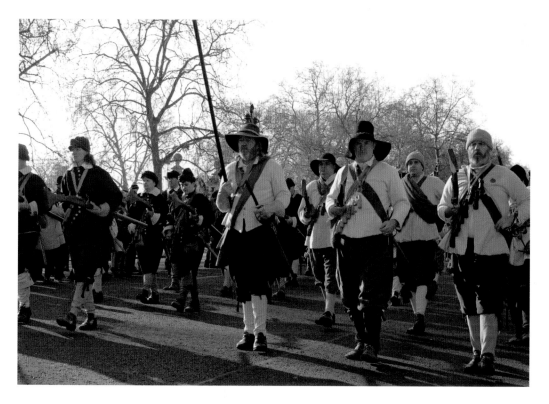

Commemorative March

Members of the King's Army of the English Civil War Society perform a slow march along The Mall with arms reversed in memory of King Charles I, who was executed in 1649 at the end of the English Civil War. Charles was beheaded in front of Banqueting House in Whitehall. The commemorative march takes place annually in January.

The Mall, SW1

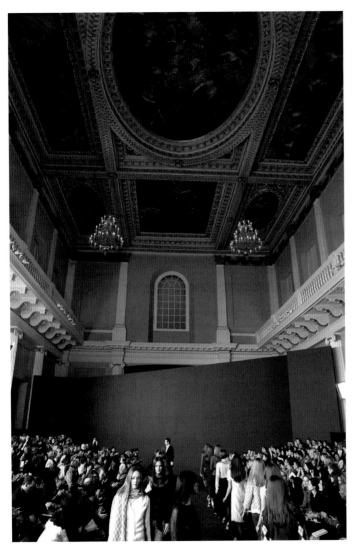

Banqueting House

Left: Models on the catwalk during a London Fashion Week show at Banqueting House. The building was designed by the famous 17th-century architect Inigo Jones, and construction began in 1619, being completed three years later. It was part (and all that remains) of the Palace of Whitehall, the main residence of English monarchs in London between 1530 and 1698, and the first building in England to be constructed in the neoclassical style.

Right: Visitors sample champagne during a tasting at Banqueting House. In January 1649, King Charles I was executed in front of the building by order of Parliament. Banqueting House is designated as a national monument and open to the public.

Whitehall, SW1

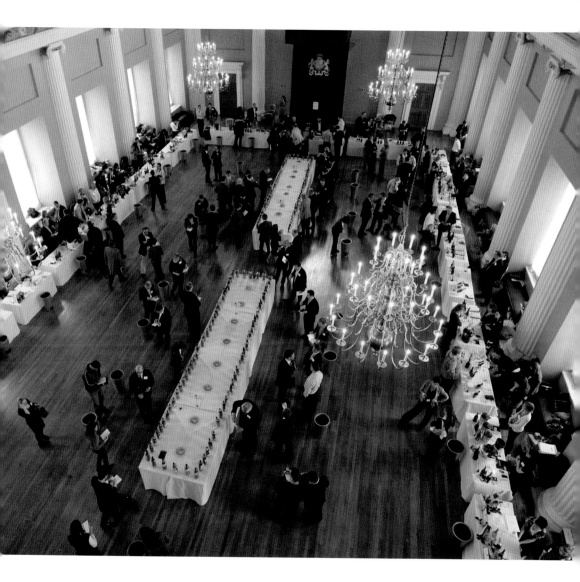

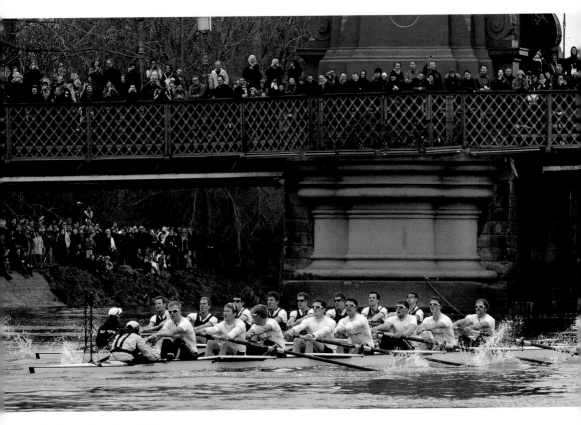

University Boat Race

Straining at their oars, the crews from Oxford and Cambridge strive to outdo each other during the 156th University Boat Race on the River Thames in 2010 (Cambridge would win). Run over a course from Putney Bridge to Chiswick Bridge, a distance of 6.8km (4 miles, 374 yards), the race has been held annually since 1856, with breaks for both world wars.

River Thames between Putney and Chiswick bridges, SW15, W4 & W6

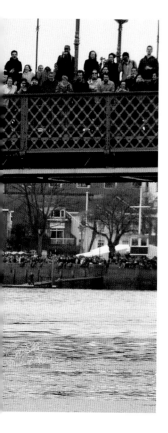

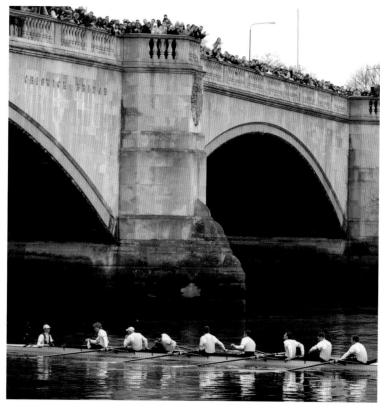

Chiswick Bridge

Having finished the University Boat Race against Oxford, the Cambridge crew pass under Chiswick Bridge, where crowds had gathered to cheer them. The bridge was opened in 1933 as one of three bridges built to relieve traffic congestion in south-west London. It is constructed of concrete faced with Portland stone, and at the time of its opening, the centre span was the longest concrete span over the Thames.

Grove Park, W4/Mortlake, SW14

Strata SE1

The 43-storey, 148m (486ft) tall Strata SE1 at Elephant and Castle, Southwark, is one of the tallest residential buildings in London. Designed by BFLS and built between 2007 and 2010, its 408 flats and penthouse accommodation can house more than 1,000 residents.

Wind Turbines

Boasting three 9m (30ft) wind turbines at the roofline, Strata SE1 is one of the few buildings in the world to incorporate such features as part of its structure. The turbines are anticipated to produce 8 per cent of the tower's electricity needs per year – enough to power the common areas of the building.

Elephant & Castle, SE1

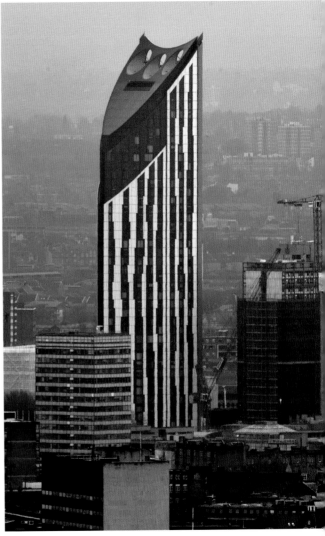

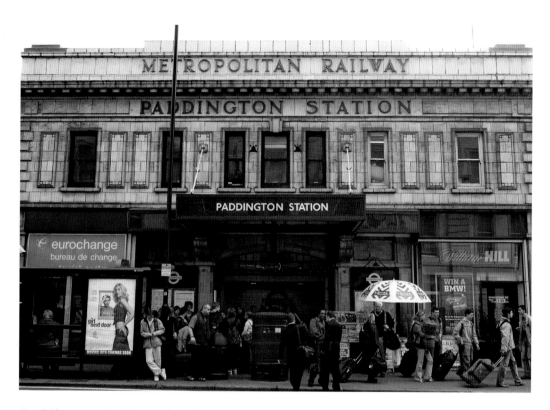

Paddington Railway Station

Designed by Isambard Kingdom Brunel and Digby Wyatt, Paddington station was built as the London terminus of the Great Western Railway between 1850 and 1854. It is home to a famous literary character who has made the station's name known throughout the world: Paddington Bear. A statue of the Peruvian bear can be seen on the station concourse, as well as one of its architect, Brunel.

Praed Street, W2

Brunswick Centre

Shopping at the Brunswick Centre, Bloomsbury. The combined residential and retail development was built during the late 1960s and early 1970s in a brutal architectural style that was widely criticised. However, it attained Grade II listed status in 2000, although by then it was quite run down. In 2002, it was subject to a £22m renovation programme, which attracted many new tenants for the shops.

Marchmont Street, WC1

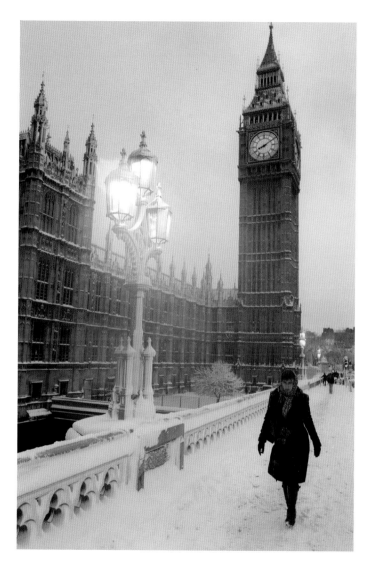

Big Ben

Facing a weary trudge to work, a woman sets out across Westminster Bridge in thick snow. Behind, the dimly-lit face of Big Ben shows the early hour.

Westminster, SW1

Heathrow Airport

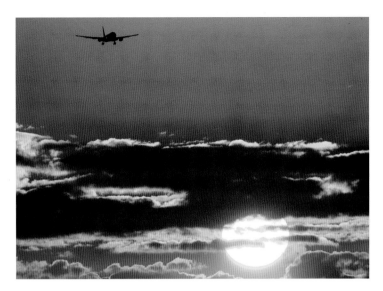

Left: An airliner descends toward Heathrow Airport as the sun rises over London. Heathrow is the world's busiest international airport: it handles over 70 million passengers annually on flights offered by 90 airlines travelling to over 170 destinations in over 90 countries.

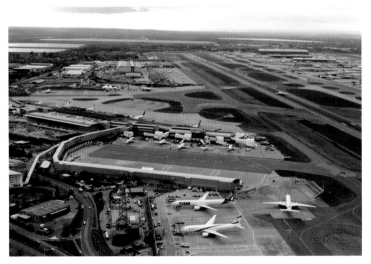

Left: London's Heathrow Airport. Originally, Heathrow was a small hamlet on Hounslow Common, a haunt of thieves and highwaymen since the earliest times. The area has been involved in aviation since the formation of the Royal Flying Corps during the First World War, when it was used as one of the first military airfields. London Airport was officially opened on 25 March 1946.

Hayes, Middlesex

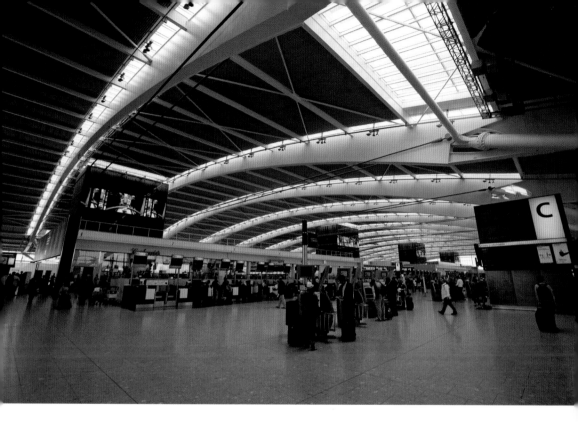

Heathrow Terminal 5

Opened in early 2008, Terminal 5 at London's Heathrow Airport is used exclusively by British Airways as its global hub. It was built at a cost of £4.3 billion, has 60 aircraft stands and can handle 30 million passengers annually. In its first two weeks of operation, however, problems with its IT systems and a lack of staff training caused 500 flights to be cancelled.

Hayes, Middlesex

Liverpool Street Railway Station

Opened in 1874, Liverpool Street Station was built for the Great Eastern Railway to serve east London, Essex and East Anglia. There was also a connection to the Metropolitan Railway, the world's first underground railway. The station is one of London's busiest commuter stations. It was built on the site of the former Bethlem Royal Hospital, popularly known as 'Bedlam'.

Liverpool Street, EC2

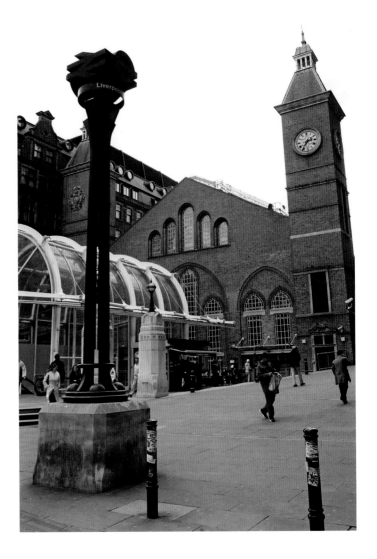

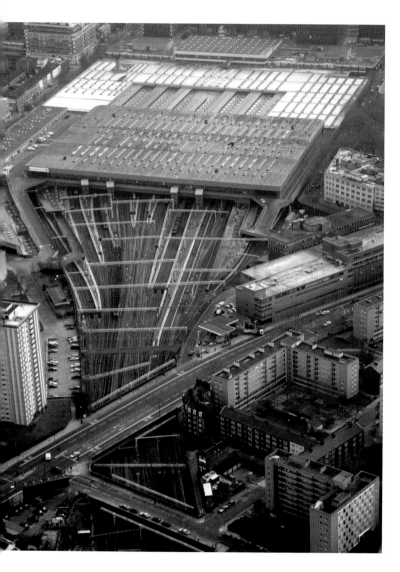

Euston Railway Station

An aerial view of the great train shed at Euston station. The sixth busiest rail terminus in London, Euston serves the west Midlands, the north-west, north Wales and parts of Scotland. It is the southern terminus of the West Coast Line. There has been a station on the site since 1837, when the London and Birmingham Railway established itself there.

Euston Road, NW1

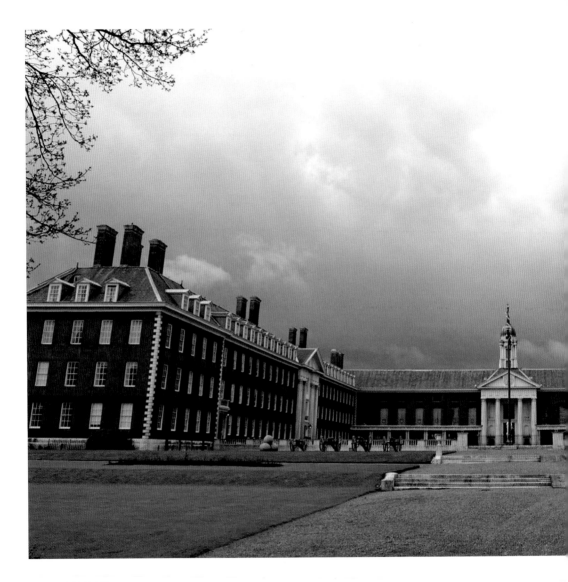

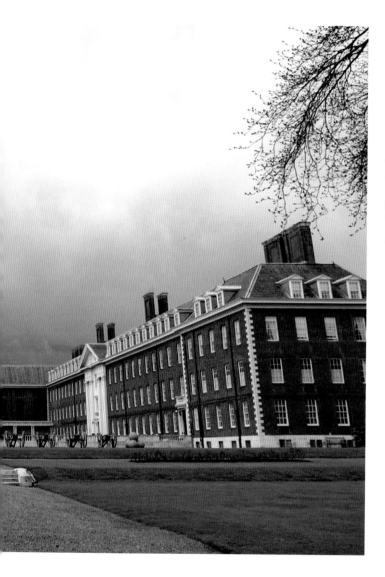

Royal Hospital Chelsea

Founded by King Charles II in 1681, the Royal Hospital Chelsea acts as a retirement and nursing home for former British soldiers. Around 300 'in-pensioners', as they are known, call the hospital home and can be seen around the hospital in their distinctive scarlet uniforms with tricorn hats. Each year, the Chelsea Flower Show is held in the grounds of the hospital.

Royal Hospital Road, SW3

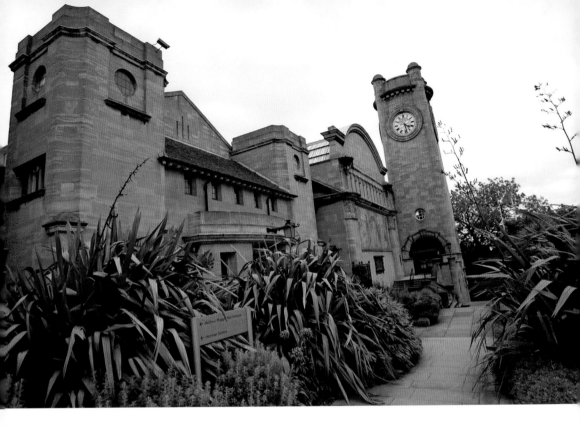

Horniman Museum

Founded by Victorian tea trader Frederick Horniman in 1901, the Horniman Museum specialises in anthropology, natural history and musical instruments. Horniman commissioned Charles Harrison Townsend to design the original museum building in the Arts and Crafts style, and in 1911 Horniman's son, Emslie, funded an additional building, also the work of Townsend. In 1999, the museum closed and underwent a three-year programme of refurbishment.

Visitors pass time in the Sunken Garden at the Horniman Museum. The 6.5-hectare (16-acre) site also contains a Grade II listed conservatory dating from 1894, which was moved from the Horniman family home, a 1912 bandstand, a small animal enclosure and a nature trail.

London Road, SE23

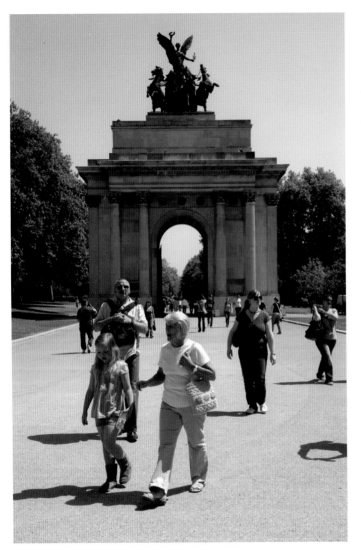

Wellington Arch

This famous landmark, together with Marble Arch to the north, was planned by King George IV to commemorate Britain's victories in the Napoleonic Wars. Completed in 1830, it was intended as a grand entrance to Buckingham Palace, although the position it occupies today is a short distance from its original location (it was moved to allow road widening). It was topped by a large statue of the Duke of Wellington originally, but this was removed and replaced in 1912 by the largest bronze statue in Europe, depicting the angel of peace descending on the chariot of war. The arch contains a small museum as well as a ventilation shaft for the Underground system.

Hyde Park Corner, W1

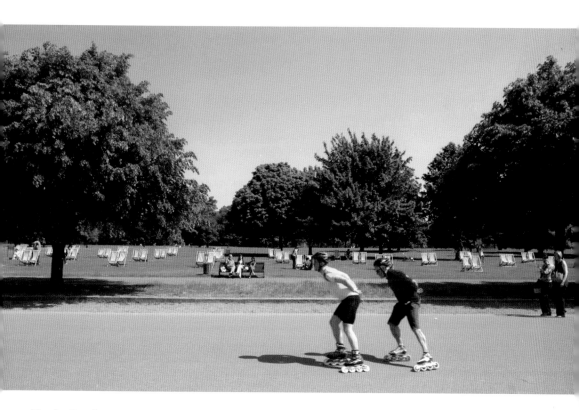

Hyde Park

Under a beautiful, clear blue sky, a pair of rollerbladers skate through Hyde Park, while the less energetic relax and enjoy the sunshine on the benches and deckchairs provided. This broad sweep of parkland in the centre of London provides a welcome relief from the hustle and bustle of the city streets.

Hyde Park, W2

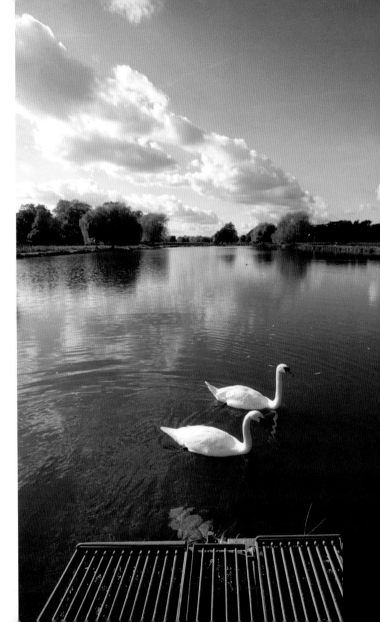

Bushy Park

Swans glide silently by on a warm, sunny autumn day in Bushy Park, Richmond. Described as the 'Sleeping Beauty' of the Royal Parks, it is the second largest, covering 445 hectares (1,099 acres). Like many of the Royal Parks, Bushy was established for Royal sport; Henry VIII used the area for hunting deer. The park contains a number of ponds and the Longford River, a 19km (12-mile) canal designed to carry water to Hampton Court.

Park Road, Teddington, Surrey

Wimbledon Common

On a crisp autumn morning, Wimbledon Common provides the ideal location for an energising stroll in the fresh air. Together with the adjacent Putney Heath and Putney Lower Common, it forms the largest expanse of heathland in the London area. Near the centre of the common is a windmill where Robert Baden-Powell wrote parts of *Scouting for Boys*.

Windmill Road, SW19

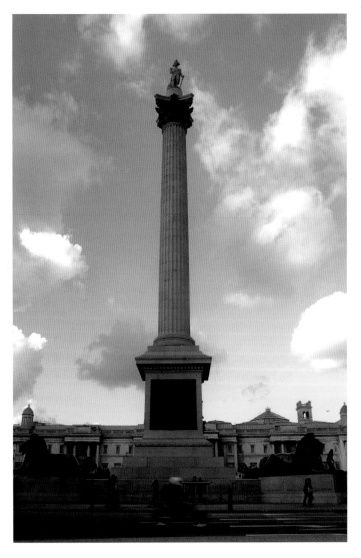

Nelson's Column

Uplighting adds drama to the statue of Lord Nelson in Trafalgar Square (*above*). The 5.5m (18ft) sandstone statue was the work of E.H. Bailey. It is positioned so that the figure looks south, toward the Admiralty and Portsmouth, where Nelson's flagship at the Battle of Trafalgar, HMS *Victory*, is preserved. The statue stands on a 46m (151ft) granite column decorated with bronze acanthus leaves cast from old cannon barrels (*left*). The memorial was completed in 1843 to commemorate Nelson's death at Trafalgar in 1805.

Trafalgar Square, WC2

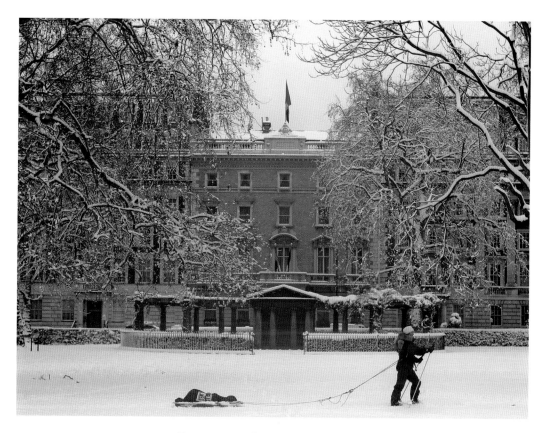

Grosvenor Square

Italian explorer Christina Franco skis past the Italian Embassy, in Grosvenor Square, following heavy overnight snowfall. In 2009, she attempted to ski solo to the North Pole, but was beaten by the conditions. Grosvenor Square takes its name from the family surname of the Duke of Westminster, who owns that area of Mayfair.

Grosvenor Square, W1

Statue of General Wolfe

The statue of General James Wolfe in Greenwich Park has a white mantle after heavy overnight snow. The statue, a gift of the Canadian people, was erected in 1930 on the same hill as the Royal Observatory. It depicts the famous general looking out towards the River Thames. Wolfe commanded the British forces at Quebec in 1759, during the Seven Years' War with the French, and won a great victory, albeit at the cost of his own life.

Greenwich Park, SE10

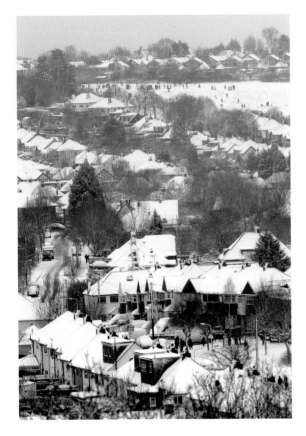

London in Winter

During a particularly harsh winter, the snow-covered rooftops of east London stretch away as far as can be seen from a vantage point in Epping Forest.

East London

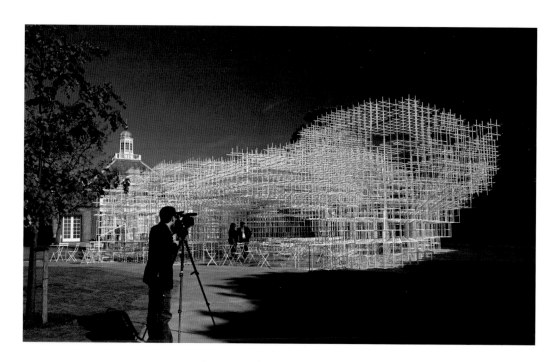

Serpentine Gallery

Set in Kensington Gardens, Hyde Park, the Serpentine Gallery specialises in exhibiting modern and contemporary art, and attracts around 750,000 visitors each year. The gallery was opened in 1970 in what had previously been a tea pavilion, built in 1934. The picture shows the Gallery Pavilion 2013, designed by Japanese architect Sou Fujimoto.

Kensington Gardens, W2

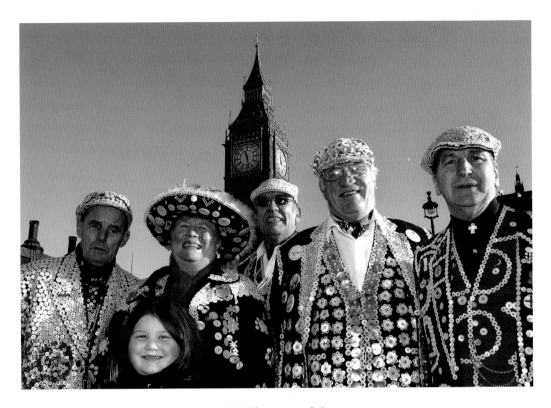

Pearly Kings and Queens

A group of Pearly Kings and Queens gather in Parliament Square for London's New Year's Day Parade. The custom of wearing clothes decorated with pearl buttons started in the 19th century and was part of a charitable tradition associated with working-class Londoners.

New Bond Street

A crowd of shoppers enjoys the spectacle of the newly illuminated Christmas lights in New Bond Street. The upmarket shopping area is one of the principal streets of London's West End shopping district, a distinction it has held since the 18th century. The street was named after Sir Thomas Bond, head of a syndicate that developed the area in the late 17th century.

New Bond Street, W1

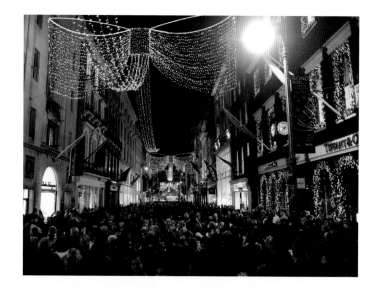

Burlington Arcade

Shoppers crowd the Burlington Arcade after the official switching on of the Christmas lights. The arcade, which opened in 1819, was built to the order of Lord George Cavendish, who owned the adjacent Burlington House. It contains around 40 small shops, many of which are antique dealers and jewellers.

Piccadilly/Burlington Gardens, W1

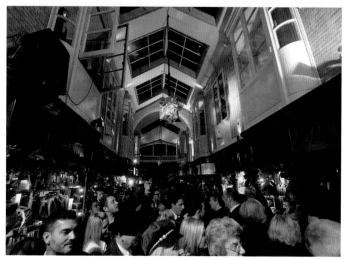

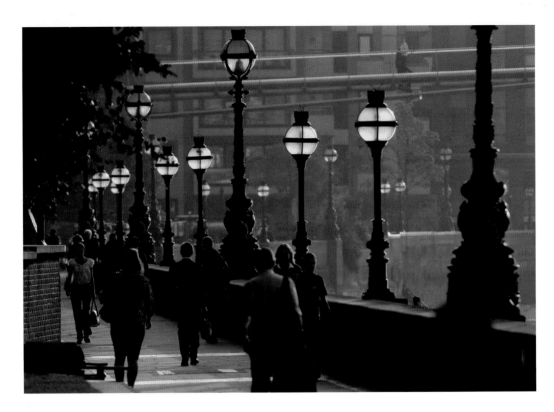

Embankment

Commuters walk along the Embankment at sunrise on an autumn morning.

Embankment, WC2

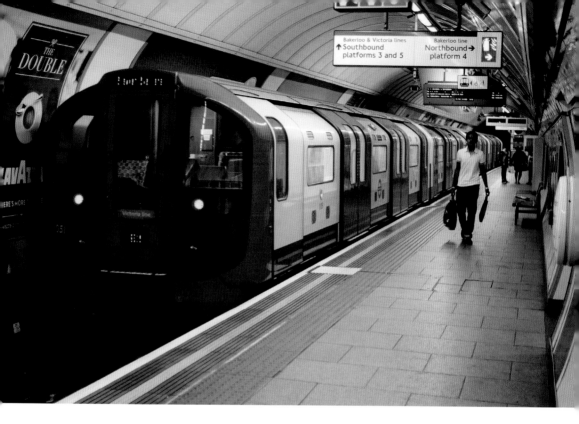

Underground Train

A Victoria line train leaves Oxford Circus tube station. The line, constructed in the 1960s, is a deep-level route that runs from Brixton in the south (Zone 2) to Walthamstow Central in the north-east (Zone 3) of London. Unlike most other lines on the network, it runs entirely below ground.

Oxford Street, W1

Brixton Windmill

Reputedly the last surviving windmill in London, the Brixton Windmill, officially Ashby's Mill after the Ashby family of millers who ran it, basks in spring sunshine. The Grade II listed building, built in 1816, has not been used since the 1930s. Following a grant of £400,000 from the Heritage Lottery Fund, the restored mill was opened to the public in May 2011.

Blenheim Gardens, SW2

Hampstead Heath

Leafless trees create a fascinating tracery against the watery sky as the spring sunshine falls upon Hampstead Heath. This large ancient park is one of the highest points in London, stretching from Hampstead to Highgate. The hilly landscape includes ponds, woodland, a lido, playgrounds and a training track.

Hampstead, NW6

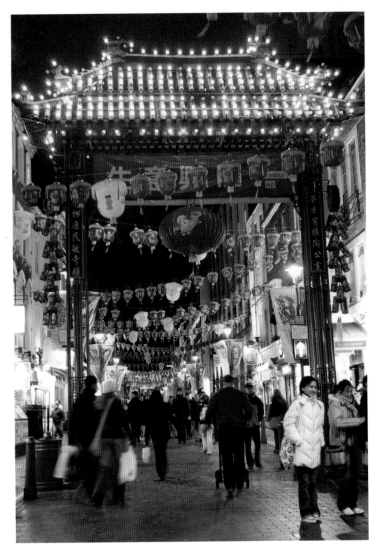

Chinatown

With strings of brightly coloured lanterns and lights, Chinatown is prepared to celebrate the Chinese New Year. Occupying the area around Gerrard Street in Soho, the community includes restaurants, bakeries, supermarkets, souvenir shops and other Chinese-run businesses. Street name signs in the area are bilingual in deference to the large Chinese presence.

Gerrard Street, W1

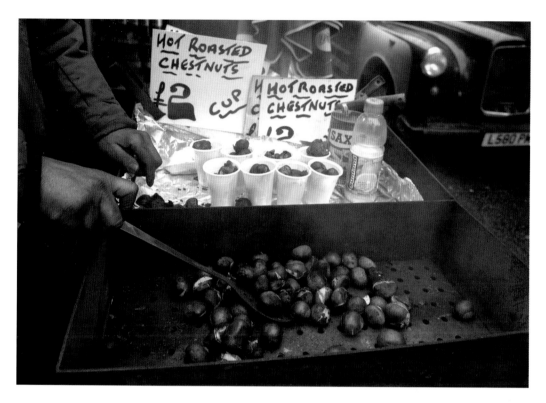

Roast Chestnut Seller

On a cold, damp wintry day, a street vendor roasts chestnuts on Oxford Street, filling the air with a delicious aroma. The tradition for this, often charred, delicacy is centuries old.

Oxford Street, W1

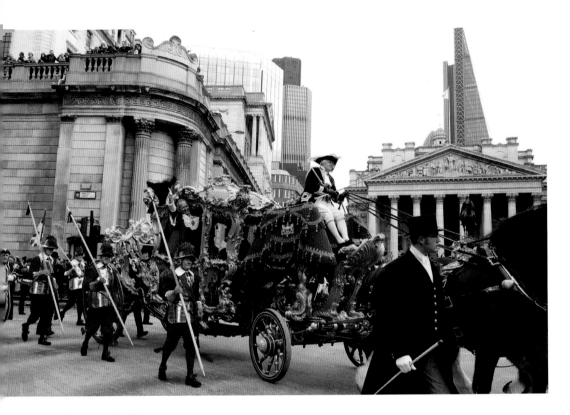

Lord Mayor's Show

A jubilant 687th Lord Mayor of London, Alderman Alan Yarrow, waves to the crowds from his gilded coach during the Lord Mayor's Show at Mansion House. The show dates back to 1535 and was created as a pageant to emphasise the important role played by the Lord Mayor and the City of London.

Bank Junction, EC4

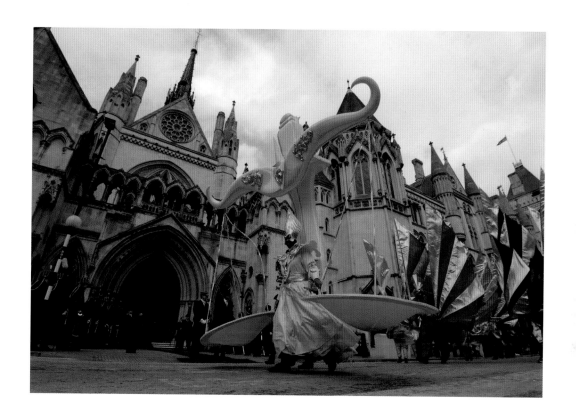

The Lord Mayor's Show parade sets off on its journey from the Guildhall in the City of London to the Royal Courts of Justice. After the mayor is sworn in, the parade reconvenes at Temple Place to make its way to Mansion House, the mayor's official residence.

Gresham Street, EC2 to Strand, WC2, via St Paul's Cathedral, EC4; Temple Place, WC2 to Mansion House, EC4, via Embankment, WC2

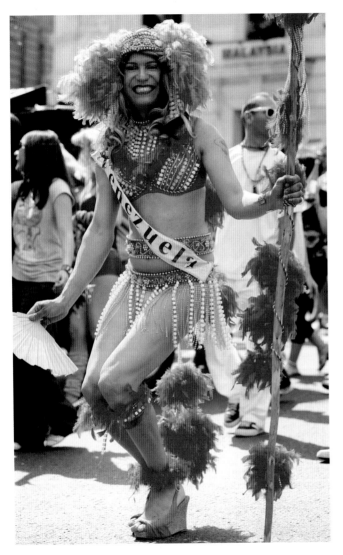

Pride Parade

Left: An exotically dressed participant in the annual Pride London parade. Promoted on behalf of lesbian, gay, bisexual and transgender people, the event regularly attracts participants and viewers numbering in the region of a million people, making it the largest outdoor event in the UK. The parade is part of a larger festival that includes a rally in Trafalgar Square and a variety of other entertainments around the capital.

Right: Revellers take part in the Pride London parade on Regent Street. A feature of the parade is the 100m (328ft) long rainbow flag, a popular symbol of the lesbian, gay, bisexual and transgender movement conceived by Californian artist Gilbert Baker in 1978. Both Oxford Street and Regent Street are closed for the parade, which wends its way from Baker Street to Trafalgar Square via Piccadilly Circus.

Baker Street, W1 to Whitehall, SW1, via Oxford Street and Regent Street, W1

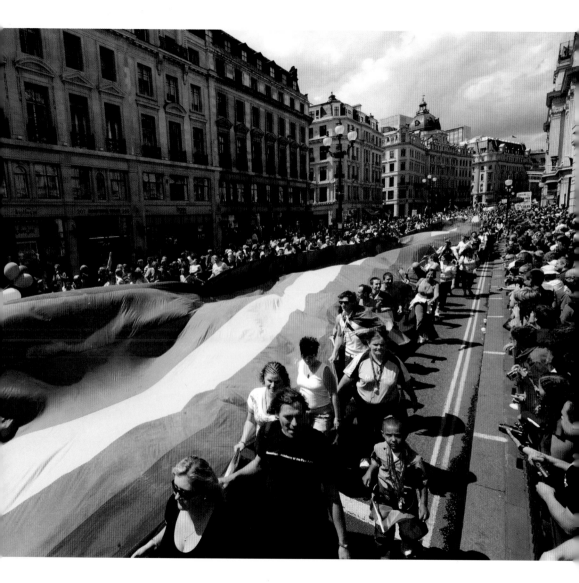

Big Ben in Spring

The Gothic clock tower of Big Ben rises above the trees with their fresh green foliage, while the vivid colours of spring flowers complete a vibrant picture. London in spring can be an enchanting place.

Embankment, SW1

Palace of Westminster

On a clear summer's day, the Palace of Westminster and Big Ben stand out clearly alongside the broad River Thames in this aerial view. In the foreground is Lambeth Bridge, while downstream can be seen the arches of Westminster Bridge. To the left of the picture is the tall roof of Westminster Abbey.

Palace of Westminster, SW1

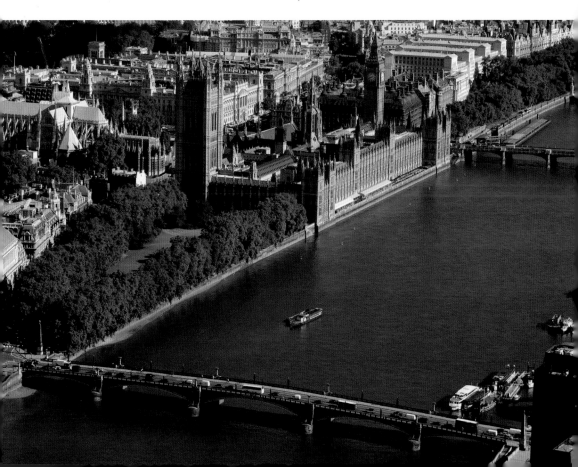

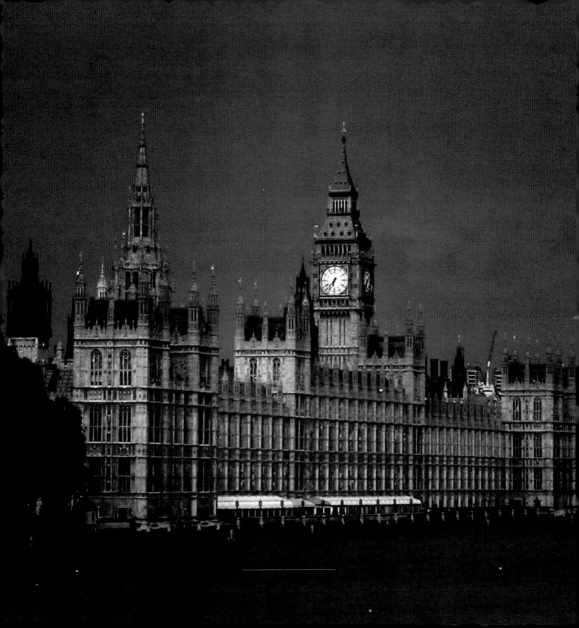

Houses of Parliament

Against a leaden sky, the camera catches a vivid lightning strike as a summer storm passes over the capital. In the foreground are the Houses of Parliament and Big Ben, with the arches of Westminster Bridge stretching out over the Thames. In the background can be seen the arched roof of Charing Cross railway station.

Westminster, SW1

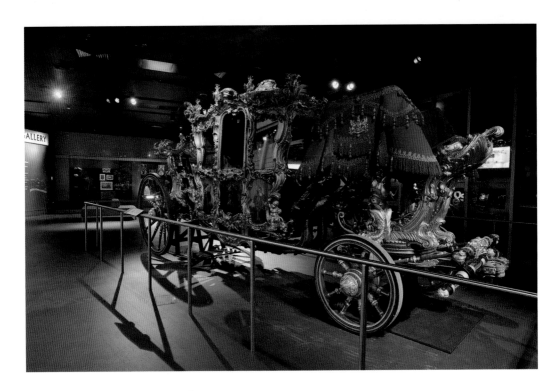

Lord Mayor's State Coach

The Lord Mayor of London's State Coach takes pride of place in the Museum of London. The glass-fronted Galleries of Modern London, which cost £20m, allow passers-by to see the State Coach at street level from London Wall. The ornate coach, which is pulled during the annual Lord Mayor's Show by six horses, was built in 1757 and has side panels painted by the Italian artist Giovanni Cipriani.

London Wall, EC2

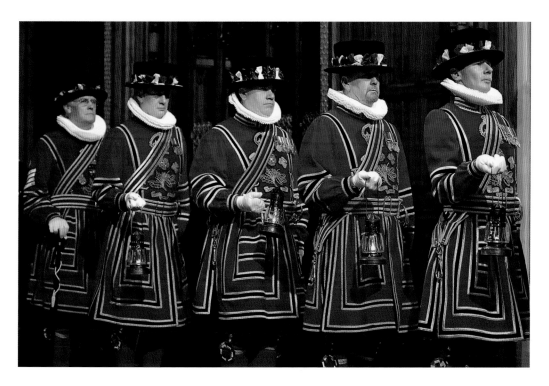

State Opening of Parliament

Yeoman Warders, popularly known as Beefeaters, prepare to carry out a ceremonial search of the Palace of Westminster before Queen Elizabeth arrives for the State Opening of Parliament. The tradition dates back to the 17th century, when a group of Catholics attempted to blow up the building and kill Protestant King James I in 1605 – the Gunpowder Plot.

Palace of Westminster, SW1

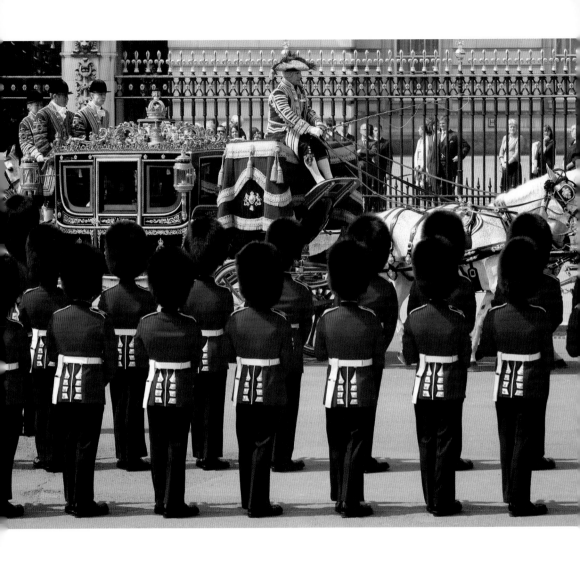

State Opening of Parliament

Left: Queen Elizabeth II and the Duke of Edinburgh leave Buckingham Palace in the Irish State Coach to attend the State Opening of Parliament at the Palace of Westminster. Traditionally, their route to Westminster is lined by members of the armed forces, and upon arrival the Royal standard is raised over Parliament in place of the Union flag.

Buckingham Palace, SW1

Right: The Queen and the Duke of Edinburgh walk through the Royal Gallery in the Palace of Westminster during the State Opening of Parliament.

Palace of Westminster, Parliament Square, SW1

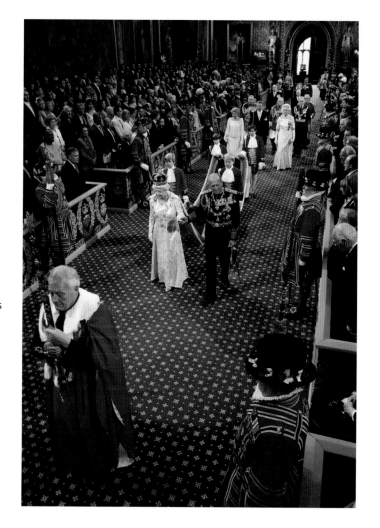

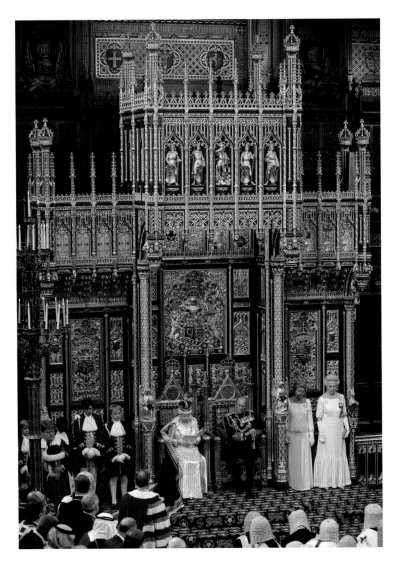

State Opening of Parliament

Left: The Queen delivers her speech, setting out the government's agenda for the coming parliamentary session, to the House of Lords during the State Opening of Parliament. The ceremony dates from the time of Henry VIII, and its style has remained the same since the reopening of the Houses of Parliament in 1852 after their destruction during the great fire of 1834.

Right: The Queen addresses politicians and members of the House of Lords during the State Opening of Parliament in Westminster. The ceremony takes place annually, usually in November or December, at the beginning of a session of Parliament. In an election year, however, it occurs when the new Parliament first assembles.

Palace of Westminster, Parliament Square, SW1

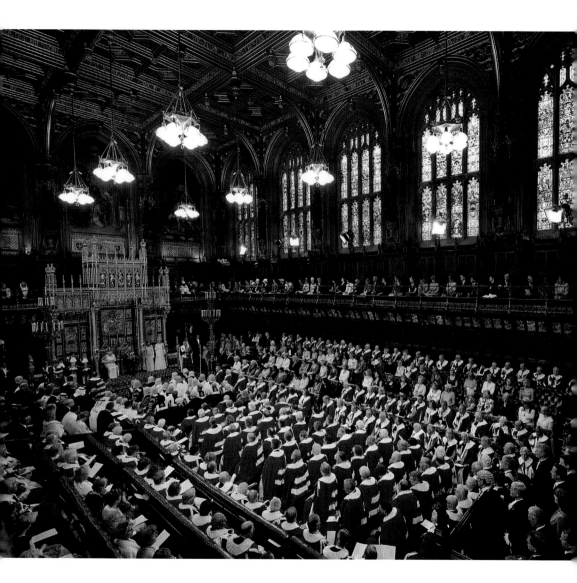

Helicopter Air Ambulance

London's air ambulance, a McDonnnell Douglas MD902, attending an emergency, lands on the nursery practice area at Lord's Cricket Ground. The service was formed in 1989. Based at the Royal London Hospital, it covers the area of London within the M25 motorway, can be airborne within two minutes and can reach the furthest part of that area within 12 minutes. Since operations began, trauma deaths in London and on the M25 have fallen by over 50 per cent.

Royal London Hospital, Whitechapel Road, E1

Madame Tussauds

The famous Madame Tussauds waxwork museum, which contains lifelike images of the famous and notorious through history to the present day. The museum opened in the 1820s, when Madame Marie Tussaud created her first permanent waxworks display in Baker Street. The dome originally housed the London Planetarium. The Planetarium closed in 2006, however, and the structure was renamed the Star Dome, being used by Tussauds for a variety of entertainments.

Marylebone Road, NW1

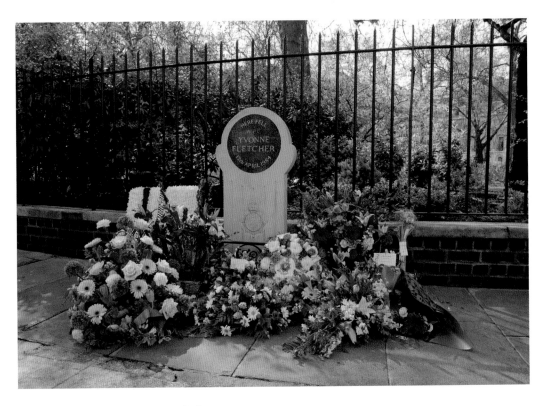

Yvonne Fletcher Memorial

On 17 April 1984, 25-year-old Yvonne Fletcher, a police officer helping to control a demonstration outside the Libyan Embassy in St James's Square, was killed when shots were fired from the embassy into the crowd. No one was ever convicted of the murder, although eventually the Libyan government accepted responsibility and paid compensation to the policewoman's family.

St James's Square, SW1

Bond Street Underground Station

Commuters on the Underground climb the escalators at Bond Street station. Serving the Central and Jubilee lines, the station was opened in 1900 and was equipped originally with lifts.

Oxford/Davies Streets, W1

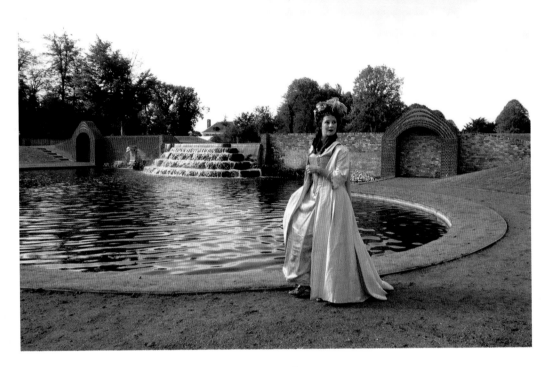

Upper Lodge Water Gardens, Bushy Park

An actor in 18th-century period costume strolls around the Upper Lodge Water Gardens in Bushy Park, south-west London. The gardens were restored in 2009, having previously virtually disappeared beneath a layer of silt and undergrowth. They comprise a baroque-style collection of pools, cascades, basins and a canal.

Teddington, Middlesex

Statue of Captain Cook

Looking down towards the River Thames, the statue of Captain James Cook occupies a prominent position at the National Maritime Museum, Greenwich. The famous 18th-century navigator and explorer made extensive maps of Newfoundland before setting off on three voyages across the Pacific Ocean, discovering Australia, New Zealand and the Hawaiian Islands.

National Maritime Museum, Romney Road, SE10

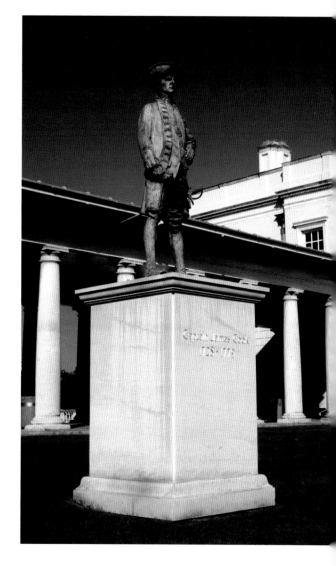

Victoria Cross and George Cross Memorial

In 2004, this permanent memorial to recipients of the Victoria Cross and George Cross was unveiled at the Ministry of Defence. The memorial takes the form of a bronze statue, by Marcus Cornish, and a stained-glass window, by Rachel Foster. The Victoria Cross is the highest British military decoration for valour, while the George Cross is its civil equivalent, although it can also be awarded to military personnel in certain circumstances.

Ministry of Defence, Whitehall, SW1

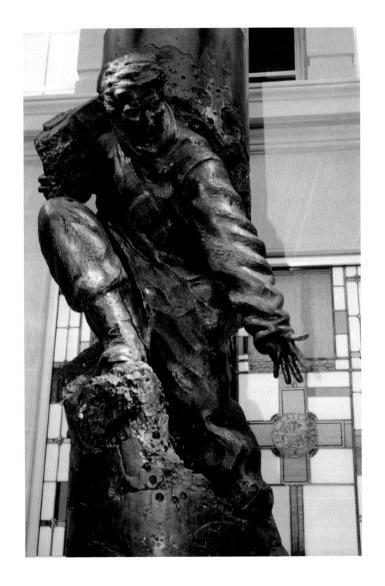

Crossrail

Left: Breakthrough beneath Finsbury Circus, as work on Crossrail continues. The 117km (73-mile) railway line – to provide a high-frequency commuter/suburban passenger service linking Berkshire and Buckinghamshire, via central London, to Essex and south-east London – is expected to be fully operative in 2019.

Finsbury Circus, EC2

Crossrail Tunnels

Below: Burrowing beneath Bond Street. Work began on Crossrail in 2009, in one of Europe's largest railway and infrastructure projects. More than 42km (26 miles) of new tunnels will run from near Paddington to Stratford via central London and Liverpool Street. A new line will branch at Whitechapel to Canary Wharf, crossing the River Thames, and connecting with the North Kent Line at Abbey Wood.

Bond Street, W1

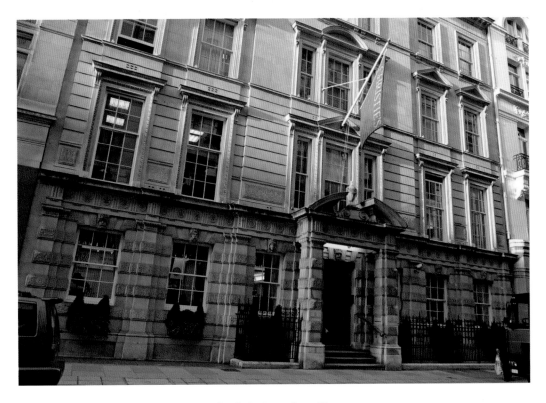

Christie's Auction House

The London headquarters of Christie's, the fine arts auction house. The company has occupied the site since 1823, although James Christie was in business as an auctioneer in London as early as 1766, and some sources say even earlier. His company became established as a major player in the international art trade following the French Revolution.

King Street, SW1

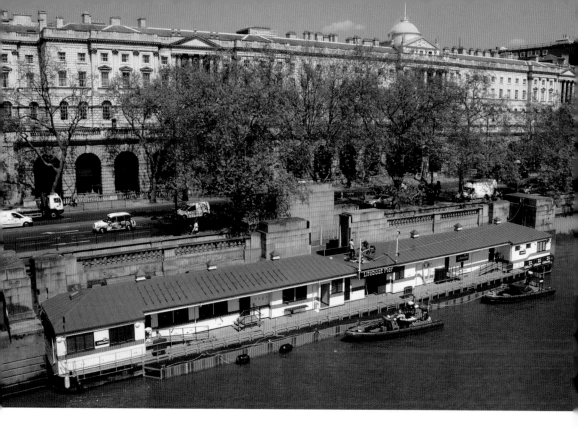

Tower Lifeboat Station

The Royal National Lifeboat Institution's lifeboat station at Victoria Embankment. Opened in 2002, the station took over from the former RNLI lifeboat station near the Tower of London, the busiest in the UK, but retained the Tower Lifeboat Station name. Previously, the pier had been used by the river police. In the background can be seen Somerset House.

Victoria Embankment, SW1

Stratford Underground Station

The great soaring roof of Stratford Underground station, built as part of the Jubilee line extension at the turn of the century. The station acts as one of the country's major rail interchanges, serving not only the Underground's Jubilee line, but also the Docklands Light Railway, the London Overground system and National Express East Anglia. The original station was established by the Eastern Counties Railway in 1839, along with a railway works that has since been turned into a freight depot.

Station Street, E15

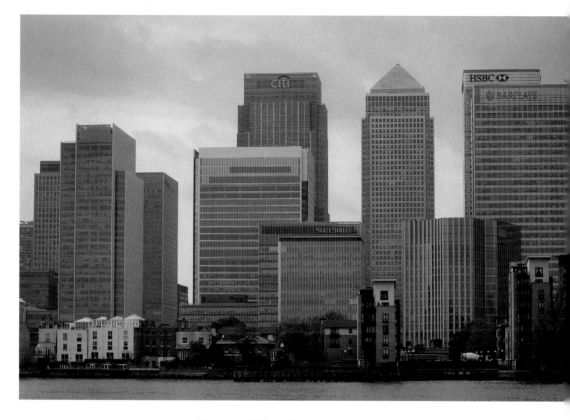

Canary Wharf

The tall skyscrapers of Canary Wharf loom over a prestigious dockside residential development.

Canary Wharf, E14

Goldfinger's House

The block of three terraced houses designed by modernist architect Ernö Goldfinger in the 1930s, in one of which, No. 2, he lived with his wife, Ursula, and their children. The concrete-framed, brick-faced building was erected on the site of a number of cottages and was opposed by local residents, including author Ian Fleming, who would give Goldfinger's name to one of his villains. Goldfinger's home is maintained by the National Trust and is open to the public.

2 Willow Road, NW3

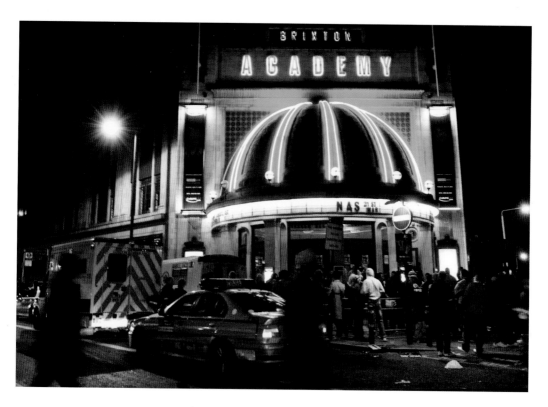

Brixton Academy

Although one of London's leading music venues and nightclubs today, the Brixton Academy began life as the Astoria cinema in 1929. As was common in cinemas at the time, the interior made much use of Art Deco design features, which remain in place. The building remained a cinema until 1972 and, after a period of use as an equipment store, was reopened as a rock venue in 1983.

Stockwell Road, SW9

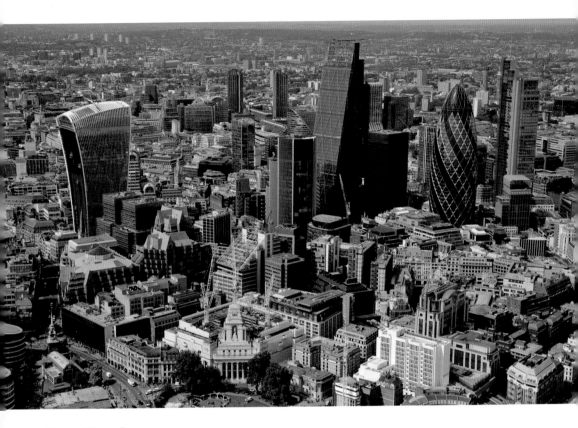

City of London

An aerial view of the City of London, including the distinctive 20 Fenchurch Street, the 'Walkie-Talkie' (*left*), the Leadenhall Building, known as the 'Cheesegrater' (*centre*) and 30 St Mary Axe, more commonly known as the 'Gherkin' (*right*).

City of London, EC3

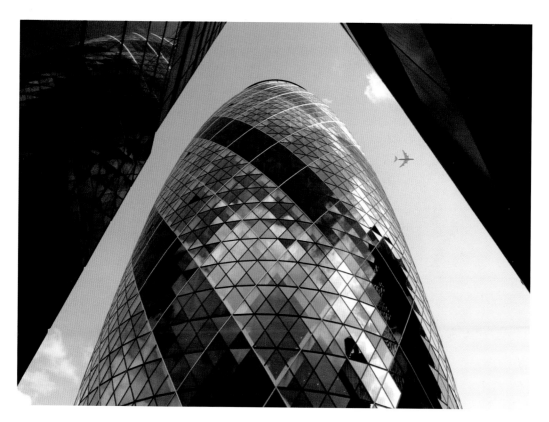

Gherkin

The award-winning 30 St Mary Axe stands on the former site of the Baltic Exchange, which was severely damaged by a Provisional IRA bomb in 1992. Completed in 2003, the building was designed by Norman Foster with his partner, Ken Shuttleworth. Despite the curved shape of the building, all of the glass, with the exception of the cap at the very top, is flat.

St Mary Axe, EC3

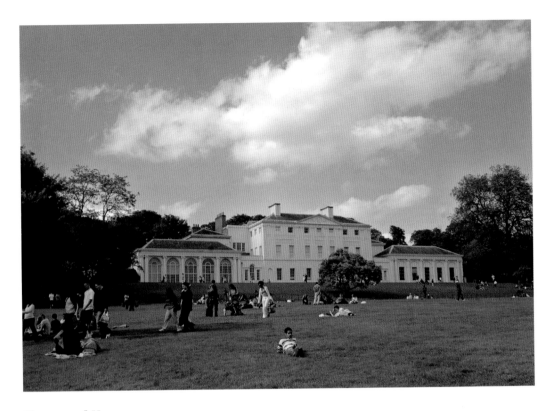

Kenwood House

Standing in rolling parkland adjacent to Hampstead Heath, Kenwood House was remodelled by Robert Adam in the late 18th century for the judge Lord Mansfield. The house and estate were bought in 1925 by Edward Guinness, the brewing magnate, who bequeathed them, with part of his collection of paintings, to the nation upon his death in 1927.

Hampstead Lane, NW3

University College Hospital

Opened in 1834, the North London Hospital was founded to provide students from the nearby London University (later University College London) with medical training. Subsequently, it became known as University College Hospital. The original hospital building has since been absorbed by the university and a new hospital, shown here, opened on Euston Road. It has 665 beds, 12 operating theatres and is a major centre for medical research.

Euston Road, NW1

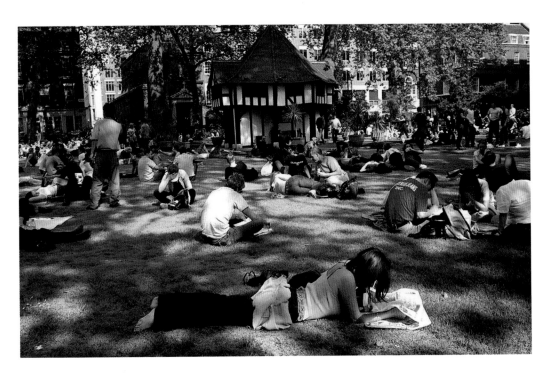

Soho Square Gardens

On a warm sunny day in early summer, the gardens in Soho Square are packed with visitors enjoying the balmy weather. Established in 1681, Soho Square was called King's Square originally, in honour of King Charles II, whose statue stands in the gardens. At the time, it was one of the most fashionable places to live in London. A unique feature of the gardens is the timbered gardener's hut.

Soho Square, W1

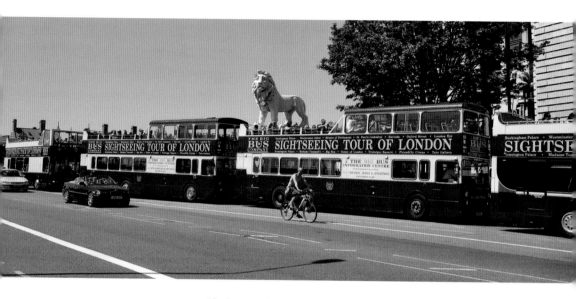

Sightseeing Buses

Open-top tourist buses congregate on Westminster Bridge as the capital enjoys high temperatures. The buses offer a good way to see all the major landmarks of the city, allowing travellers to hop on and off at will throughout the day for further exploration.

Westminster Bridge, SW1

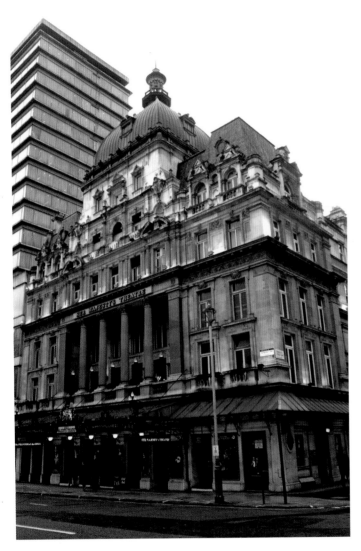

Her Majesty's Theatre

Left: Dating from 1897, Her Majesty's Theatre is the fourth theatre to stand on the site in Haymarket. The original theatre was established in 1705 by playwright John Vanbrugh and called Queen's Theatre. Throughout its history, the name of the theatre has changed with the sex of the monarch. The present theatre became Her Majesty's upon the accession of Queen Elizabeth to the throne in 1952; prior to that, it had been His Majesty's Theatre.

Haymarket, SW1

John Lewis, Oxford Street

Right: John Lewis opened his first drapery shop on the site in 1864; today, the store is the John Lewis Partnership's flagship store; it is also the largest.

Oxford Street, W1

Mounted Police

Two mounted police officers patrol near the Tower of London. The Mounted Branch of the Metropolitan Police was formed in 1760 and continues to play a major role in policing in the city. It has an establishment of 140 officers and 120 horses housed in eight stables across London.

Tower of London, EC3

Skinny House

Built to utilise the narrow space between two existing buildings, perhaps to accommodate servants, this house is one of the thinnest in Britain. The two-bedroom property is only 1.5m (5ft 6in) wide at the front, although it is 2.9m (9ft 11in) at its widest point and is on five levels. In 2009, it was offered for sale at just under £550,000.

Goldhawk Road, W12

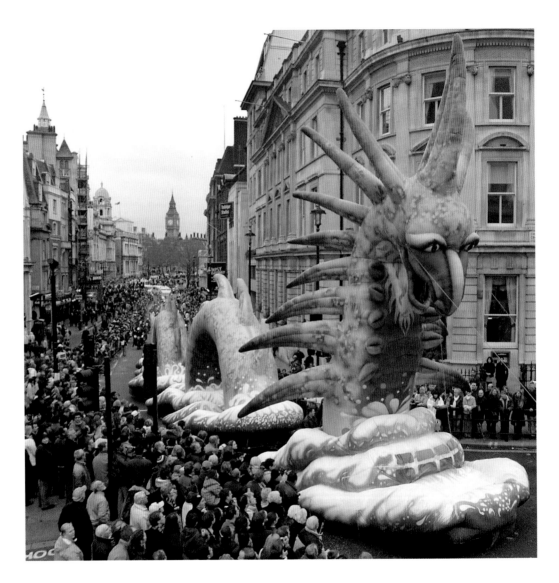

New Year's Day Parade

Left: A giant inflatable dragon arrives at Trafalgar Square as part of the New Year's Day Parade. The annual parade, which takes place on 1 January, sees around 10,000 participants take to the streets of the West End. The parade winds its way from Parliament Square, along Whitehall to Trafalgar Square, and along Regent Street and Piccadilly to Green Park.

Trafalgar Square, WC2

Trellick Tower

Right: Dancers pass the Trellick Tower during the Notting Hill Carnival. Designed by architect Ernö Goldfinger in the brutalist style, the 31-storey apartment block was commissioned by the Greater London Council in 1966 and completed in 1972. Although a significant number of the apartments are privately owned today, by far the majority remain social housing. The building was awarded a Grade II listing in 1998.

Goldbourne Road, W10

Veteran Car Run to Brighton

Participants cross Westminster Bridge at daybreak, shortly after the start of the London to Brighton Veteran Car Run. The event is the oldest motoring event in the world, the first run having taken place in 1896. To qualify, cars must have been built before 1905, and well over 400 regularly take part. It takes place on the first Sunday of November and starts from Hyde Park.

Westminster Bridge, SW1

Mahatma Gandhi Statue

A statue of Mahatma Gandhi installed in Parliament Square in 2015. The 2.75m (9ft) bronze statue marks 100 years since Gandhi returned to India from South Africa to begin his struggle for independence. Gandhi used non-violent protest and hunger strikes to protest against the oppression of India's poorest classes. The statue, by British sculptor, Philip Jackson, was unveiled by Indian finance minister, Shri Arun Jaitley, in a ceremony that also involved Gandhi's grandson, Gopalkrishna Gandhi.

Parliament Square, SW1

MAHATMA GANDHI

Lincoln's Inn Fields

People enjoy the afternoon sunshine in Lincoln's Inn Fields, the largest public square in London. The square, with its large grass area in the centre, was created in the 1630s by William Newton, under the direction of Inigo Jones. It was private property until purchased by the London County Council in 1895. Today it is a popular place for local office workers to relax at lunchtime.

Holborn, WC2

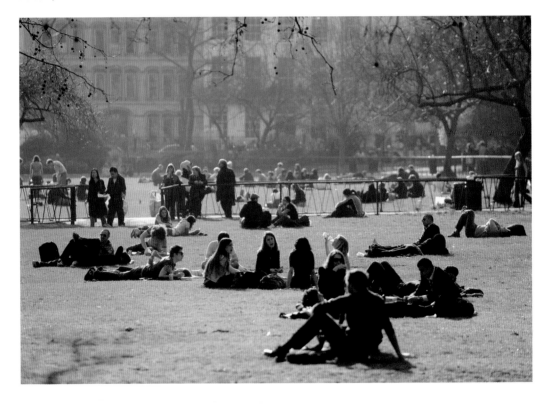

Croydon Airport

Airport House in Croydon, Surrey, formerly the main terminal building for Croydon Aerodrome, London's first International airport, opened in 1928. The aircraft displayed outside is a de Havilland Heron, carrying the markings of G-AOXL of Morton Air Services, the aircraft that flew the last passenger flight from Croydon on 30 September 1959.

Purley Way, Croydon, Surrey

Royal Botanic Gardens

Above: The Davies Alpine House at the Royal Botanic Gardens, Kew. The structure, which was opened in 2006, is the only public glasshouse to have been constructed at Kew in the last 20 years. It was designed by Wilkinson Eyre, twice winner of the prestigious Stirling Prize. The glasshouse features automatic sunblinds and a cool-air system to prevent overheating.

Right: The striking Palm House at the Royal Botanic Gardens, Kew. Designed by Charles Lanyon, the building was the first large-scale structural use of wrought iron. It was erected by Richard Turner and opened in 1840. The gardens at Kew date from 1759, when an exotic garden was created in Kew Park by Lord Capel John of Tewkesbury. In 1840, the gardens were adopted as a national botanical garden.

Kew Green, Richmond, Surrey

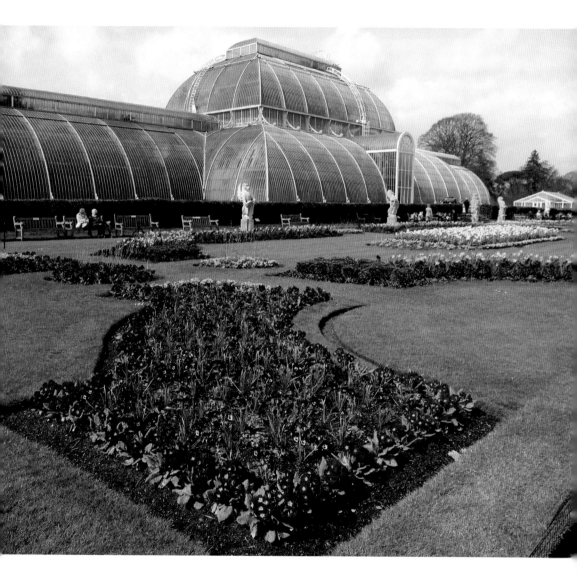

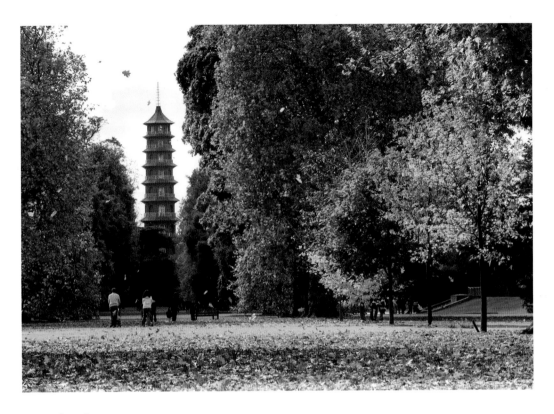

Kew Gardens

On a mild autumn day, visitors to the Royal Botanic Gardens at Kew take a stroll towards the Great Pagoda among the fallen leaves and golden trees. The pagoda, in the south-east corner of the gardens, was designed by Sir William Chambers after an original Chinese building and erected in 1762. It has ten octagonal storeys and stands 50m (163ft) high. During the Second World War, holes were cut in the floors so that model bombs could be dropped through to test how they fell.

Magnolia blossom covers trees and carpets the ground at the Royal Botanic Gardens, Kew, encouraged by a warm spell in early March. The gardens and associated buildings make for a fascinating and relaxing day out for anyone interested in horticulture.

Kew Green, Richmond, Surrey

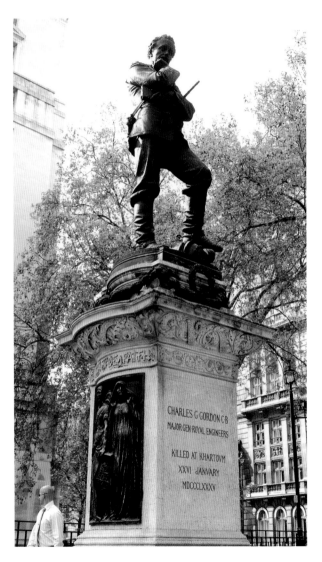

Statue of General Gordon

A statue of General Charles Gordon of the Royal Engineers, who was killed at Khartoum in Sudan in 1885. Gordon is remembered for his campaigns in China in the early 1860s, and in northern Africa during the late 1870s and early 1880s. He was known popularly and variously as Chinese Gordon, Gordon Pasha and Gordon of Khartoum. He was made Governor-General of Sudan, but was killed during the Mahdist Revolt. The statue was the work of Hamo Thornycroft and was erected originally in Trafalgar Square in 1888. It was removed in 1943 and re-erected on Victoria Embankment in 1953.

Victoria Embankment, SW1

Eltham Palace

The dramatic entrance hall of Eltham Palace in south London. Originally a 14th-century Royal palace, given to Edward II by the Bishop of Durham, the buildings and estate were ransacked during the English Civil War; little more than the Great Hall survived. In the 1930s, the site was leased by Sir Stephen and Lady Courtauld. They restored the hall and incorporated it into a new home that had a lavish Art Deco interior.

Court Yard, SE9

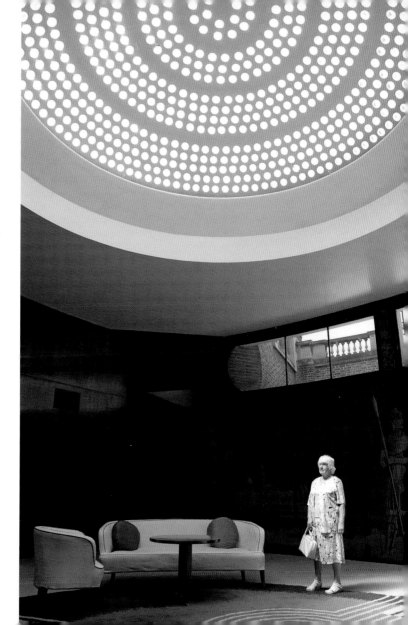

London Zoo

The Outback exhibit at London Zoo, an area that used to be home to polar bears, but has since been transformed into a representation of the Australian plain. The exhibit is home to a group of over 20 wallabies and four emus.

Young visitors get close to meerkats at London Zoo's Animal Adventure. Inspired by children and built at a cost of £2.3m, the flagship exhibit was opened in 2009 with the intention of encouraging children as young as three to take an interest in wildlife. Animal Adventure was built on the same spot as the original children's zoo, which opened in 1938.

Regent's Park, NW1

London Zoo

Twelve-year-old, 127kg (20-stone) male gorilla Yeboah (*left*) with Effie, one of his three female mates, at London Zoo. The zoo is the world's oldest scientific zoo, having been established in 1828 for scientific study. It was opened to the public in 1847 and today has a collection of over 15,000 creatures from 755 species.

A trio of rock hopper penguins, from the Falkland Islands, takes a stroll in the snow at London Zoo. Smallest of the crested penguins, rock hoppers are feisty and noisy creatures that are fiercely protective of their young. They are one of many unusual species of bird that can be seen at the zoo.

Regent's Park, NW1

Millbank Tower

The Grade II listed skyscraper known as Millbank Tower stands on the north bank of the River Thames, just upstream from the Palace of Westminster. Built originally for Vickers in 1963, the 118m (387ft) high tower is probably most associated with the Labour Party, who occupied two floors at the base of the building during and after the General Election campaign of 1997; the party left the building in 2002, no longer willing to pay the £1m annual rent demanded.

Millbank, SW1

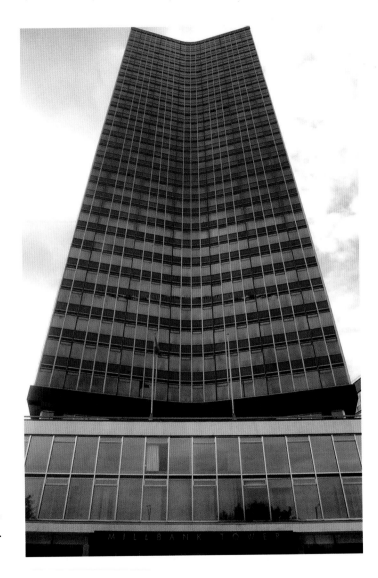

Topolski Century

Feliks Topolski's 'Memoir of the 20th Century' is a 183m (600ft) long installation under Hungerford Bridge on London's South Bank that takes viewers on a journey through a century's history, including portraits of Gandhi, Mao, George Bernard Shaw, Martin Luther King and Picasso. Topolski worked continuously on the piece from 1975 to his death in 1989, and in 2006 it received a £1m Heritage Lottery Fund grant for restoration work.

Hungerford Bridge, SE1

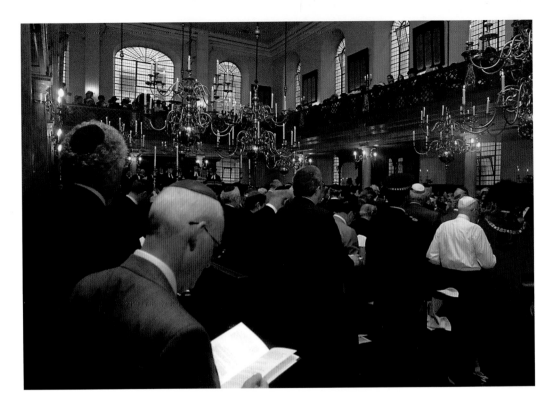

Bevis Marks Synagogue

The interior of the Bevis Marks Synagogue in the City of London, the oldest synagogue in the UK. It was constructed to meet the needs of a growing Spanish and Portuguese Jewish community at the beginning of the 18th century by Joseph Avis, a Quaker, who refused his fee because he considered it wrong to profit from erecting a building devoted to God. Since then, the building has changed little, apart from the rebuilding of the roof after it was destroyed by fire in 1738.

Heneage Lane, EC3

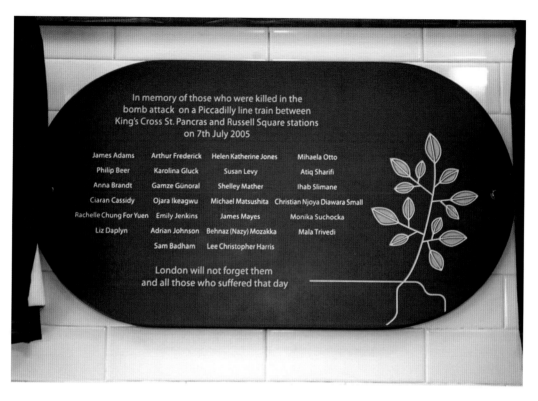

In memory of those who were killed in the
bomb attack on a Piccadilly line train between
King's Cross St. Pancras and Russell Square stations
on 7th July 2005

James Adams	Arthur Frederick	Helen Katherine Jones	Mihaela Otto
Philip Beer	Karolina Gluck	Susan Levy	Atiq Sharifi
Anna Brandt	Gamze Gunoral	Shelley Mather	Ihab Slimane
Ciaran Cassidy	Ojara Ikeagwu	Michael Matsushita	Christian Njoya Diawara Small
Rachelle Chung For Yuen	Emily Jenkins	James Mayes	Monika Suchocka
Liz Daplyn	Adrian Johnson	Behnaz (Nazy) Mozakka	Mala Trivedi
	Sam Badham	Lee Christopher Harris	

London will not forget them
and all those who suffered that day

7/7 Memorial Plaque

This Remembrance Plaque was erected at Russell Square Underground Station in memory of those who died during a suicide bomb attack on a Tube train between King's Cross and Russell Square stations on 7 July 2005. The train was one of three attacked at the same time, in addition to a bus. As well as the bombers, 52 people were killed, while around 700 were injured.

Bernard Street, WC1

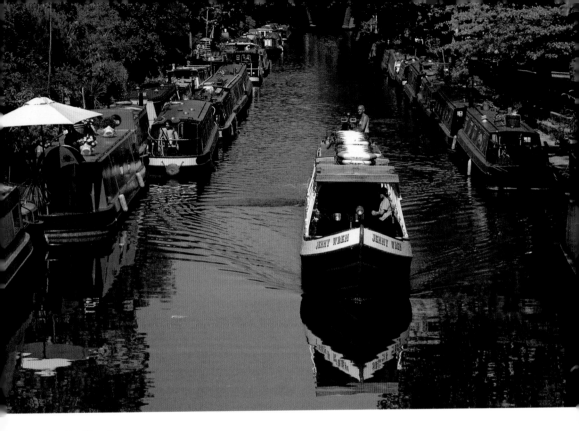

Little Venice

The area around Browning's Pool, at the junction of Regent's Canal and the Paddington branch of the Grand Union Canal in Maida Vale, is known as Little Venice. The title is thought to have been coined by the poet Robert Browning, after whom the pool is named. Although once busy commercial waterways, today the canals are populated by leisure craft, many of them restored barges.

Maida Vale, W9

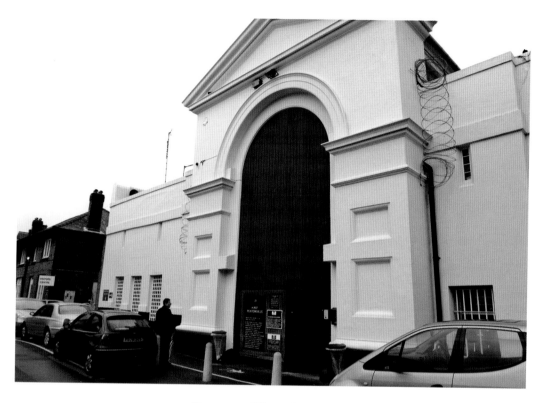

Pentonville Prison

Completed in 1842, Pentonville became a model for other prisons, 54 being built to the same design in the UK, and hundreds throughout the Empire. When Newgate Prison closed in 1902, executions in north London were carried out at Pentonville. Among those hanged there was Hawley Harvey Crippen. The last execution took place in 1961. Other than Crippen, notable inmates include Oscar Wilde, John Christie, Pete Doherty, George Michael and Boy George.

Holloway Road, N7

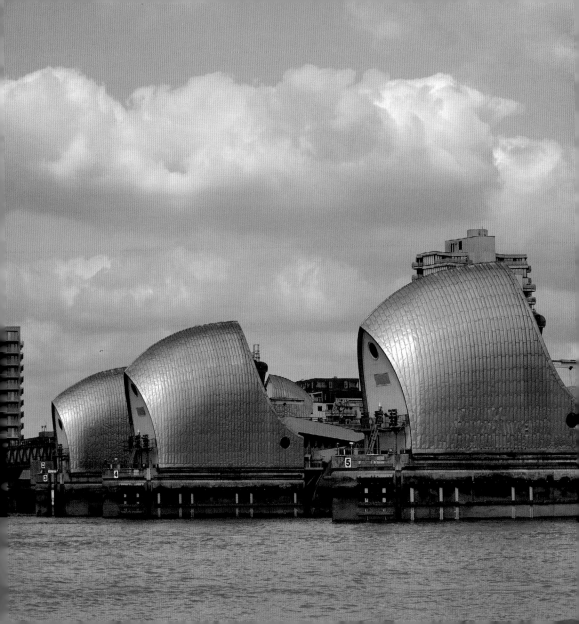

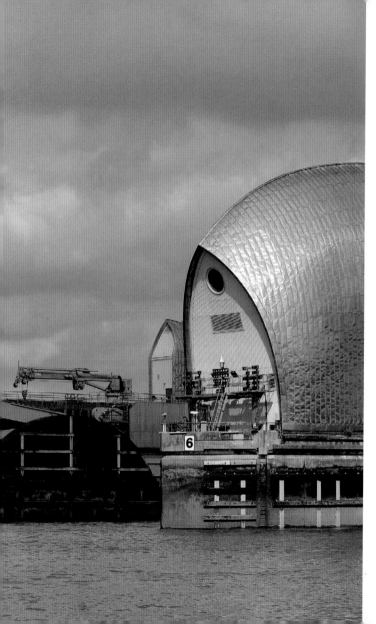

Thames Barrier

The Thames Barrier was built
to prevent London from being
flooded by a combination of
a high spring tide and storm
surge travelling upriver from the
North Sea. It comprises a series of
rotating curved gates supported
by piers. These provide a number
of navigable channels, allowing
river traffic to pass through.
With rising sea levels, the barrier
is closed more frequently: 75
occasions during the first decade
of the 21st century, compared to
35 in the previous ten years.

Silvertown, E16/New Charlton, SE7

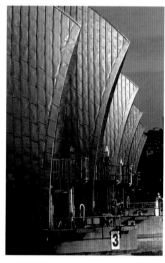

Queen's Theatre

Despite the modern appearance of its façade, Queen's Theatre actually dates from the Edwardian era, having opened in 1907; during the Second World War, a German bomb destroyed the original façade. The theatre was designed by the architect W.G.R. Sprague as a twin to the neighbouring Gielgud Theatre, which opened in 1906 as the Hicks Theatre.

Shaftesbury Avenue, W1

Protest March

A group of protesters marches past the Houses of Parliament in Westminster, calling on world leaders to put climate change at the top of their agendas. The streets of London and its squares are regularly closed to allow people their democratic right of protest.

Westminster, SW1

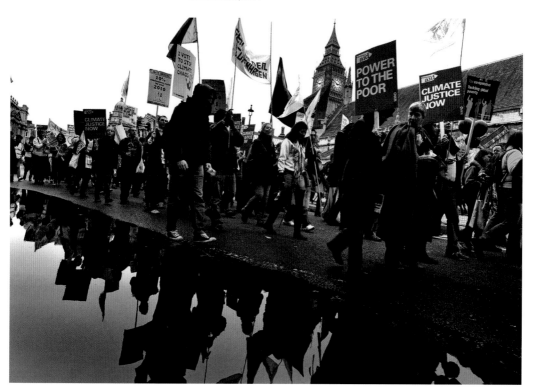

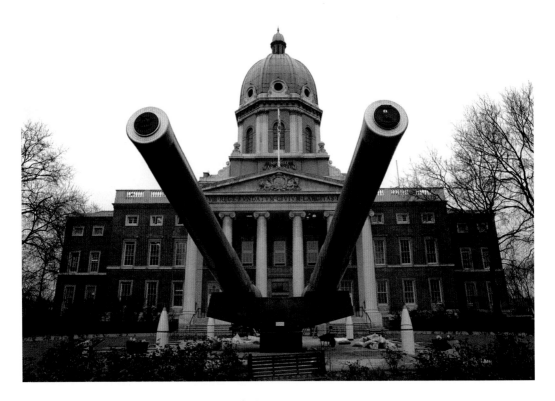

Imperial War Museum

Founded in 1917 during the First World War, not as "a monument of military glory, but a record of toil and sacrifice" of Britain and her empire, the Imperial War Museum was finally opened to the public in 1920 at the Crystal Palace. After a move to the Imperial Institute in South Kensington, the museum finally established a permanent home in the former Bethlem Royal Hospital in Southwark in 1936. Today, that building is one of three sites operated by the museum in London.

The atrium of the Imperial War Museum contains a varied collection of exhibits from conflicts of different eras, including a Second World War German V2 rocket (*left*) and modern Polaris missile (*right*). Suspended from the roof are First World War BE2 and Sopwith Camel aircraft (*foreground*), and Focke-Wulf 190 (*back left*) and Supermarine Spitfire (*back right*). The parachuting dog has since been discovered to have been a hoax by wartime SAS members.

Lambeth Road, SE1

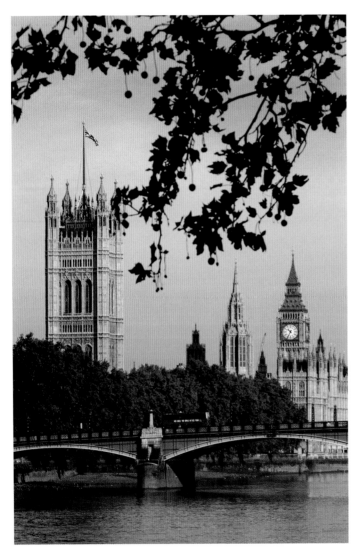

Lambeth Bridge and Palace of Westminster

On a mild day in October, the sun glows warmly on the spires of the Palace of Westminster and the clock tower of Big Ben. In the foreground, the sweeping arches of Lambeth Bridge are reflected in the rippled waters of the River Thames. The red paint on the bridge matches the colour of the leather benches in the House of Lords; Westminster Bridge, downstream, is predominantly green to match the seating of the House of Commons.

Westminster, SW1

Reuters News Agency

The UK headquarters of the famous Reuters news agency at Canary Wharf. The organisation moved into the building in 2005, having been based previously in Fleet Street. Almost every news outlet in the world subscribes to Reuters' news service, which operates in 94 countries around the world.

South Colonnade, Canary Wharf, E14

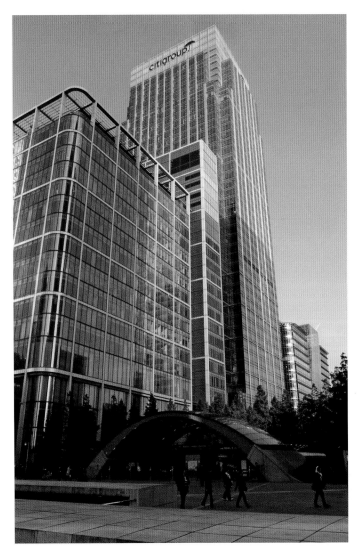

Canary Wharf

Left: This 45-storey tower and adjacent 18-storey building form the Citigroup Centre at Canary Wharf, headquarters of the Citigroup financial institution. The tower is the joint third tallest building in the UK.

Right: This striking building at Canary Wharf is occupied by Bank of America Securities and Credit Suisse. It was designed by a team from American architects Skidmore, Owings and Merrill, who received an American Institute of Architects Honor Award for their work. The building contains one of Europe's largest trading floors.

Canada Square, E14

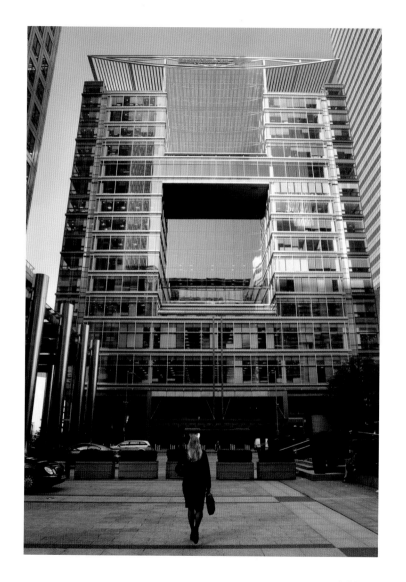

Limehouse Marina

Surrounded by luxury apartment blocks, today the Limehouse Marina and Basin, part of the Docklands development, is home to leisure craft. When it was opened in 1820 by the Regent's Canal Company, however, it was a busy working dock used by seagoing vessels, whose cargoes would be transferred to barges for carriage on the Regent's Canal and beyond. At one point, it was the primary link between the national canal network and the Thames.

Goodhart Place, E14

Bust of Isaac Newton

The gardens in Leicester Square were opened to the public in 1874, and in addition to containing flowerbeds and lawns, they included busts of famous local residents. Among these was Isaac Newton, who lived in St Martin's Street, to the south of the square, between 1710 and 1725. The bust, which is somewhat eroded, was the work of William Calder Marshall and it stands near the Newton Gate to the gardens.

Leicester Square, WC2

NEWTON

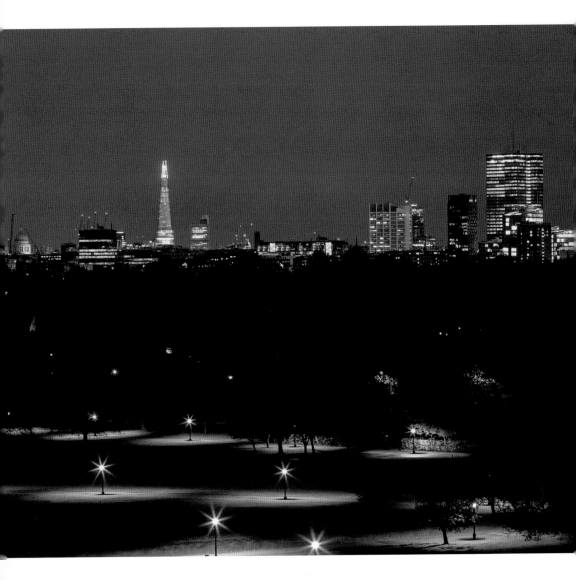

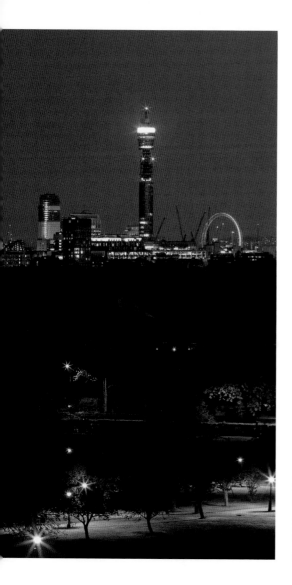

London Evening Skyline

The iconic London skyline viewed from the elevated position of Primrose Hill, on the northern side of Regent's Park.

Primrose Hill Road, NW3

Notting Hill Carnival

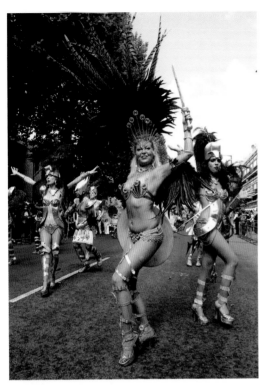

Left: With their extravagant costumes and floats, the participants in the Notting Hill Carnival create a 32km (20-mile) ribbon of vibrant colour, while over 40 static sound systems and hundreds of stalls selling Caribbean food make for a memorable party atmosphere.

Below: Drummers take part in the Notting Hill Carnival. The annual event was inaugurated in 1964 as a celebration of the diversity and colour of British Afro-Caribbean culture, taking place over the Sunday and Monday of the August Bank Holiday. The popular event has attracted as many as two million people, making it the second largest street festival in the world.

West London, W10 & W11

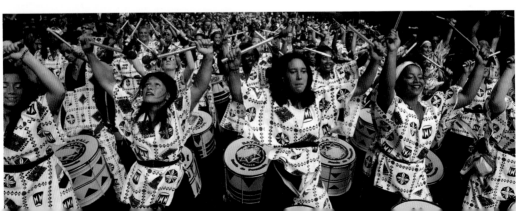

National Portrait Gallery

Carefully placed lighting highlights the architectural details of the National Portrait Gallery. Before the gallery was opened in 1896, the national portrait collection had been housed in a variety of locations across London. The collection's permanent home was built with funding of £80,000 from philanthropist William Henry Alexander, who chose the architect, Ewan Christian. Today, the gallery has a collection of 10,000 portraits in the form of paintings, drawings, sculptures, photographs and caricatures.

St Martin's Place, WC2

Highbury Fields

Heavy snow covers Highbury fields, north London. The 12-hectare (29-acre) site is surrounded by elegant Georgian and Victorian town houses, which are highly sought after. The park is the largest open space in Islington, and in addition to parkland it contains a number of recreational facilities, including tennis courts and a pool.

Highbury Place, N5

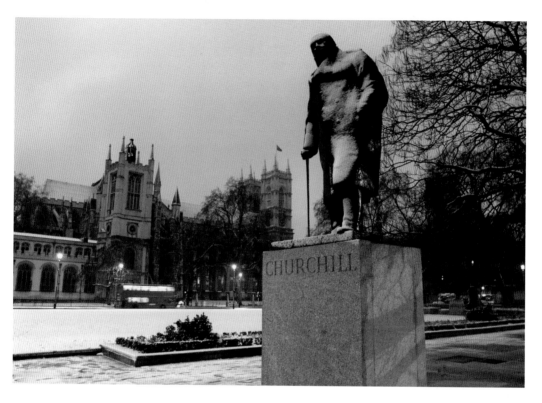

Statue of Winston Churchill

A dusting of snow highlights the contours of the statue of Sir Winston Churchill in Parliament Square. Unveiled by Lady Churchill in 1973, the 3.6m (12ft) bronze statue atop a 2.4m (8ft) granite pedestal was the work of Ivor Roberts-Jones. It depicts a brooding Churchill in military greatcoat during the period of his wartime premiership, and it was said that Lady Churchill did not like the piece.

Parliament Square, SW1

St James's Park and The Mall

In this aerial view looking toward the west, Admiralty Arch can be seen at the bottom of the picture, with The Mall stretching away from it towards the Victoria Memorial and Buckingham Palace. To the left of the Mall is St James's Park; Green Park and the corner of Hyde Park are also visible (*centre right*). The broad expanse of Horse Guards Parade (*front left*) is bordered on the southern side by the backs of the houses on Downing Street, on the other side of which are the Foreign Office and Treasury buildings. Beyond those is Westminster Abbey.

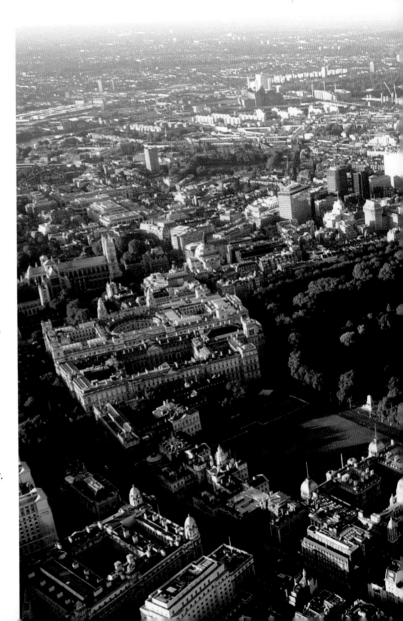

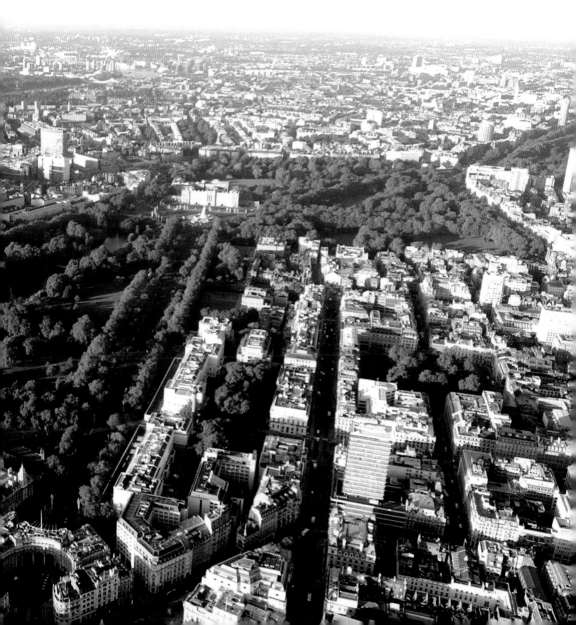

Temple Church

Located between Fleet Street and the River Thames, Temple church dates from the late 12th century and was built by the Knights Templar as their English headquarters. Noted for its effigy tombs and for being a round church, it was badly damaged by German bombing during the Second World War.

An elaborate stained-glass window in Temple Church. The church was featured in Dan Brown's popular novel, *The Da Vinci Code*, and used as a location in the film of the book.

Tudor Street, EC4

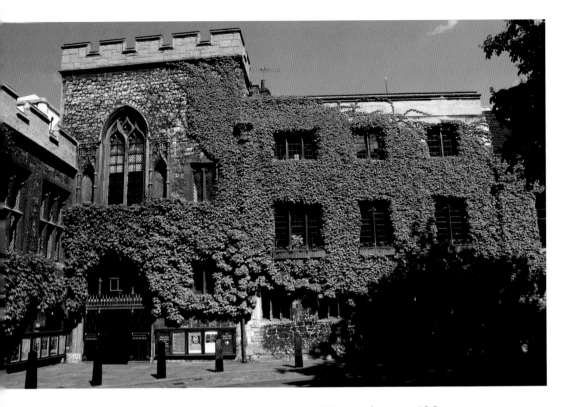

Chapter House, Westminster Abbey

The entrance to the 13th-century Chapter House, next to Westminster Abbey, a building that features in the popular book by author Dan Brown, *The Da Vinci Code*. Constructed between 1245 and 1253 in geometrical Gothic style, the building was restored in 1872 by Sir Gilbert Scott. Originally, the building was used by Benedictine monks for their daily meetings; subsequently, it was the meeting place of the King's Great Council and the Commons, forerunners of Parliament.

Westminster Abbey, Dean's Yard, SW1

Black Cab and Cabmen's Shelter

One of London's familiar black cabs passes a cabmen's shelter in Kensington Road. Known officially as hackney cabs, the vehicles are traditionally black, hence the name, although today other colours may be seen. Run by the Cabmen's Shelter Fund, the green wooden huts provide somewhere for cabbies to take a meal and refreshments without leaving their cabs. The fund was the idea of the Earl of Shaftesbury and was set up in 1875; 13 shelters remain in London.

Kensington Road, W8

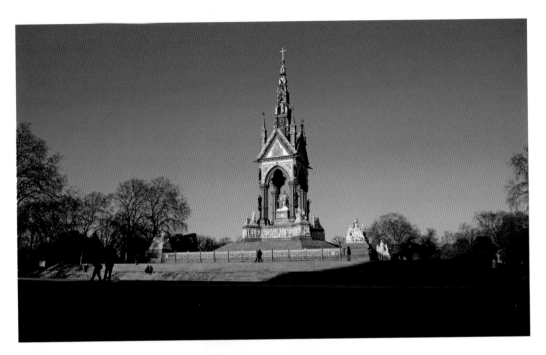

Albert Memorial

Above: Facing the Royal Albert Hall, the gilded statue of Prince Albert, Queen Victoria's husband, is seated beneath an ornate canopy. The memorial was designed by Sir George Gilbert Scott in the Gothic Revival style and opened in 1872, although it was not until 1875 that the statue was set in place.

Left: The statue in the Albert Memorial was the work of John Henry Foley, and it shows Prince Albert in the robes of a Garter Knight holding a catalogue from the Great Exhibition, which he helped organise. The memorial stands 54m (176ft) high.

Princes Square, W2

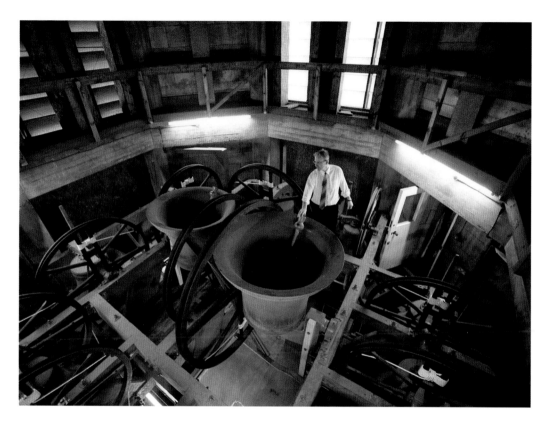

St Mary-le-Bow Church

The tower master of St Mary-le-Bow church positions the great Bow Bells before they are rung. The church was designed by Christopher Wren and completed in 1673, although its 68m (223ft) steeple was not finished until 1680. It is said that a true cockney must be born within earshot of the church's bells, which are also said to have persuaded Dick Whittington to return to London to become Lord Mayor; the bells were immortalised in the nursery rhyme *Oranges and Lemons*.

Bow Lane, EC4

Wembley Arena

Located opposite Wembley Stadium, Wembley Arena was built for the 1934 Olympic Games as a swimming venue, being known originally as the Empire Pool. The pool itself was used again for the 1948 London Olympics. Since then, the venue has been used primarily for music events. The 12,500-seat building is London's second largest indoor arena after the O2.

Arena Square, Wembley, Middlesex

Princess Diana Memorial

On a warm, sunny day in mid-March, people enjoy the weather around the Diana, Princess of Wales Memorial Fountain in Hyde Park. Although described as a fountain, it actually takes the form of an oval stream bed laid out on a gentle slope, so that water runs from the top to the bottom. Designed by American landscape artist Kathryn Gustafson, the water feature is shallow enough for wading. Built at a cost of £3.6m, the memorial was dogged initially by controversy and safety issues. The patches of green on the bottom are caused by rotting leaves blown into the water.

Hyde Park, W2

Richmond Park

Fallow deer bucks tussle with their juvenile horns in Richmond Park on the first day of spring. The park is home to herds of fallow and red deer, which number over 600.

Richmond, Surrey

Edgware

Right: A housing estate in Edgware makes concentric patterns on the ground.

Edgware, Middlesex

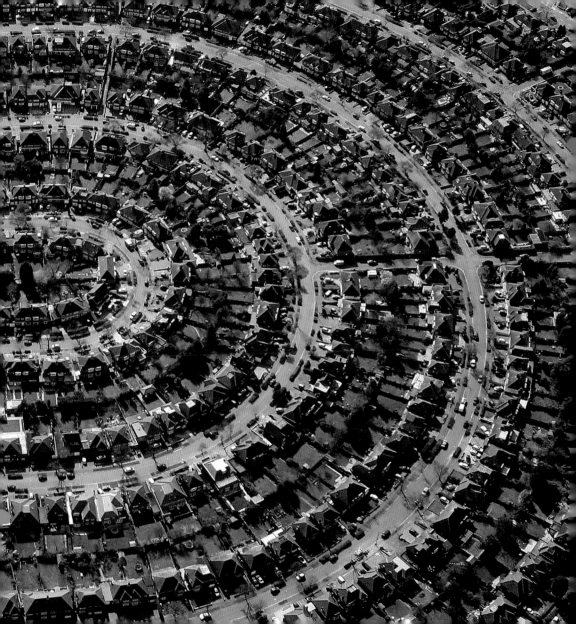

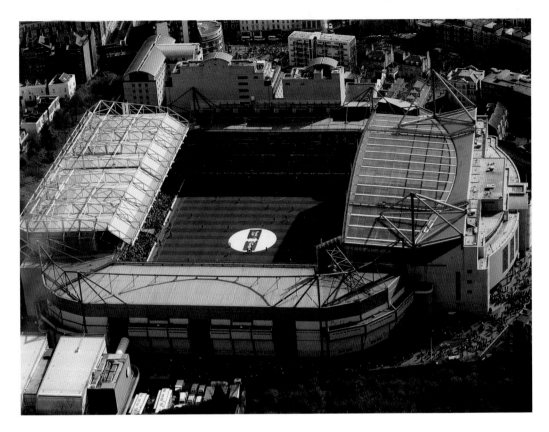

Stamford Bridge Football Stadium

Fans swarm around Chelsea Football Club's Stamford Bridge stadium for an FA Cup match. The roofed, 42,500-seat stadium was constructed in the early 1990s in response to the Football League's edict that all top-division clubs should have all-seater stadiums, following the Hillsborough disaster. It the 1980s, the pitch was surrounded by an electric fence to prevent invasions by fans, although it was short-lived and never used.

Fulham Road, SW6

Victoria Palace Theatre

Standing on the site of the former Royal Standard Music Hall, the Victoria Palace Theatre was designed by Frank Matcham, who incorporated an innovative sliding roof that could be opened to cool the auditorium during the summer. The theatre opened in 1911, offering mainly music-hall entertainment.

Victoria Street, SW1

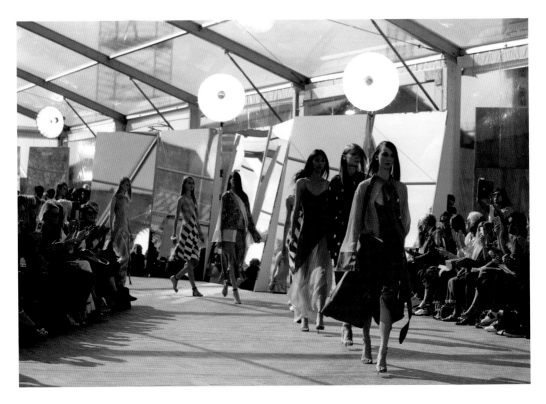

London Fashion Week

Models parade on the catwalk during the Jonathan Saunders Spring/
Summer 2015 London Fashion Week show at Lewis Cubitt Square
in King's Cross. Two fashion weeks are held each year in London at a
variety of venues, allowing British designers to showcase their spring/
summer and autumn/winter collections.

King's Cross, N1

London Palladium

Although the façade of the London Palladium is 19th century, having been part of Argyll House, the building itself dates from 1910 and was designed by prolific theatre architect Frank Matcham. The 2,286-seat theatre was associated with popular variety acts from the 1930s to the 1960s, and it provided the venue for the long-running television variety show *Sunday Night at the London Palladium*, which established compere Bruce Forsyth as a major TV personality.

Argyll Street, W1

Hampton Court Palace

Originally built for Cardinal Wolsey in the early 16th century, Hampton Court Palace was taken over by King Henry VIII when the cardinal fell out of favour. King William III commissioned a massive expansion programme in the following century in an attempt to rival Versailles in France. The work was never completed, however, leaving the palace a combination of Tudor and baroque architectural styles.

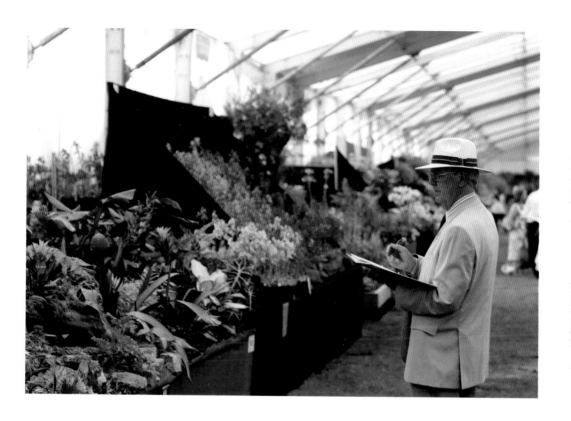

A judge inspects flowers at the Hampton Court Palace Flower Show. Organised by the Royal Horticultural Society, the annual show emphasises environmental issues and encourages visitors to grow their own produce. It is the second major national gardening show after the Chelsea Flower Show.

East Molesey, Surrey

Millbank Tower

In this aerial view looking eastward, the foreground is dominated by the Millbank Tower, headquarters of the Labour Party during its successful General Election campaign of 1997. Behind the tower is the Palace of Westminster and the clock tower of Big Ben, while on the opposite bank of the Thames is the London Eye. Several bridges are visible: Lambeth (foreground), Westminster, Hungerford and Waterloo.

Millbank, SW1P

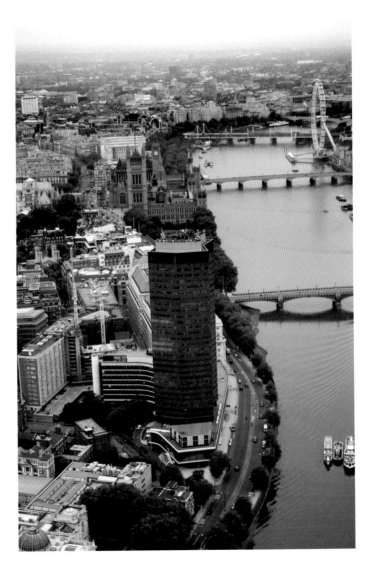

Lambeth Palace

Lambeth Palace seen from the Millbank Tower. The palace is the official London residence of the Archbishop of Canterbury and was acquired by the archbishopric around 1200. It stands on the south bank of the Thames, diagonally opposite the Palace of Westminster. A fig tree in the courtyard is thought to have been planted by Cardinal Pole in 1525.

Lambeth Palace Road, SE1

Royal Festival Hall

Built as part of the Festival of Britain, the Royal Festival Hall was opened in 1951 on the South Bank. In keeping with the festival's emphasis on a bright future, the building's architecture was unashamedly modernist. Since then, the façade has been modified with foyers and terraces, and the building underwent a two-year restoration between 2005 and 2007, during which changes were made to the 2,900-seat auditorium to improve the acoustics.

Belvedere Road, SE1

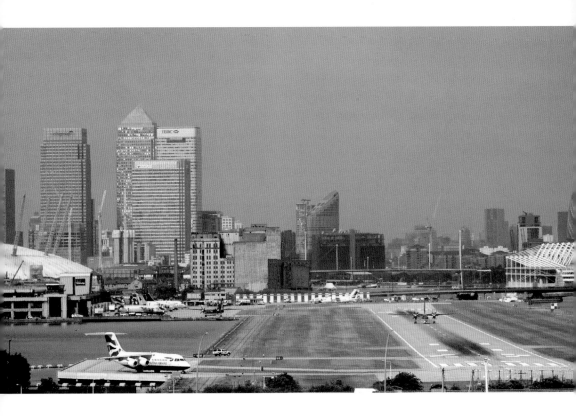

London City Airport

With a backdrop of tall buildings and the skyscrapers of Canary Wharf, London's City Airport appears dwarfed by its surroundings. Suitable for STOL (Short-Take-Off-and-Landing) aircraft only, the single-runway airport occupies a peninsular that separates the Royal Albert and King George V docks.

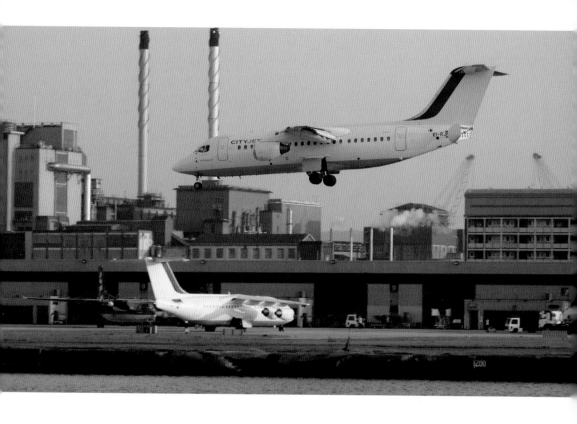

An Avro RJ85 of Irish airline CityJet lands at London City Airport in Docklands. The airport principally serves the financial district of London. Commercial flights began in October 1987, and today it is the 15th busiest airport in the UK.

Royal Docks, E16

Tate Modern

Left: The internationally renowned Tate Modern art gallery occupies the former Bankside Power Station, which closed in 1981. The gallery houses a collection of modern and contemporary art dating from 1900 onwards.

Right: The cavernous Turbine Hall of the former power station that now houses the Tate Modern art gallery. The Turbine Hall, which once contained electricity generators, is five storeys tall and is used for large, specially commissioned temporary exhibitions.

Park Street, SE1

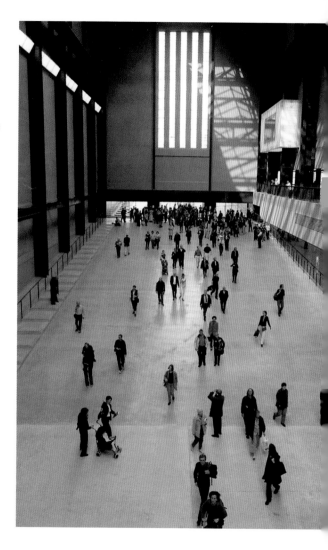

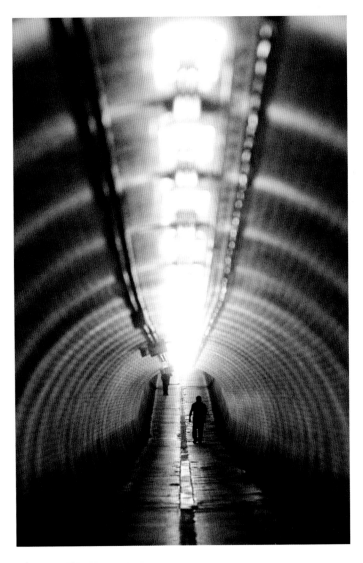

Woolwich Foot Tunnel

Opened in 1912, the Woolwich foot tunnel runs under the River Thames, linking Woolwich on the south bank with North Woolwich on the north bank. A similar tunnel nearby, running from Greenwich to the Isle of Dogs, was opened in 1902. Both pedestrian tunnels are reached by means of shafts containing lifts and stairs beneath buildings with glazed domes.

Ferry Road, SE18/Pier Road, E16

Gurdwara Sri Guru Singh Sabha

The largest Sikh temple in Europe, the Gurdwara Sri Guru Singh Sabha, was opened in 2003. Built at a cost of £17.5m, much of that donated by members of the local Sikh community, the Gurdwara serves the large Sikh population of Southall.

Havelock Road, Southall, Middlesex

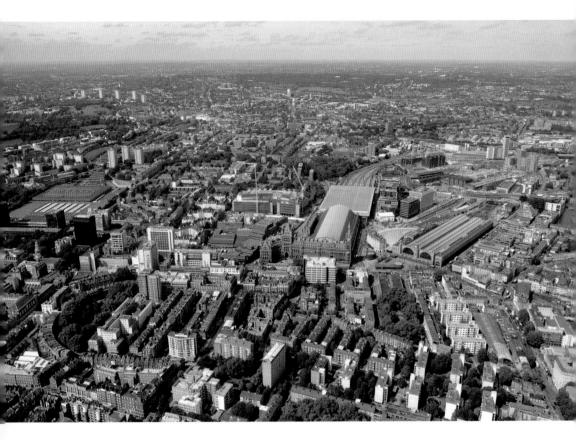

King's Cross, St Pancras and Euston Stations

Immediately to the west of King's Cross Station (*right*) lies St Pancras International (*centre*), the London terminus of Eurostar services to continental Europe. The two stations share King's Cross St Pancras tube station. The station is also a stone's throw north-east of Euston Station (*left*), the southern terminus for the West Coast Main Line.

N19 – NW1

King's Cross Station

A major London terminus, King's Cross station was opened in 1852. It is the southern terminus of the East Coast Main Line, which provides high speed inter-city services to Yorkshire, the North East and Scotland, and a terminus for Great Northern's commuter services to north London, Hertfordshire and Cambridgeshire. The station was designed by Lewis Cubitt, brother of Thomas Cubitt (architect of Bloomsbury, Belgravia and Osborne House), and Sir William Cubitt (chief engineer of The Crystal Palace and consulting engineer to the Great Northern and South Eastern Railways). The structure is based on two great arched train sheds, with a brick facade at the south end reflecting the main arches behind.

Euston Road, N19

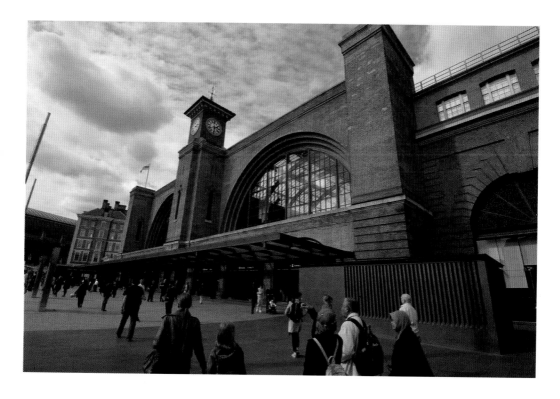

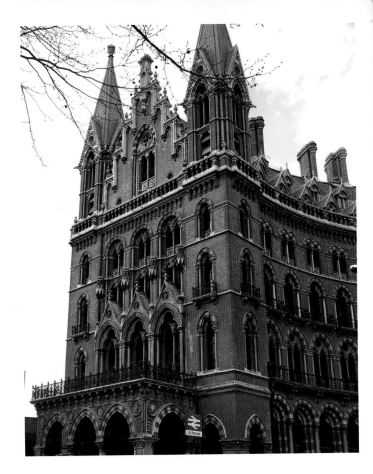

St Pancras Railway Station

St Pancras Station was constructed by the Midland Railway as its London terminus serving the Midlands and Yorkshire. Towering above the station, the former Midland Grand Hotel was built between 1868 (the year the station opened) and 1873. It was designed by Sir George Gilbert Scott and was the first hotel in London to have lifts (called 'ascending rooms').

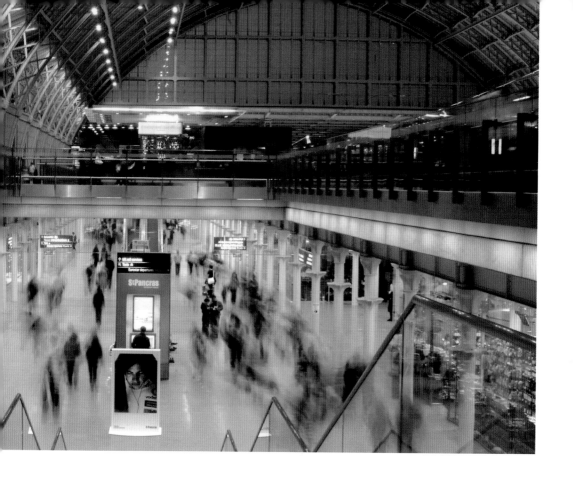

Above: The 19th-century Barlow train shed, along with the rest of the station, underwent an £800m renovation and expansion programme during the early part of the 21st century, and includes a split-level section, with Rendezvous on the upper platform level concourse, where Eurostar departs, and the Arcade below, formed of the undercroft and set beneath Victorian brick arches. The station was reopened officially as St Pancras International in November, 2007 by Queen Elizabeth.

Euston Road, NW1

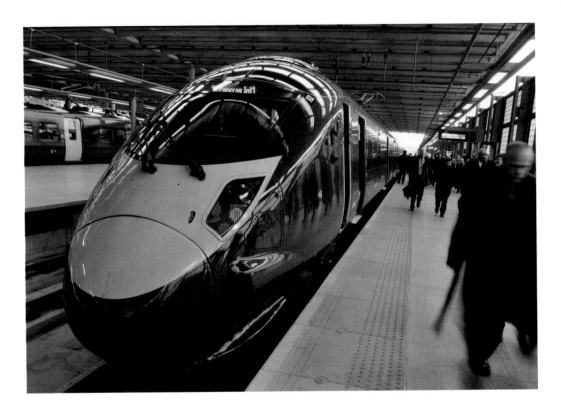

High-speed Javelin Train

Kent commuters arrive by high-speed Javelin train at St Pancras Station. The Javelin services were introduced in December 2009, the first train being named after double Olympic gold medallist Dame Kelly Holmes. Built in Japan, the trains are employed by Southeastern Rail on commuter lines and the high-speed channel tunnel rail link.

Eurostar Terminal

The entrance to the international Eurostar terminal at St Pancras station. Opened in 2007, the terminal provides a direct link to Paris Gare du Nord via the high-speed rail link to the Channel Tunnel. In addition, Eurostar trains are run daily to Brussels, while seasonal services are offered to the French Alps and Avignon.

Euston Road, NW1

New Bond Street

The Burberry Store on New Bond Street. For many years, the street was known for its upmarket art dealers and antiques shops. These were encouraged by the presence of the Fine Art Society and Sotheby's auction house. Today, however, many shops are occupied by premium fashion outlets.

New Bond Street, W1

Statue of Nelson Mandela

Unveiled in 2007, this bronze statue of former South African president Nelson Mandela joined those of other great leaders, Benjamin Disraeli, Abraham Lincoln and Winston Churchill, in Parliament Square. It was created by Ian Walters, who died shortly after its completion.

Parliament Square, SW1

London Fields Lido

Over 100 people take part in a bid to set a new Guinness World Record for the most people taking part in a synchronised swimming routine at London Fields Lido. The pool is the only heated outdoor 50m (164ft) swimming pool in London. It is set in parkland that also boasts a cricket pitch, a BMX track, tennis courts and children's play areas.

London Fields West Side, E8

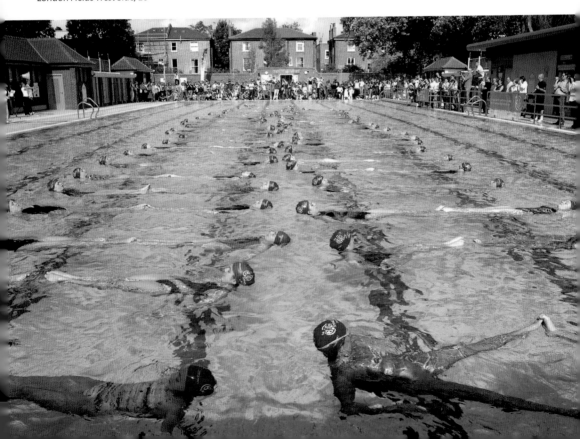

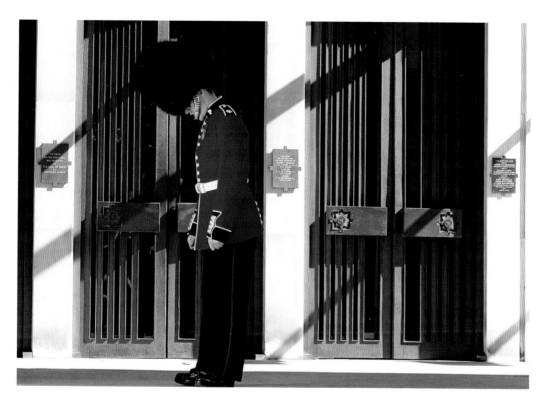

Guards Chapel

A guard stands with head bowed outside the Guards Chapel at Wellington Barracks. Known officially as the Royal Military Chapel, the building serves the Household Division, which is made up of the various Guards regiments. Built originally in 1838, the building was bombed during 1940–1 and suffered significant damage in 1944 when it was hit by a V1 flying bomb, which collapsed the roof on to the congregation, killing 121. In the 1960s, it was rebuilt in modern style.

Birdcage Walk, SW1

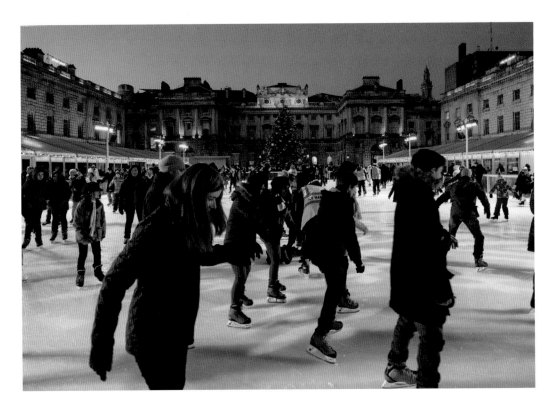

Somerset House Ice Rink

Ice skaters on the skating rink at Somerset House in central London, which is open from 11 November to 11 January. An outstanding neoclassical building, Somerset House was created by the architect Sir William Chambers. Used by various learned societies and government offices since its construction in the late 18th century, Somerset House today is a centre for the visual arts.

Strand, WC2

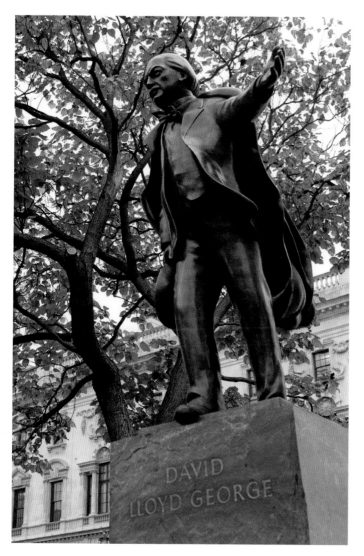

Statue of David Lloyd George

Unveiled in 2007, this statue of David Lloyd George was erected in Parliament Square, Westminster. The Welsh politician, popularly known as the 'Welsh Wizard', was Prime Minister between 1916 and 1922 and, as such, directed Britain's war effort during the First World War. Considered a great statesman by many, nevertheless others have criticised him for leaving a legacy of violence in the Middle East.

Parliament Square, SW1

St James's Park

The striking yellow and orange colours of autumn foliage are reflected in the still water of the lake in St James's Park as gulls circle above.

Horse Guards Road, SW1

Foundling Museum

A white marble statue entitled *Peasant Boy,* from the British School, stands at the bottom of the central stairwell at the Foundling Museum, with John Opie's portrait of Sir Thomas Bernard (governor 1787–1806) in the background. Originally created as a home for abandoned children by Thomas Coram, the Foundling Hospital became London's first public gallery, thanks to the inspiration of William Hogarth, one of the Foundling's governors.

Brunswick Square, WC1

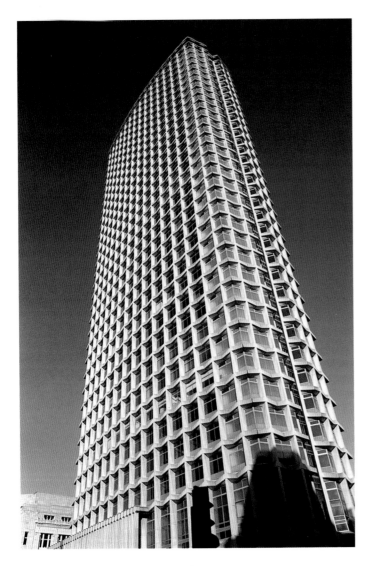

Centre Point

Standing on the site of a former gallows, the 32-storey Centre Point was completed in 1966 and was one of London's first skyscrapers. It was built for property tycoon Harry Hyams, who kept it empty for many years in the hope that he could find a single tenant, and it soon became a symbol of greed in the property business. Eventually, Hyams was forced to relent and let the building on a floor-by-floor basis. From 1980 to 2014, the building was the headquarters of the Confederation of British Industry. In 2015 work began to convert the property into luxury flats.

New Oxford Street, WC1

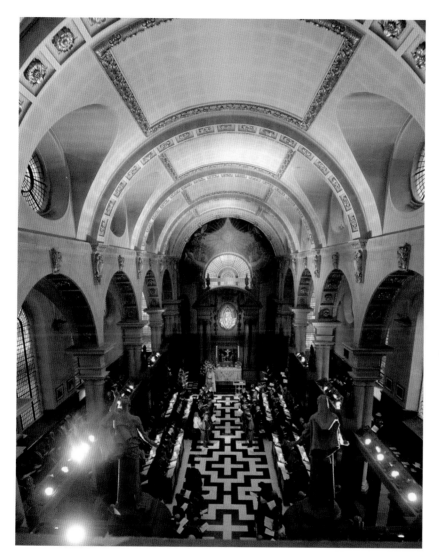

St Bride's Church

A service of thanksgiving, attended by Queen Elizabeth and Prince Philip, takes place in St Bride's Church to mark the 50th anniversary of its rededication. The church is in Fleet Street, once the home of most major British newspapers, and the congregation of hundreds included press barons, journalists and photographers. The building, which dates to 1672, was designed by Christopher Wren.

Fleet Street, EC4

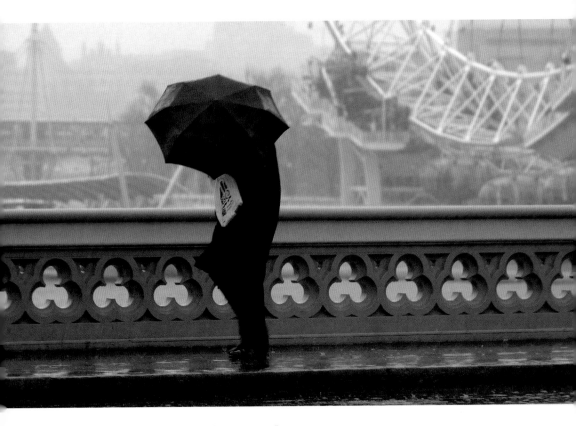

Rainy Weather

A man battles to hold on to his umbrella in the wind on Westminster Bridge, as heavy rain sweeps central London. In the murky background can be seen the framework and passenger pods of the London Eye.

Westminster Bridge, SW1

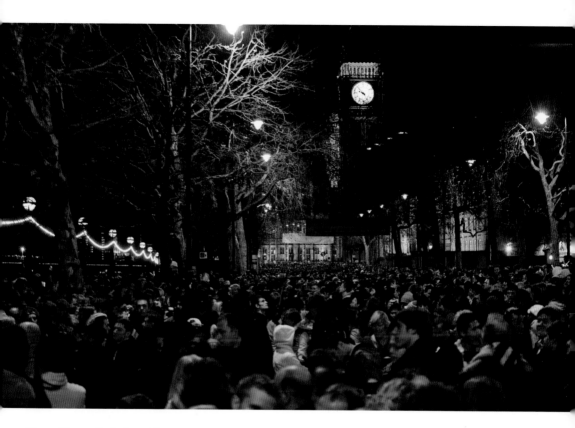

New Year Celebrations

With the clock of Big Ben in the background, crowds gather on the Embankment to see in the New Year. Across the Thames, on the south bank, the London Eye will become the focus of a massive firework display at the striking of midnight.

Embankment, WC2

Clapham Junction

A train heads towards Clapham Junction station in south London. The
station, which dates from 1863, is the busiest rail interchange in the
UK. Clapham Junction is actually in Battersea, but when it was built,
the area was considered poor, while Clapham just to the east was more
fashionable. Wanting to attract middle- and upper-class passengers,
the railway companies opted for the grander of the two names.

Clapham Junction, SW11

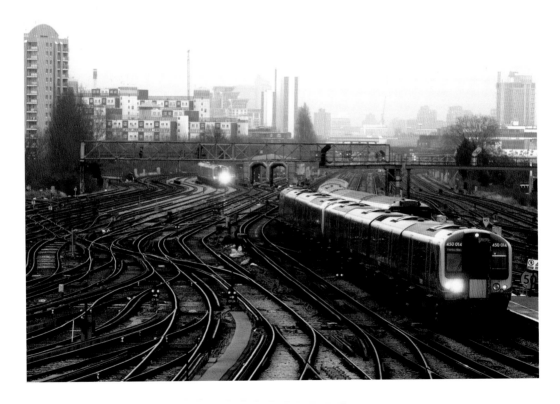

White Hart Lane Football Stadium

Tottenham Hotspur players celebrate victory at the final whistle as the scoreboard shows the final score in their match against Arsenal. Built originally in 1899 on the site of a disused nursery, the stadium was progressively renovated and enlarged throughout the 20th century, and today has a capacity of just over 36,000. In 2009, however, the club submitted plans to redevelop the site with a new 61,000-seat stadium.

White Hart Lane, N17

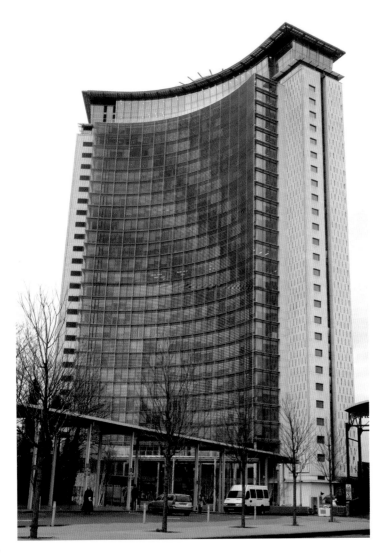

Empress State Building

Built in 1961 and renovated in 2003, the 30-storey Empress State Building is 117m (385ft) high. Today, it is occupied by the Metropolitan Police. The building is named after the Empress Hall, which originally stood on the site. A private revolving bar at the top provides panoramic views of the city.

Lillie Road, SW6

Oxo Tower

Built in the late 1920s as part of an Art Deco refurbishment of a cold store owned by the Liebig Extract of Meat Company, the manufacturer of Oxo stock cubes, the Oxo Tower was intended by the architect, Albert Moore, to carry illuminated advertising signs. However, planning permission for these was denied. In response, Moore incorporated a vertical set of windows on each side in the shape of a circle, a cross and a circle. In the 1990s, the tower and former cold store were refurbished to include housing, shops, a restaurant and an exhibition space.

Barge House Street, SE1

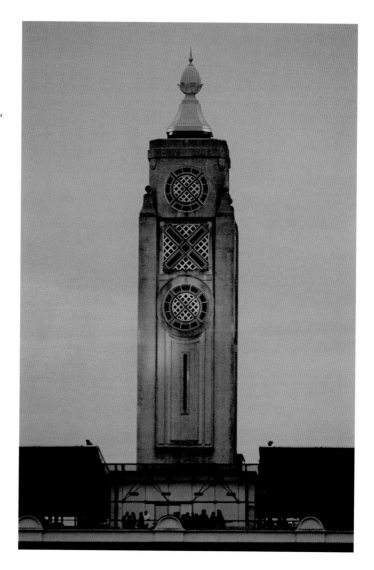

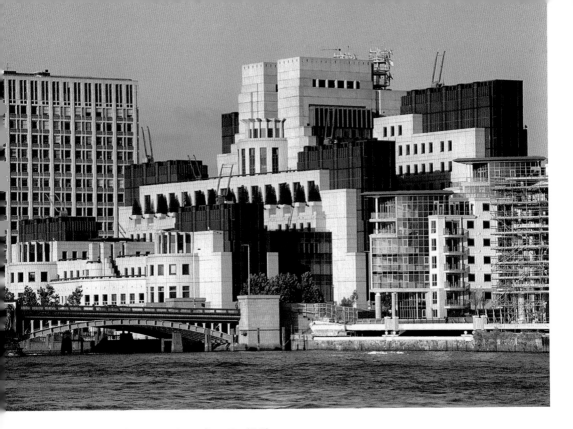

Secret Intelligence Service Building

Above and right: Known popularly as 'Legoland' by those who work in the building, and also 'Babylon-on-Thames', due to its resemblance to an ancient Babylonian ziggurat, the eye-catching building was built in the early 1990s and incorporates many classified features to protect the foreign-intelligence-gathering agency. On 20 September 2000, the building received superficial damage during a rocket attack.

Albert Embankment, SE1

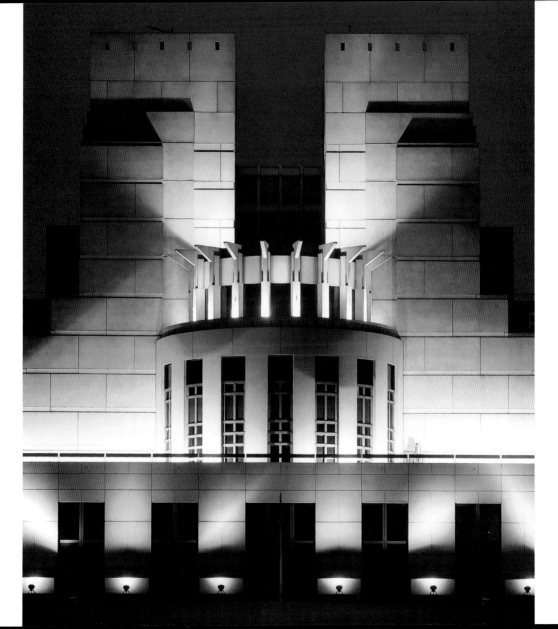

Bazalgette Memorial

A memorial to the 19th-century English civil engineer Joseph Bazalgette, who was chief engineer of London's Metropolitan Board of Works. In response to the 'Great Stink' of 1858, Bazalgette developed a sewer network for central London that helped free the city of cholera epidemics by preventing contamination of drinking water, and initiated the cleansing of the Thames by discharging the sewage much further downstream.

Victoria Embankment, WC2

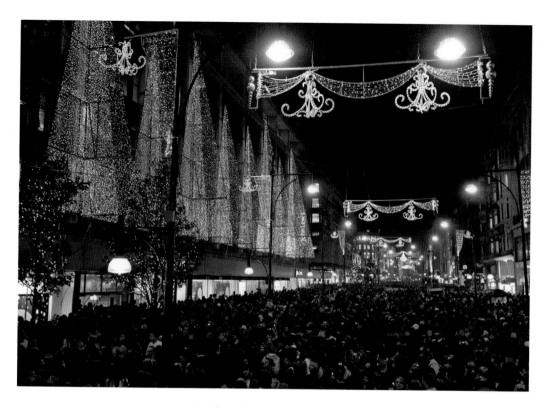

Oxford Street Lights

To the appreciation of the expectant crowd, the Oxford Street Christmas lights are switched on. The tradition dates back to 1959, although neighbouring Regent Street had already introduced such festive displays five years before. The lights are switched on by a celebrity in late November and remain illuminated until 6 January.

Oxford Street, W1

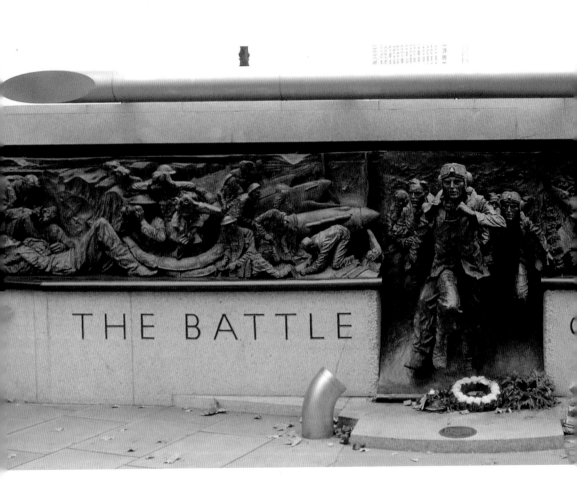

THE BATTLE

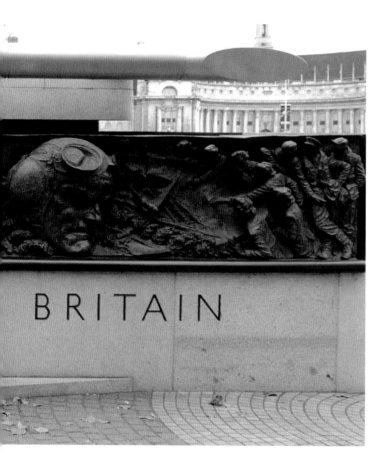

Battle of Britain Memorial

The striking Battle of Britain Memorial on Victoria Embankment. Unveiled by the Prince of Wales in 2005 to commemorate the 65th anniversary of the famous air battle, the bronze relief was created by Paul Day. It carries the names of the 2,953 aircrew from 16 different countries who fought in the conflict between 10 July and 31 October, 1940 – a battle that proved a turning point by thwarting German invasion plans.

Victoria Embankment, WC2

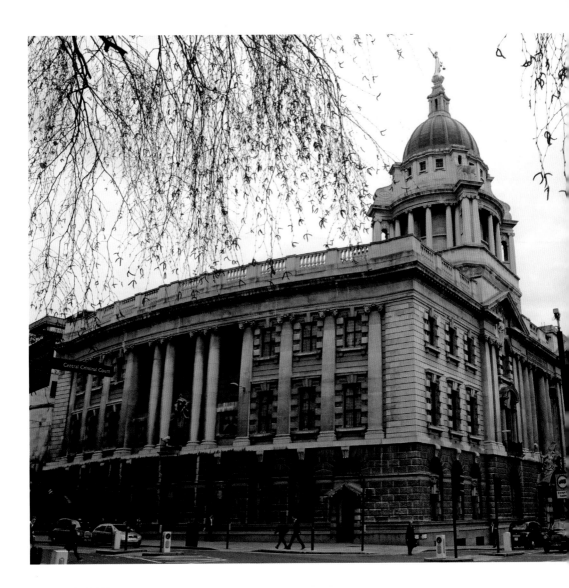

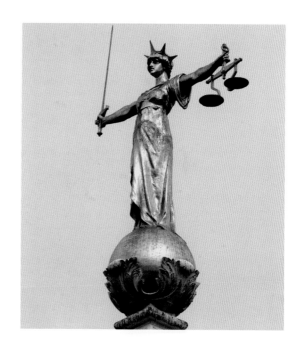

Old Bailey

Built on the site of the notorious Newgate Prison, the Central Criminal Court is commonly known as the Old Bailey, from the street in which it stands. It deals with major criminal cases from the Greater London area. The present building was opened officially in 1907, and inscribed above the main entrance is the legend, "Defend the Children of the Poor & Punish the Wrongdoer". The domed roof above the court bears the golden statue of Lady Justice, the work of the sculptor Frederick William Pomeroy. The figure holds a sword in her right hand and the scales of justice in her left.

Old Bailey, EC4

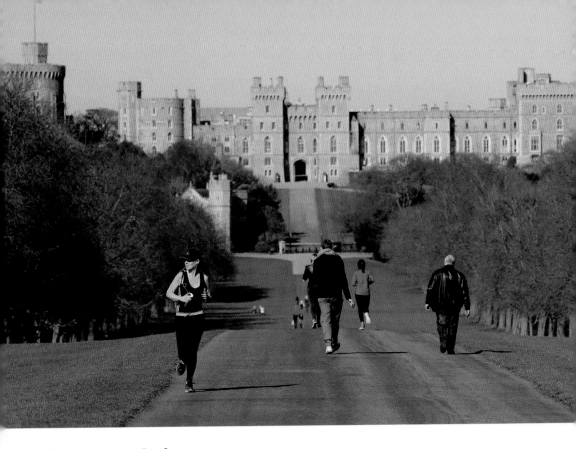

Windsor Great Park

Joggers and pedestrians make their way along The Long Walk against a backdrop of Windsor Castle. The walk, which is over 4km (2½ miles) long, stretches through Windsor Great Park, from the George IV gateway of the castle south to the mounted statue of George III atop Snow Hill. The hill affords impressive views of the castle itself.

Windsor Great Park, Windsor, Berkshire

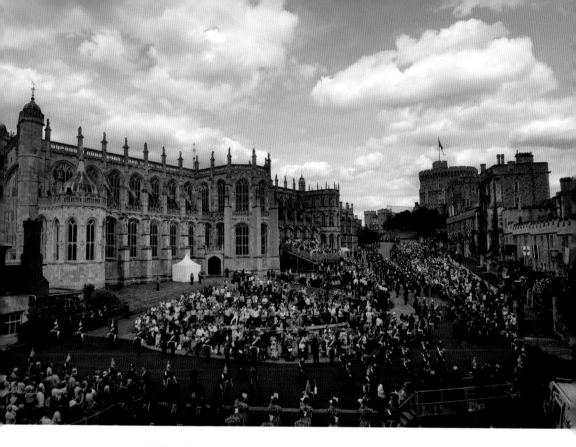

Windsor Castle

The annual procession for members of the Order of the Garter, ahead of the service at St George's Chapel, Windsor Castle. The largest inhabited castle in the world, Windsor Castle dates to the time of William the Conqueror and has been continuously occupied since then. With Buckingham Palace and Holyrood Palace in Edinburgh, it is one of the three principal residences of Queen Elizabeth.

Windsor, Berkshire

Bank of England

The imposing edifice of the Bank of England, sometimes known as the 'Old Lady of Threadneedle Street'. The bank was established in its current location in 1734, having moved from Walbrook. The present structure was designed by Sir Herbert Baker in the 1900s to replace Sir John Soane's earlier building, described by Nikolaus Pevsner as: "The greatest architectural crime, in the City of London, of the twentieth century."

Threadneedle Street, EC2

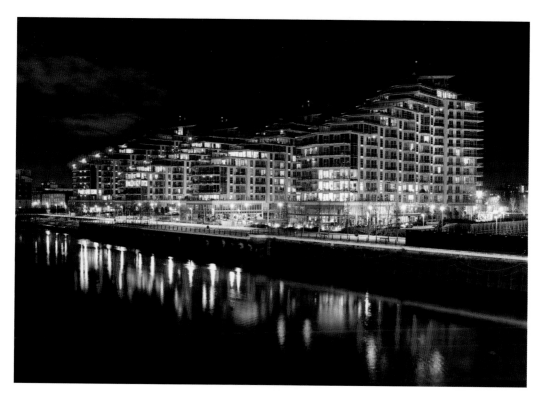

Riverside Living

A dramatic collection of apartment blocks at Battersea Reach on the south bank of the River Thames. Built on a brownfield site, the former location for a gin distillery, an oil depot and warehousing, the development now provides luxurious riverside accommodation for a thriving new community.

Battersea Reach, SW18

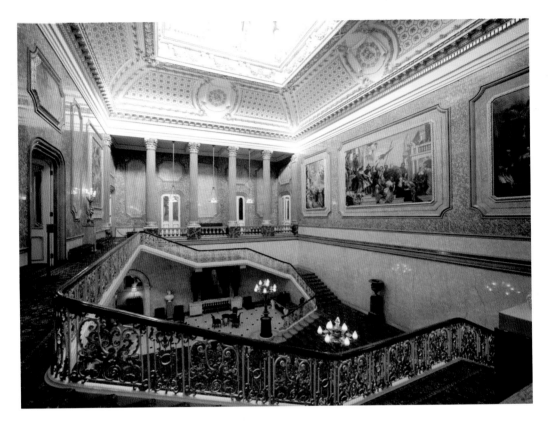

Lancaster House

The impressive entrance hall and staircase of Lancaster House, which is used by the Foreign and Commonwealth Office for high-level functions. The mansion was built for the Duke of York and Albany in 1825 and originally named York House. In 1912, Sir William Lever bought it and renamed it in honour of his home county, Lancashire.

St James's, SW1

Wellcome Collection

A man looks at an exhibit showing a piece of kidney with a knife wound in the 'Forensics: The Anatomy of Crime' exhibition at the Wellcome Collection in Euston. The museum displays an unusual mixture of medical artefacts and original artworks, exploring connections between medicine, life and art, in the past, present and future. Founded in 2007, the Collection attracts over 500,000 visitors annually, and describes itself as, "The free destination for the incurably curious."

Euston Road, NW1

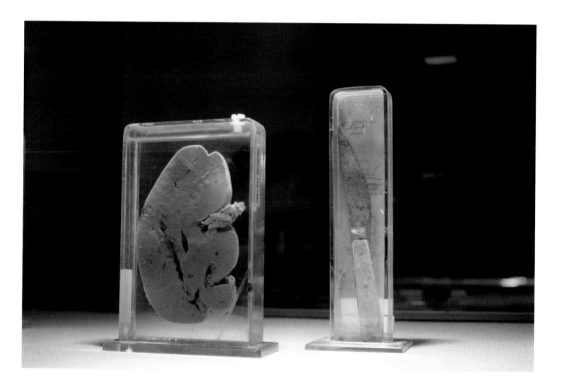

Horse Guard

A trooper of the Life Guards on sentry duty at the entrance of the Horse Guards building. The guard is mounted daily, with a final inspection carried out at 4pm every day, which originates from a time when Queen Victoria passed through the entrance and saw that no guard was present: the troopers were all drunk. Consequently, she ordered that the entire guard parade each day at 4pm for the next 100 years. Although that time limit has expired, the tradition remains. The Life Guards are a ceremonial cavalry unit, part of the Household Cavalry with the Blues and Royals.

Horse Guards Parade, Whitehall, SW1

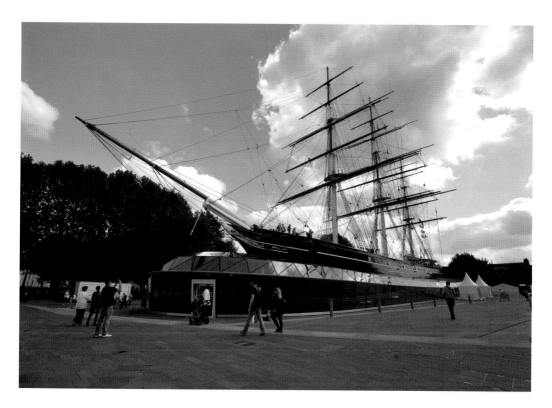

Cutty Sark

One of the last tea clippers, and one of the fastest, *Cutty Sark* was built on the Clyde in 1869 for the Jock Willis Shipping Line. She came at a time when sailing ships gave way to steam propulsion and placed in permanent dry dock at Greenwich in 1954, where she became a popular tourist attraction. Sadly damaged by fire in May 2007, while undergoing conservation, she was restored and reopened to the public in April 2012. As part of the restoration work, the ship was raised 3m (10ft) and a state of the art museum space constructed beneath, which allows visitors to view her from below.

King William Walk, SE10

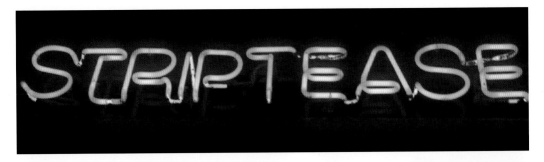

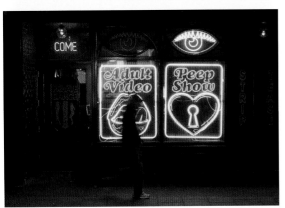

Soho

Once notorious for sleazy strip clubs and sex shops, Soho today is slightly more respectable, with many upmarket restaurants and media offices. It is also a centre for London's gay community. Some of its old 'attractions' remain, however, as the neon signs indicate.

Soho W1

Carnaby Street

The sign indicating one of London's most famous streets. Carnaby Street, Soho, came to fame during the 'Swinging Sixties', when it was home to a large number of leading fashion boutiques, including Mary Quant and Sally Tuffin. It epitomised the youthful London scene. Today, the pedestrianised street continues to meet the needs of the fashion conscious.

Carnaby Street, W1

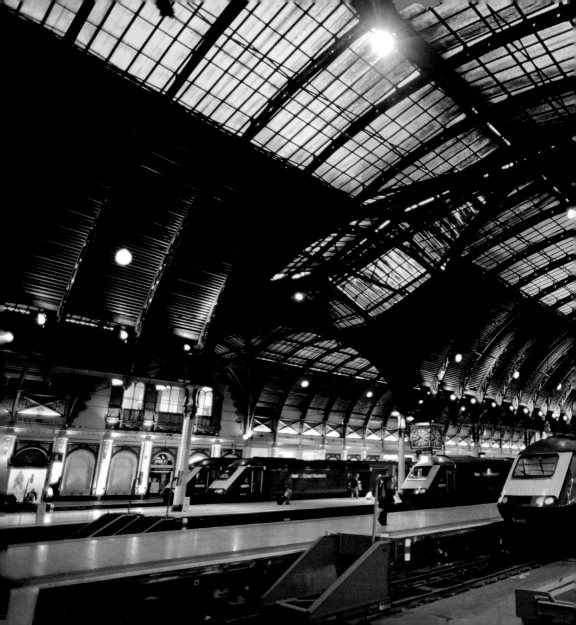

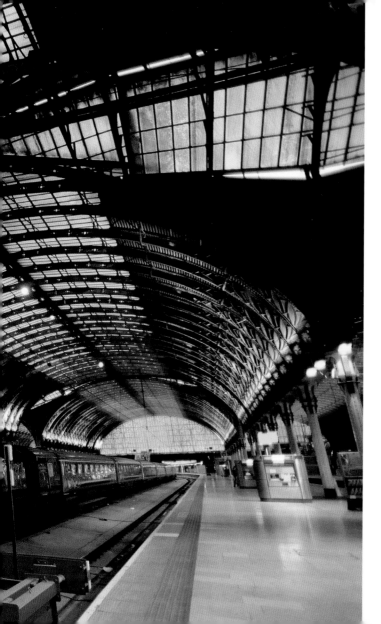

Paddington Railway Station

The train shed of Paddington Railway Station in west London. The first station on the site was built in 1838, and much of the existing mainline structure dates from 1854, having been designed by Isambard Kingdom Brunel for the Great Western Railway. The world's first underground railway, the Metropolitan, arrived at Paddington in 1863, the station serving as its western terminus.

Praed Street, W2

Christ Church Spitalfields

Designed by architect Nicholas Hawksmoor, Christ Church, Spitalfields is known as a 'Commissioners' Church', having been built at the instruction of the Commission for Building Fifty New Churches between 1714 and 1729. At the time, the commission had been tasked with acquiring sites and constructing churches to meet the needs of London's new settlements. Christ Church was one of the first to be opened, and it is considered to be one of the finest of its kind.

Commercial Street, E1

Statue of Lord Byron

R.C. Belt's statue of Lord Byron at Hyde Park Corner, which was unveiled in 1881. Byron, one of the great English poets and a leading figure in Romanticism, became ill and died while fighting for Greek independence from the Ottoman Empire in Greece in 1824.

Hyde Park Corner, W1

London Hilton on Park Lane Hotel

The looming tower of the London Hilton on Park Lane hotel. Built in 1963, the hotel has 28 storeys and 450 rooms, and for many it is an obtrusive eyesore that ruins the ambience of Hyde Park. Among its detractors is Queen Elizabeth, whose garden at Buckingham Palace is overlooked by the hotel.

Park Lane, W1

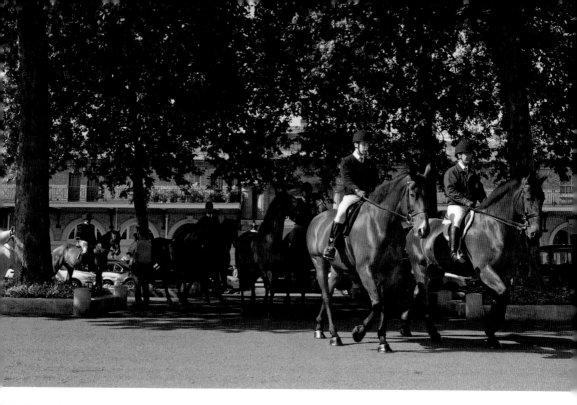

Royal Mews

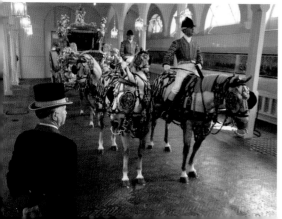

Royal carriage horses are exercised by being ridden around the Royal Mews in the grounds of Buckingham Palace. The mews were established by King George III, but the present buildings, designed by John Nash, were not completed until 1825. The Royal Mews contain the Gold State Coach and other carriages, and are open to the public on selected days.

Buckingham Palace Road, SW1

Forum

The Forum, in Kentish Town, north London, began life in 1934 as an Art Deco cinema, re-emerged as a bingo hall and then an Irish dance hall. In the 1980s it became The Town & Country Club: one of the must-play live music venues on the indie circuit for up and coming bands and established names alike. Mean Fiddler took over in 1993 and restored its original name. In 2007, MAMA & Company purchased The Forum and spent £1.5 million refurbishing it, increasing capacity to 2,300. It has standing downstairs and benched seating on the upper balcony, or can have a fully seated layout for certain shows.

Highgate Road, NW5

Fortnum & Mason

William Fortnum and Hugh Mason established their store on Piccadilly in 1707, selling high-quality and luxury food. It is also famous for its tearoom and its picnic hampers. Fortnum & Mason created the scotch egg in 1851, and in 1886 became the first store in Britain to stock Heinz Baked Beans.

Piccadilly, W1

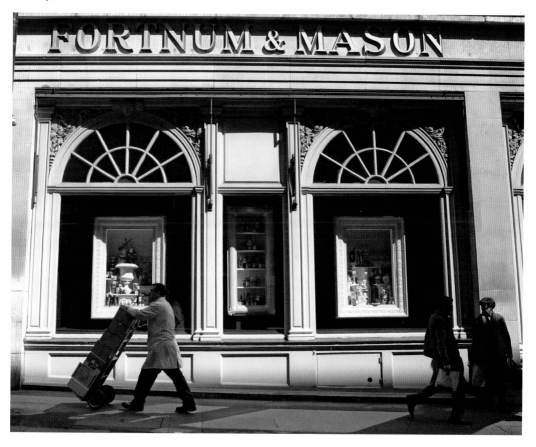

Euston Tower

Rising to a height of 124m (407ft), the 36-floor Euston Tower became famous among Londoners for being the home of Capital Radio, from 1973 to 1997. Today, it is occupied by a number of businesses and a branch of HM Revenue and Customs.

Euston Road, NW1

British Telecom Tower

Rising above central London, the BT Tower is a unique feature of the skyline. It was built originally for the Post Office, when that organisation was responsible for the telephone system in the UK, to carry microwave aerials and other telecommunications equipment. Above the aerial dishes was a revolving restaurant, operated by Butlins, but this was closed in 1980 and there is no longer any public access to the building. In total, including the aerial rigging at the top, it stands 188m (620ft) high.

Cleveland Street, W1

Women of World War II Memorial

Situated in Whitehall, the National Monument to the Women of World
War II is the work of John W. Mills. It was dedicated by Queen Elizabeth
on 9 July 2005. The sculpture incorporates 17 sets of clothing to
symbolise the hundreds of jobs taken on by women during the war
and given back by them when the men returned from the forces.

Whitehall, SW1

Royal College of Music

The Royal College of Music in South Kensington, central London. Founded in 1882, the college moved to its current building in 1894. In red brick dressed with buff Welden stone, it was designed by Sir Arthur Blomfield in Flemish Mannerist style. The college teaches all aspects of Western classical music from undergraduate to doctorate level.

Prince Consort Road, SW7

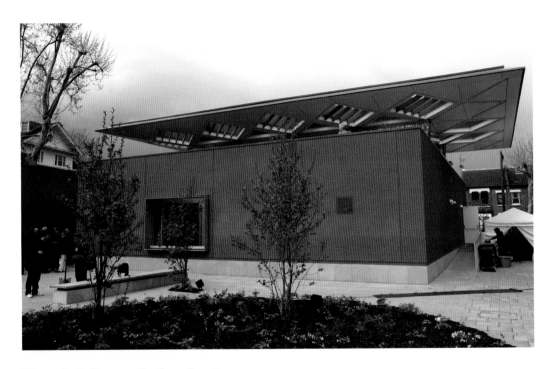

Maggie's Cancer Caring Centre

Designed by architect Richard Rogers, the Maggie's Cancer Caring Centre at Charing Cross Hospital is the first such facility to open outside Scotland. The centre is open to anyone in London affected by cancer in any way. Among the forms of support it offers are counselling, and information on treatment and nutrition.

Charing Cross Hospital, Fulham Palace Road, W6

Pavement Artists

Two pavement artists create a 3D chalk drawing depicting an elephants' graveyard at the entrance to the world's biggest antique market on Portobello Road, in a bid to convince shoppers not to buy ivory trinkets. The market is a major European source of ivory items, not all of them genuinely old.

Portobello Road, W11

Cavalry Memorial

Wreaths are arranged on the Cavalry Memorial in Hyde Park, following the Combined Cavalry Old Comrades Association annual parade. The memorial honours members of the British and Empire cavalry regiments who lost their lives during the First and Second World Wars, and subsequent conflicts.

Hyde Park, W1

Chelsea Physic Garden

Established as a garden for medicinal herbs and plants by the Society of Apothecaries in 1673, the Chelsea Physic Garden is the second oldest botanical garden in Britain; 'Physic' is an archaic term for the science of healing. It contains the largest fruiting olive tree in Britain as well the oldest garden in England devoted to alpine plants.

Royal Hospital Road, SW3

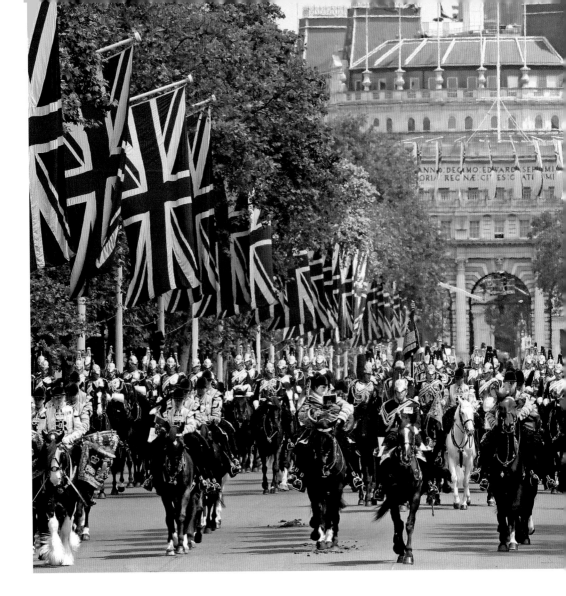

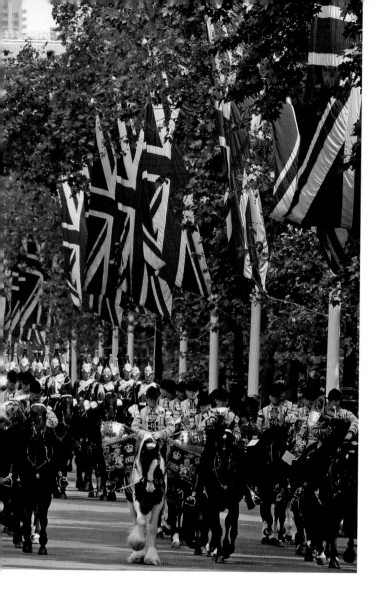

The Mall

Troops from the Household Cavalry march along The Mall to Buckingham Palace, following the annual Trooping the Colour ceremony at Horse Guards Parade, Whitehall. The Mall, which links the palace with Trafalgar Square, was created as a ceremonial route in the early 20th century. It is closed to traffic on Sundays, Bank Holidays and ceremonial occasions.

The Mall, SW1

Tate Britain

The entrance to Tate Britain, situated on Millbank. Opened in 1897 on the site of the former Millbank Prison, the gallery is the oldest in the Tate network and is dedicated to British art. It houses a large collection of the works of J.M.W. Turner.

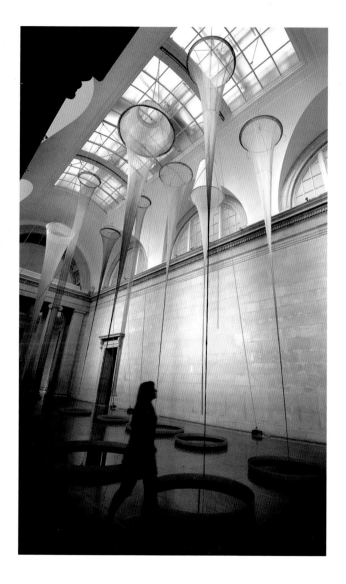

Tate Britain Commission

Part of an installation by artist Christina Mackie, inspired by a fascination with pigments and colour. It was created for the annual Tate Britain Commission 2015, at the Tate Britain gallery.

Millbank, SW1

Savoy Hotel

Built by Richard D'Oyly Carte with the profits from his Gilbert and
Sullivan Operas, the Savoy hotel opened in 1889. It was the first hotel
in the UK to have electric lighting throughout, electric lifts, and hot and
cold running water in all rooms. It was managed initially by César Ritz,
with Auguste Escoffier as head chef.

Strand, WC2

Connaught Hotel

The Connaught hotel in Mayfair first opened its doors in 1815, originally as the Prince of Saxe-Coburg, but the name was changed during the First World War because of its German connotations (Saxe-Coburg and Gotha was the family name of the Royal family). The Connaught was chosen to honour Queen Victoria's third son, Prince Arthur, the first Duke of Connaught.

Carlos Place, W1

Browns Hotel

Opened originally in 1837, Browns hotel was bought by the Ford family in 1859, and under the direction of Henry Ford, fixed baths, electric lighting and a lift were installed, as was the first public dining room in London. In 1876, Alexander Graham Bell stayed at the hotel, where he demonstrated his new invention, the telephone. Over the years, the hotel has been home to exiled royalty and has accommodated a number of celebrities, including Rudyard Kipling and Agatha Christie.

Albemarle Street, W1

Allotments

Even in the city, there are green spaces where people can relax and even grow their own produce, such as these allotments at Fulham Palace Meadows. A gift from the Bishop of London in 1916, the land by the River Thames has over 400 plots and includes an Anglo-Saxon site of historical importance, ensuring its protection from development.

Bishops Park, SW6

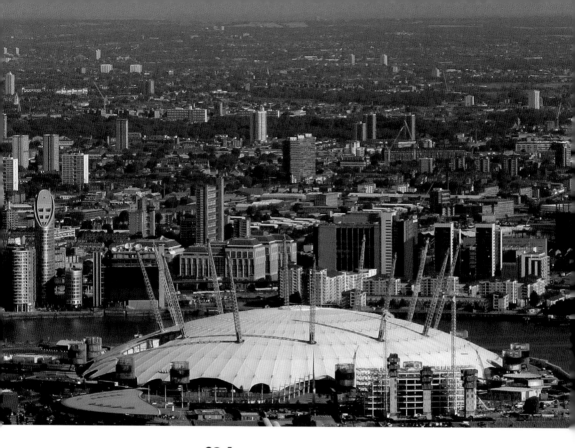

O2 Arena

The O2 Arena, formerly the Millennium Dome, in Greenwich, is the focal point of this view that stretches to the north, across Newham to Redbridge and Waltham Forest, and on to the very edge of London. The O2 was intended as a temporary structure to celebrate the Millennium, but it has since found a role as a performance venue.

O2 Arena, Peninsula Square, SE10

National Archives

An executive agency of the Department for Culture, Media and Sport of the United Kingdom, the National Archives contains "1,000 years of history from Domesday Book to the present". Records consist of parchment and paper scrolls through to digital files. Entrance is free to anyone 16 years or older, and original documents can be accessed on production of two proofs of identity. Based in Kew, south-west London, close to Kew Gardens tube station, the building was opened in 1977 as an additional home for the public records, which were held at Chancery Lane, in the City of London.

Kew, Richmond, Surrey, TW9 4DU

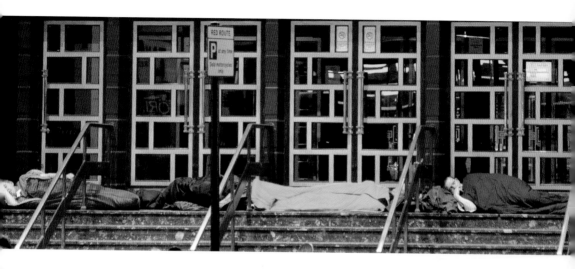

Rough Sleepers

Homeless men sleep on the steps of a London theatre. Like any large city, London has a significant population of homeless people, estimated at over 3,000 in 2008. Despite the fact that there are many charitable organisations that provide support, the problem seems set to continue.

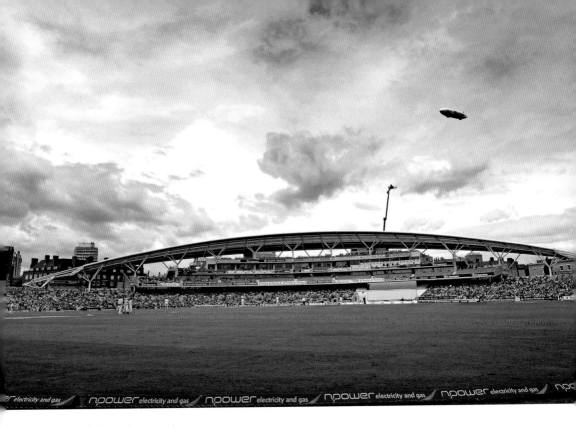

Oval Cricket Ground

Against the backdrop of a cloudy sky, an airship flies over the Oval
Cricket Ground during a Test match. The Oval is home to Surrey
County Cricket Club, which took a lease on the ground in 1845, and
traditionally it is the venue for the final Test match of each season.
The sweeping four-tier grandstand was completed at the Vauxhall
End in 2005, increasing the ground's crowd capacity to 23,000.

The great skeletal framework of a gasometer looms over the Oval Cricket Ground as Surrey takes on Middlesex. The ground is on the site of a former market garden. It was the venue for the first game played by a foreign side in England when it hosted the 1868 Aboriginal cricket tour.

Kennington Oval, SE11

St James's Park

On a warm day in August, St James's Park is a green oasis among the buildings of the city. Basking on their favourite rocks in the lake are the resident pelicans; there has been a tradition of keeping pelicans in the park since 1664, when the Russian Ambassador presented some as a gift. They are friendly creatures, often choosing to sit among visitors.

Horse Guards Road, SW1

Brockwell Lido

A lifeguard keeps a watchful eye on swimmers enjoying the pool at the lido in Brockwell Park, Herne Hill, south London. The lido was opened in 1937, but was closed as a cost saving measure by the local council in 1990. After a campaign by a local lobby group, it was reopened in 1994 and has since undergone a £2.5m redevelopment programme.

Dulwich Road, SE24

Earl's Court Underground Station

The Warwick Road entrance of Earl's Court Underground Station, which was completed in 1937 in the modern brick and glass style employed by London Transport at the time. The station had been established originally in 1871, with a main entrance on Earls Court Road. It was the first station on the Underground to be equipped with escalators.

Warwick Road, SW5

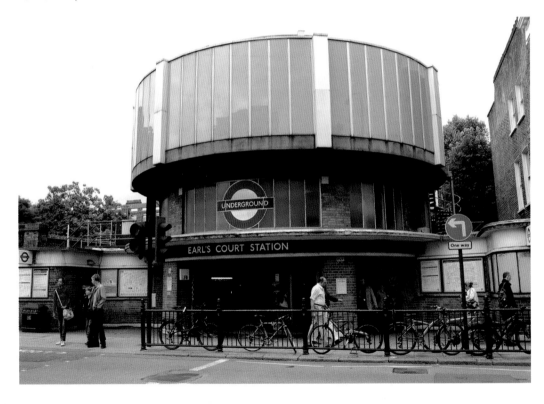

Regent Street

Right: The view to the south along Regent Street, showing the hustle and bustle of traffic and shoppers. In the centre can be seen the red blinds of Hamleys, the famous toy store. The street was named after the Prince Regent, later George IV, and was laid out by John Nash in the early 19th century, although all of his original buildings, apart from All Souls Church, have been replaced.

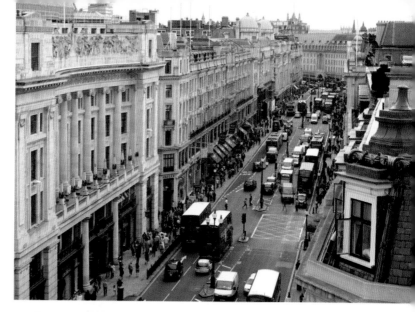

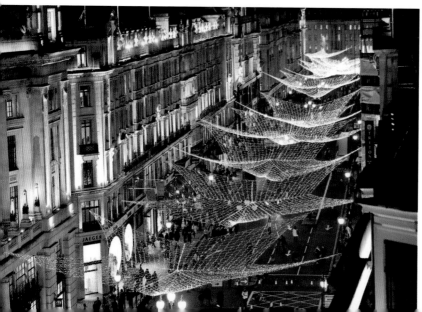

Left: Christmas lights form an illuminated network strung between the buildings of Regent Street, adding a magical element to the classic façades. Regent Street pioneered the use of Christmas lights in 1954, but it was five years before the neighbouring Oxford Street followed suit.

Regent Street, W1

Yeomen of the Guard

Yeomen of the Guard take part in a parade at Buckingham Palace. The historic military corps, the oldest in existence, was formed by Henry VII as a Royal body guard at the Battle of Bosworth Field in 1485, hence their Tudor uniforms. Today their role is purely ceremonial, but they are drawn from retired members of the Army and Royal Air Force.

Buckingham Palace, SW1

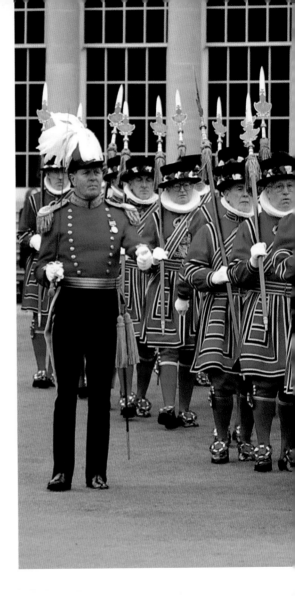

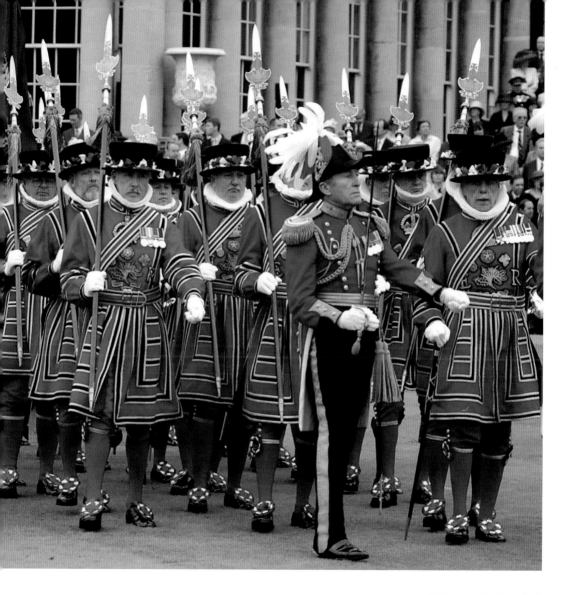

Regent's Park

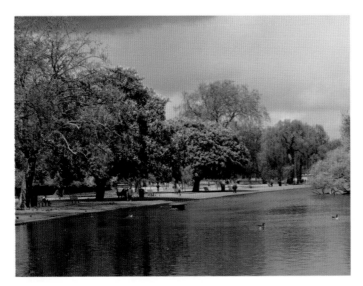

Left: Despite the leaden sky, people enjoy a mild spring day beside the lake in Regent's Park. Primarily open parkland, the park contains gardens, a lake and heronry, waterfowl, boating, sports pitches and children's playgrounds. In addition, it is home to London Zoo and an open-air theatre.

Left: Originally a hunting park and then given over to smallholdings, Regent's Park was redeveloped by John Nash in 1811 at the wishes of the Prince Regent. The bandstand was the site of a Provisional IRA bombing in 1982 that killed seven members of the Royal Green Jackets band. The structure was rebuilt and today carries a plaque to commemorate the atrocity.

Regent's Park, NW1

Regent's Canal

Left: The tranquillity of the Regent's Canal on a sunny day in May does nothing to suggest that this was once a busy waterway providing an important link between seagoing ships on the River Thames and the Grand Union Canal, which carried all manner of cargoes between London and Birmingham.

Regent's Park, NW1

Left: Thick ice blankets the surface of the Regent's Canal in Camden Town. The canal, first proposed in 1802, was a successful commercial artery for decades, but it had lost almost all of its traffic by the late 1960s. Today, however, it is used by pleasure vessels and a waterbus service, while the towpath has become a popular cycle route.

Camden Town, NW1

Ritz Hotel

Overlooking Green Park, the Ritz hotel was opened in 1906 by César Ritz, a Swiss hotelier, who had previously managed the Savoy on the Strand. The building's neoclassical architecture was intended to mimic a stylish Parisian apartment block, while arcades below were evocative of the Rue de Rivoli. From the outset, the hotel provided a very high standard of service and luxury, being frequented by royalty and similarly wealthy patrons. In the late 1990s, it underwent a £40m restoration programme.

Piccadilly, W1

Ritzy Cinema

Opened in 1911, Brixton's Ritzy Picturehouse was originally called
the Electric Pavilion. It was one of the first purpose-built cinemas in the
UK, seating 750, and like many cinemas of the period, it had an organ.
This was removed in 1954, when the cinema was renamed the Pullman.
Threatened with closure in 1976, the cinema survived thanks to a
collaboration between Lambeth Council and the management that
saw the façade restored to near-original condition. Today, it operates
as a multi-screen facility complete with bar and café.

Coldharbour Lane, SW2

Statue of John Betjemen

Former Poet Laureate John Betjeman is evoked in this affectionate statue by Martin Jennings, which stands at St Pancras Station. Betjeman, who was passionate about Victorian architecture, was a leading figure in the fight to save the site when it was threatened by redevelopment in the 1960s. The statue was sponsored by London and Continental railways as a tribute to him.

St Pancras Station, Euston Road, NW1

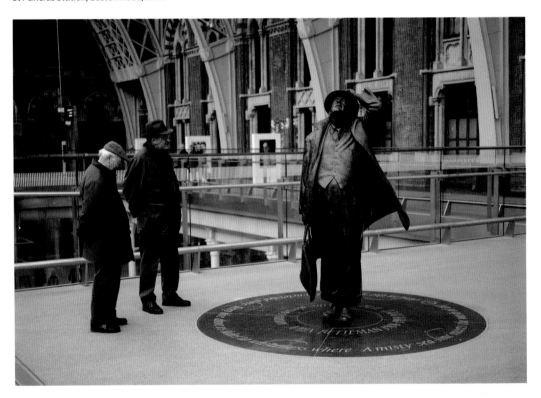

Proms in the Park

The stage during the BBC Proms in the Park concert in Hyde Park. The outdoor concerts have been developed as an extension of the Proms season, which is largely centred on the Royal Albert Hall.

Hyde Park, W2

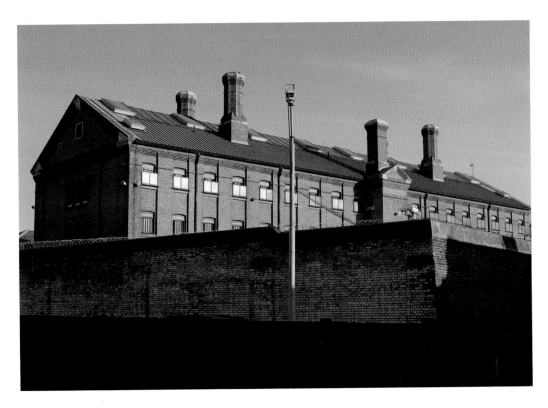

Brixton Prison

Built in 1820, Brixton prison was intended to house 175 prisoners, but regularly exceeded this number. The overcrowding, and the introduction of treadwheels, led to Brixton gaining a reputation as being one of the worst prisons in London. Although it is much larger and conditions are far better today, it is still an unpleasant place, said to be overrun by rats and mice.

Jebb Avenue, SW2

Churchill War Rooms

Left: The entrance to the Imperial War Museum's Churchill War Rooms, located at Clive Steps, King Charles Street.

Below: Dame Vera Lynn, whose singing entertained members of the armed forces throughout the Second World War, at the Cabinet War Rooms, which form part of the Churchill War Rooms Museum. The War Rooms were the government's underground command centre during the war. Today, they form part of the Imperial War Museum.

King Charles Street, SW1

Saatchi Gallery

Exhibits in the Saatchi Gallery at the Duke of York's HQ in Chelsea. The gallery was opened by Charles Saatchi in 1985 to exhibit his personal collection of contemporary art. It has occupied a variety of premises and is the only completely free contemporary art gallery of its size in the world.

King's Road, SW3

Bronze Woman Monument

The Bronze Woman monument, a 3m (10ft) high sculpture of a Caribbean woman holding her child high above her head stands in Stockwell Memorial Garden. It was inspired by a poem called *Bronze Woman*, written by Cécile Nobrega, a poet born in Guyana in 1919.

Clapham Road, SW9

Odeon, Leicester Square

This famous cinema, with its striking black granite façade and 36.5m (120ft) tower displaying its name, is known for hosting European and world film premieres. Built in 1937, the Odeon had a magnificent Art Deco interior, much of which was destroyed during a modernisation programme in the 1960s. Subsequent restoration work has reinstated much of its grandeur.

Leicester Square, WC2

Prospect of Whitby

This historic public house stands on the north bank of the Thames in Wapping, east London, and is one of the most famous pubs in London. It is said to stand on the site of the earliest known riverside tavern, thought to date to around 1520. In the 17th century, the pub gained a reputation as a meeting place for smugglers and villains, becoming known as the Devil's Tavern. A fire gutted the building in the 18th century, but it was rebuilt and renamed the Prospect of Whitby, after a Tyne collier that used to be moored nearby.

Wapping Wall, E1

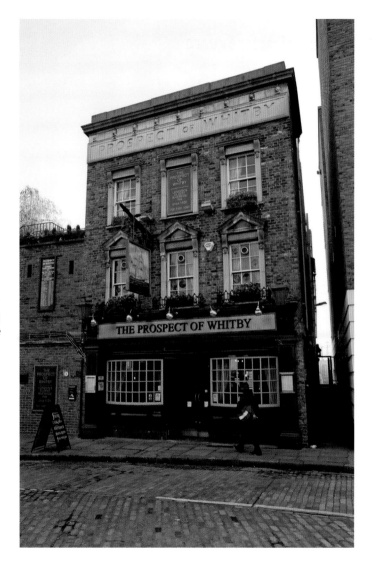

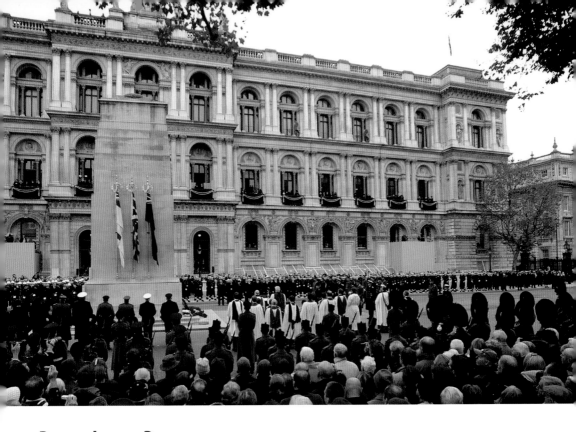

Remembrance Day

Led by Queen Elizabeth, the annual Remembrance Day service and parade takes place at the Cenotaph on Whitehall. The tradition honours the sacrifice made by Britain's war dead and takes place on the Sunday closest to 11 November, the date when the armistice came into effect to end the First World War in 1918. The ceremony includes a two-minute silence at the stroke of 11am that is respected throughout the nation.

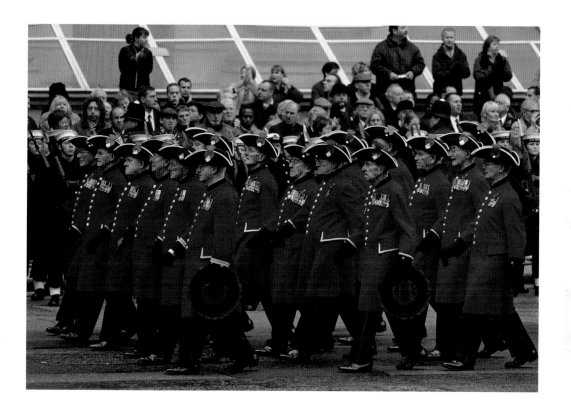

Chelsea Pensioners, retired ex-servicemen from the Royal Hospital Chelsea, resplendent in their scarlet coats and tricorn hats, carry poppy wreaths to the Cenotaph during the ceremony of remembrance in Whitehall on Armistice Day in November.

Whitehall, SW1

Union Chapel

The Stereophonics perform at the Union Chapel in Islington. The Grade II listed church has adopted a new role as a music venue with a capacity of around 800 people. Designed by James Cubitt in Gothic Revival style, it was completed in 1877 as a Congregationalist church for Henry Allon. The 'Union' in its name refers to its original joint congregation of Anglicans and non-conformists.

Compton Avenue, N1

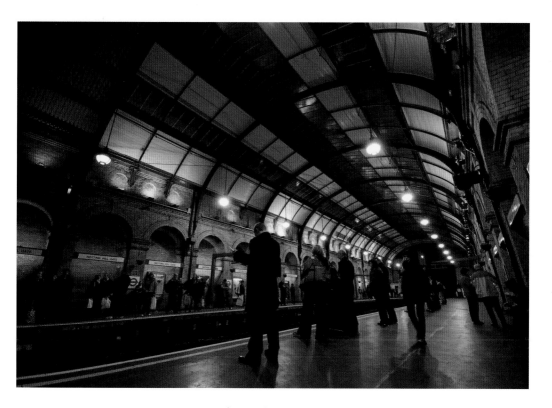

Notting Hill Gate Underground Station

Passengers wait on the Circle Line platform at Notting Hill Gate Underground station. The station was opened by the Metropolitan Railway in 1868 with platforms for the Circle and District lines. Central Line platforms were opened in 1900 by the Central London Railway, but the two sets of platforms were reached from separate entrances on the opposite sides of Notting Hill Gate. The entrances were not combined until the station was redeveloped in the late 1950s.

Notting Hill Gate, W11

Royal London Hospital

The Royal London Hospital in Whitechapel. Originally called the London Infirmary and founded in the summer of 1740, it is one of the oldest surviving hospitals in London. It provides district general hospital services for the City and Tower Hamlets, and specialist tertiary care for London and elsewhere. It acts as a base for London's air ambulance service and also houses a museum of medicinal history.

Whitechapel Road, E1

Hyde Park

On a glorious day in April, hot sunshine floods Hyde Park as sunbathers enjoy the spell of good weather. The park is a wonderful leisure facility for Londoners and visitors alike.

Hyde Park, WC2

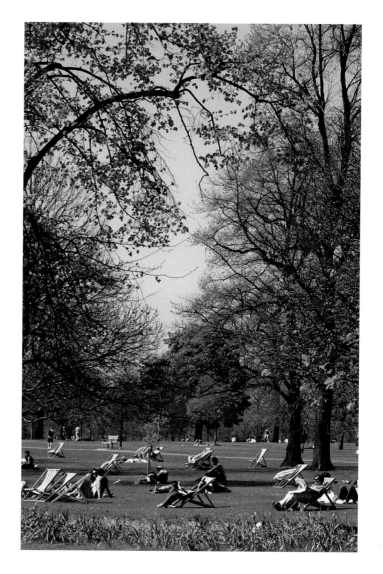

Crown Jewels

The coronation crown of Queen Elizabeth The Queen Mother, who died in 2002 at the age of 101. The crown was the first to be made in platinum for a British consort and was worn by the Queen Mother at the coronation of her husband, King George VI, in 1937.

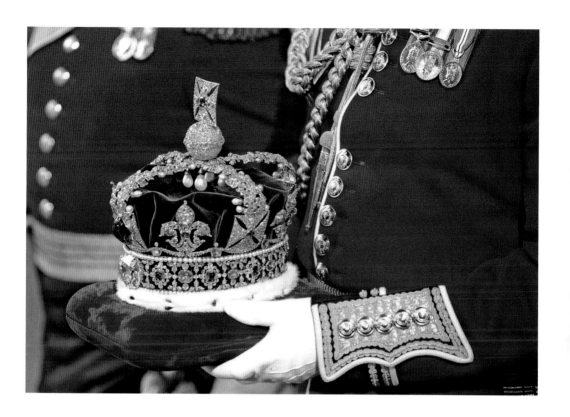

The Imperial State Crown, worn by the Queen, is carried from the Palace of Westminster following the State Opening of Parliament. The crown has a velvet cap with an ermine border, and is set with 2,868 diamonds, 273 pearls, 17 sapphires, 11 emeralds and 5 rubies. When not in use, it is displayed with other Crown Jewels at the Jewel House of the Tower of London.

Tower of London, Tower Hill, EC3

Ronnie Scott's

Opened originally in Gerrard Street in 1959, Ronnie Scott's Jazz Club moved to larger premises in Frith Street in 1965. Over the years, many famous jazz musicians have played there, including Zoot Sims, Johnny Griffin, Sonny Rollins, Tubby Hayes and Dick Morrissey. The club was the venue for Jimi Hendrix's last performance.

Frith Street, W1

Groucho Club

The renowned Groucho Club, a private social club that draws most of its members from the media, entertainment, arts and fashion industries. Opened in 1985 as 'the antidote to the traditional club', the establishment was named after the famous comedian Groucho Marx because of his remark that he would not wish to join any club that would have him as a member. The club has three bars, two restaurants, a billiards room and 20 bedrooms.

Dean Street, W1

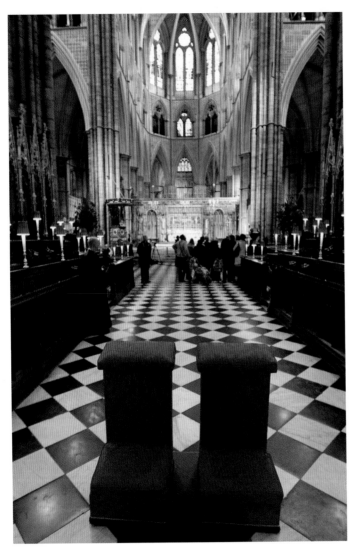

Westminster Abbey

Left: The dramatic interior of Westminster Abbey with its vaulted roof. The abbey contains King Edward's Chair, the throne on which British sovereigns are seated at the moment of coronation. It has been used at every coronation since 1308.

Right: There has been a place of worship on the site of Westminster Abbey for well over 1,000 years, and the present abbey, with its dramatic soaring Gothic architecture, was largely built during the 13th century, at the urging of King Henry III. In addition to being the place where British monarchs are crowned, it contains the graves or memorials of over 3,000 people, from kings and queens to the Tomb of the Unknown Warrior.

Dean's Yard, SW1

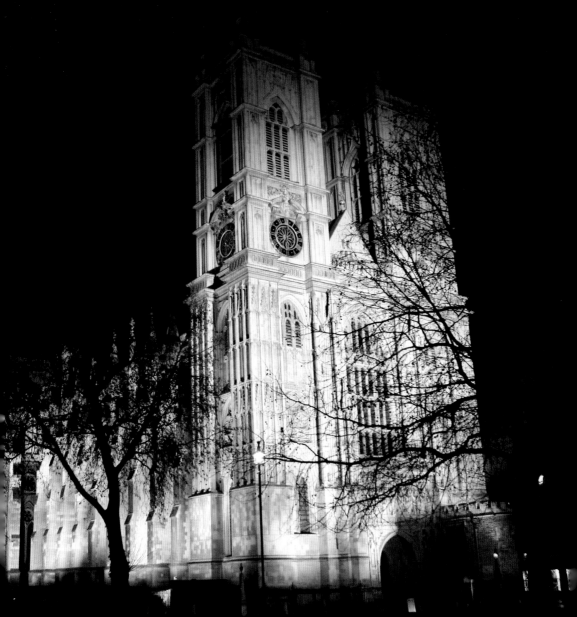

Westminster Cathedral

Left: Built between 1895 and 1903, in a neo-Byzantine style, Westminster Cathedral is the mother church of the Roman Catholic community in England and Wales. It is also the largest Catholic church in those two countries. The striking building stands on the site of the former Tothill Fields Bridewell prison.

Right: Hundreds of couples renew their vows at a special mass held at Westminster Cathedral. The cathedral opened in 1903, but much of the interior remained unfinished; thus the consecration ceremony did not take place until 1910.

Victoria Street, SW1

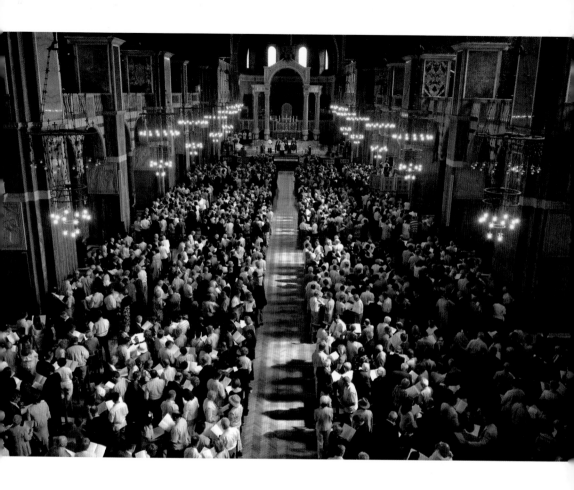

Canalway Cavalcade

The Inland Waterways Association's Canalway Cavalcade is a gathering of more than 100 narrowboats, which has taken place at Little Venice since 1983, on the May Bank Holiday weekend. Elaborately decorated waterborne homes are moored along the stretch of the Grand Union Canal between Blomfield Road, Warwick Avenue and Warwick Crescent. This very British pageant includes Morris dancers, food and trade stalls, children's activities and a real-ale tent.

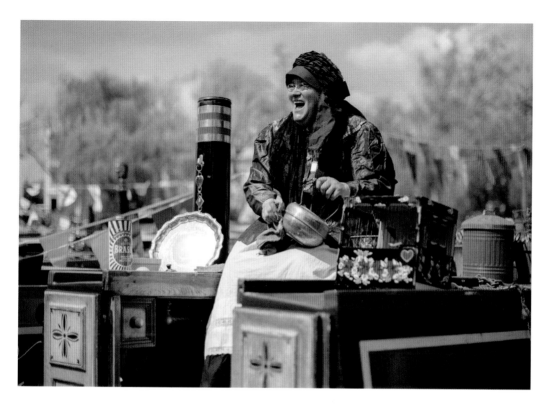

Canal Life Art

Professional artist and writer Linda Anfuso, a landscape artist specialising in scenes of canal life in England, enjoys the fun of the Canalway Cavalcade aboard her narrowboat.

Maida Vale, W9

Royal Albert Hall

Right: Flag-waving concertgoers enjoy the raucous celebrations during the Last Night of the Proms.

Below: Designed by Captain Francis Fowke and Major-General Henry Y.D. Scott of the Royal Engineers, the Royal Albert Hall was built by Lucas Brothers and opened by Queen Victoria in 1871 – it was named after her late husband, Prince Albert. Each year, the famous concert venue hosts more than 350 performances, including the renowned BBC proms concerts. Although the building appears round, it is actually an ellipse in plan and is surmounted by a glazed dome.

Kensington Gore, SW7

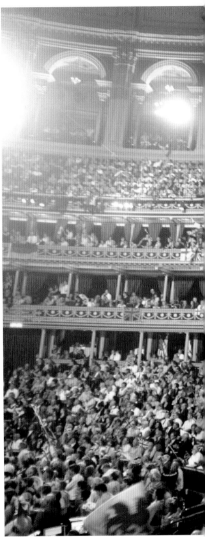

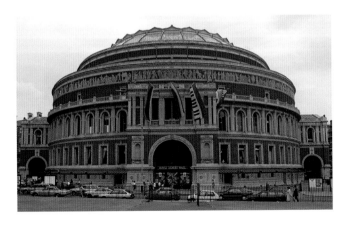

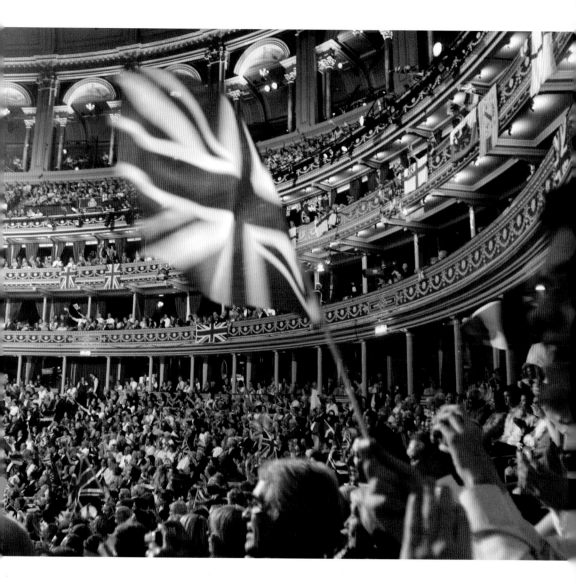

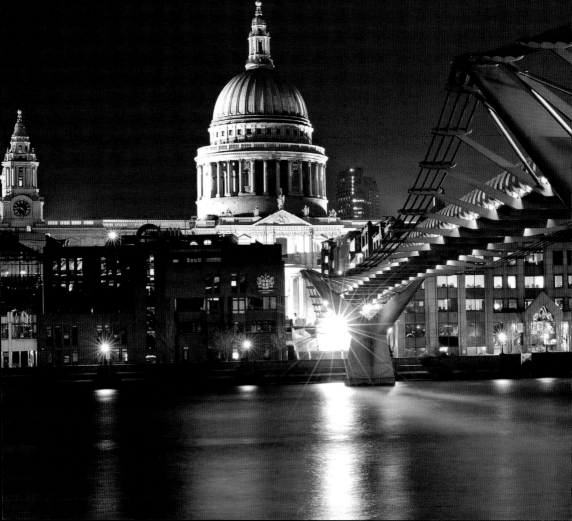

Millennium Bridge

Night can be a magical time in the city. Here, seen from the South Bank, the dome of St Paul's Cathedral and the Millennium Bridge make dramatic, illuminated statements against the night sky, while the lights of the buildings along the north bank of the Thames throw shimmering reflections on the surface of the river.

South Bank, SE1

Pillar Boxes

Above: The bright red Post Office pillar box is a common sight on the streets of London, being decorated with the Royal cipher to indicate that it is for the collection of the Royal Mail.

Right: A replica of an early six-sided Penfold pillar box erected at Tower Bridge in 1989. This ornate design was introduced in 1866, mainly in cities.

Mount Pleasant Sorting Office

Built on the site of the former Coldbath Fields Prison, the Mount Pleasant Sorting Office was opened in 1889 and today is the largest sorting office operated by the Royal Mail in London. At one stage, all mail into and out of London passed through Mount Pleasant. The British Postal Museum and Archive is also on the site.

Farringdon Road, EC1

London Stock Exchange

Established in Threadneedle Street in 1801, the London Stock Exchange subsequently moved to Capel Court, where it remained until the Stock Exchange Tower was opened in Threadneedle Street in 1972. A further move occurred in 2004, to this new building in Paternoster Square.

Paternoster Square, EC4

Chelsea Bridge

Festooned with lights, Chelsea Bridge makes a striking statement against the night sky. The bridge was opened in 1937 and was the first self-anchored suspension bridge in Britain. It replaced an earlier bridge that had been completed in 1857 to provide access between the north bank of the Thames and the newly created Battersea Park on the opposite bank.

Chelsea Bridge Road, SW1

St Katherine Docks

Dating from 1828, the St Katherine Docks formed part of the Port of London and were designed by Thomas Telford. They were not a great commercial success, however, as they were unable to accommodate large vessels. Today, they operate as a marina, while the surrounding buildings have been converted into housing, shops, a hotel and restaurants.

St Katherine's Way, E1

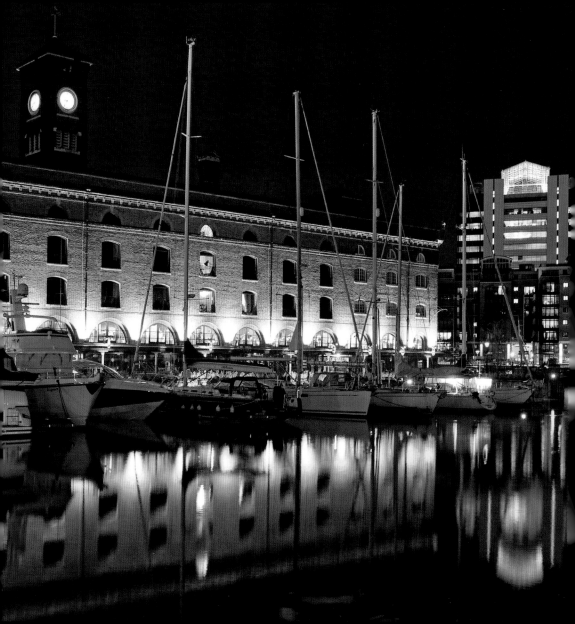

Monument

The top of the Monument, a commemorative column that marks the place where the great fire of London started in 1666. The 61.5m (202ft) high structure, built of Portland stone and surmounted by a gilded urn of fire, was designed by Christopher Wren and Robert Hooke. Its height represents the distance from the Monument to the bakery in Pudding Lane where the fire began. A spiral staircase within the column allows visitors to climb to the top.

Monument Street, EC3

Lyceum Theatre

The 2,000-seat Lyceum is famous for being the first theatre in London
to be lit by gas. The Lyceum name has been used by theatres in the
vicinity since 1765, the current building having opened in 1834.
It was designed by Samuel Beazley, but today only the original façade
remains, the structure behind having been constructed in 1904.

Wellington Street, WC2

Aldwych Theatre

With uplighting throwing the details of its façade into sharp relief and its leaded-glass canopy casting a warm glow, the Aldwych Theatre beckons theatregoers to another evening of entertainment. The theatre opened in 1905, having been built as a pair with the Waldorf Theatre (now Novello), both being designed by W.G.R. Sprague. The theatre, which seats 1,200, hosted the Royal Shakespeare Company from 1960 to 1982.

Aldwych, WC2

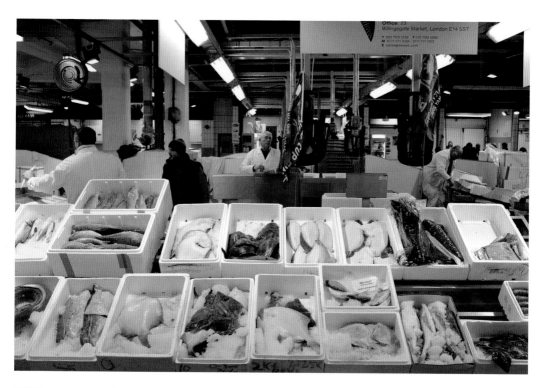

Billingsgate Fish Market

The catch of the day is displayed on a fishmonger's stall at Billingsgate Market in Docklands, east London. Originally, the market was located on the bank of the Thames in Lower Thames Street, and during its heyday, in the late 19th and early 20th centuries, it was the largest fish market in the world. It remains the UK's largest inland fish market. The market moved from its historic arcaded hall to its current address near Canary Wharf in 1982. For centuries, Billingsgate was renowned for the vulgar language of its fishmongers.

Trafalgar Way, E14

Royal Artillery Museum

One of two Chinese-built cannons on display in the Royal Artillery Museum, Woolwich. These 2.25-tonne (2.5-ton) bronze guns date from the mid-19th century and are thought to have been captured during the Second Anglo-Chinese War of 1860. They are particularly important, however, since they have provided the metal for over 800 Victoria Cross medals.

Royal Arsenal, SE18

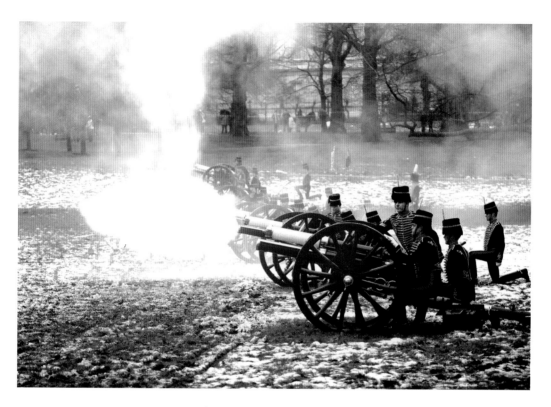

King's Troop, Royal Horse Artillery

The King's Troop Royal Horse Artillery fire a salute to mark the anniversary of Queen Elizabeth's accession to the throne in 1952 at Green Park. The ceremonial unit of the British Army is equipped with First World War-vintage 13-pounder guns drawn by teams of six horses. In addition to firing Royal salutes, the unit provides gun carriages and black horses for military and state funerals.

Green Park, SW1

Statue of George VI

Depicting King George VI, father of Queen Elizabeth, in his Order of the Garter robes, this bronze statue was erected in The Mall in 1955, three years after his death. Known as the 'reluctant King', George (born Albert) ascended to the throne upon the abdication in 1936 of his elder brother, Edward VIII, who chose to give up his Royal duties to marry his mistress, the American divorcee Wallis Simpson. When informing his mother, Queen Mary, of the situation, Albert broke down and sobbed like a child. The Second World War and its aftermath dominated his reign. The stress of the war, plus his heavy smoking, took a heavy toll on his health, and he died at the age of 56.

The Mall, SW1

Statue of Queen Elizabeth The Queen Mother

This statue of the late Queen Elizabeth The Queen Mother stands in The Mall in front of that of her husband, King George VI. The 2.75m (9ft) bronze sculpture depicts the Queen Mother at the age of 51, when her husband died, wearing her Order of the Garter robes. It is flanked by two reliefs that show her visiting bombed-out families during the Blitz and enjoying the races at Ascot.

The Mall, SW1

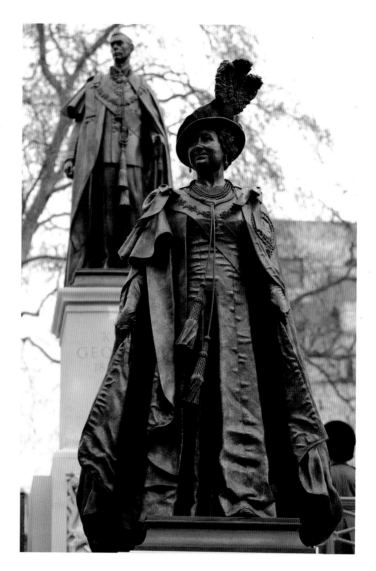

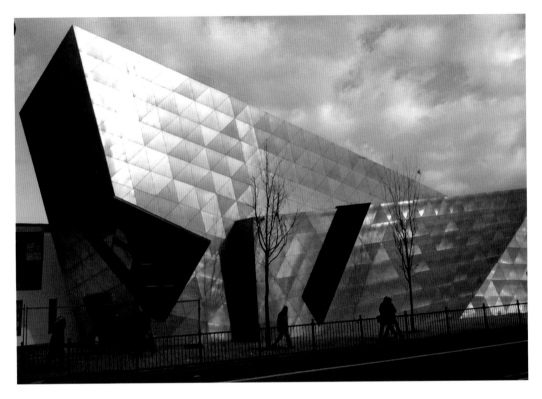

London Metropolitan University

Built at a cost of £3m, this striking extension to the London Metropolitan University stands on Holloway Road, north London. It was designed by world renowned architect Daniel Libeskind, who was contracted to oversee the rebuilding of the World Trade Center site in New York. Not surprisingly, the steel-clad angular building divided local opinion when it was revealed in 2004.

Holloway Road, N7

St Bartholomew's Hospital

The main entrance to St Bartholomew's Hospital, the oldest surviving hospital in the UK. It was founded in the 12th century by Rahere, a favourite courtier of King Henry I, and has remained a hospital ever since. This entrance is known as the Henry VIII Gate and was completed in 1702. It incorporates the only public statue of Henry VIII in London. Elsewhere on the hospital wall is a plaque marking the site of the execution of Sir William Wallace in 1305.

West Smithfield, EC1

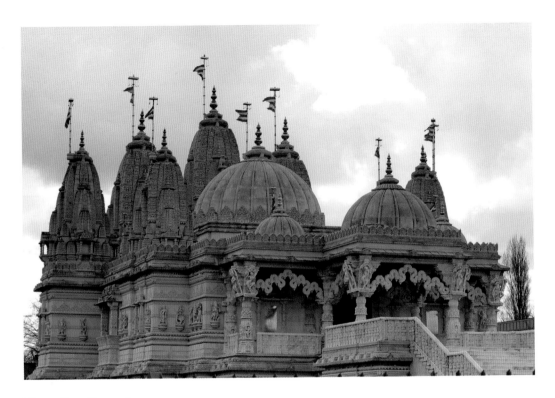

Neasden Temple

BAPS Shri Swaminarayan Mandir, more commonly known as the Neasden Temple. This striking place of Hindu worship was inaugurated in 1995 by Indian holy man Pramukh Swami Maharaj. It was Europe's first traditional Hindu stone temple and was built, at a cost of £12m, using all traditional methods and materials. It is the largest Hindu temple outside India.

Devotees observe midday prayers at the BAPS Shri Swaminarayan Mandir (Neasden Temple). The three illuminated figures in the shrine are known as *murtis* and represent divinities; as such, they act as a focus for worship. The murtis are attended by monks (*sadhus*), who dress and bathe them according to the time of day and provide them with offerings of food.

Brentfield Road, NW10

Whitechapel Art Gallery

Designed by the architect Charles Harrison Townsend, the Whitechapel Art Gallery was opened in 1901 as one of London's first publicly funded galleries for temporary exhibitions. It exhibits contemporary artists and organises retrospectives. In 2009, it reopened following a £13.5m refurbishment that included incorporating the neighbouring former library building, which tripled the exhibition space. This has allowed the gallery to remain open all year round.

Whitechapel High Street, E1

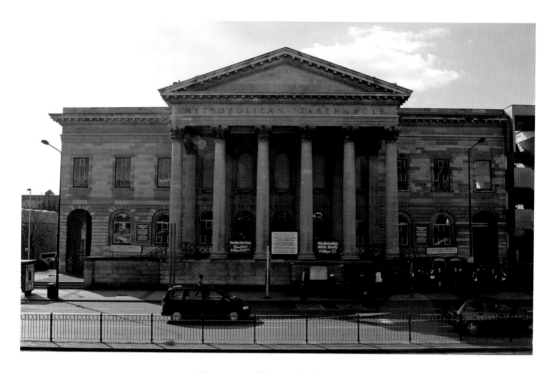

Metropolitan Tabernacle

The Metropolitan Tabernacle in the Elephant and Castle. Designed by William Wilmer Pocock, it was dedicated on 18 March 1861, and was, at the time, the largest church edifice in England. Destroyed and rebuilt twice during its history, it is still in use today as a Reformed Baptist church, which was its original purpose.

Elephant and Castle, SE1

Twickenham Stadium

Above: This golden statue of a lion stands above the West Gate at Twickenham Stadium. Known as the home of English rugby, the stadium is owned and operated by the Rugby Football Union, and is the headquarters of the English rugby union team (whose symbol is the Three Lions). The statue itself came from the Red Lion Brewery on the South Bank, which was demolished in 1951 to make way for the Festival Hall.

Right: A record crowd fills Twickenham Stadium for a club game between Leicester Tigers and London Wasps. The 82,000-seat stadium is the second largest in the UK after Wembley and the fourth largest in Europe. The stadium, on the site of a former market garden, saw its first match in 1909. Since then, it has been progressively improved and enlarged.

Rugby Road, Twickenham, Surrey

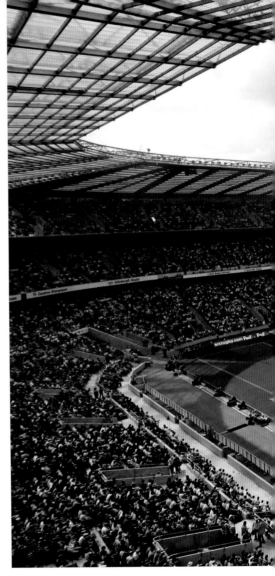

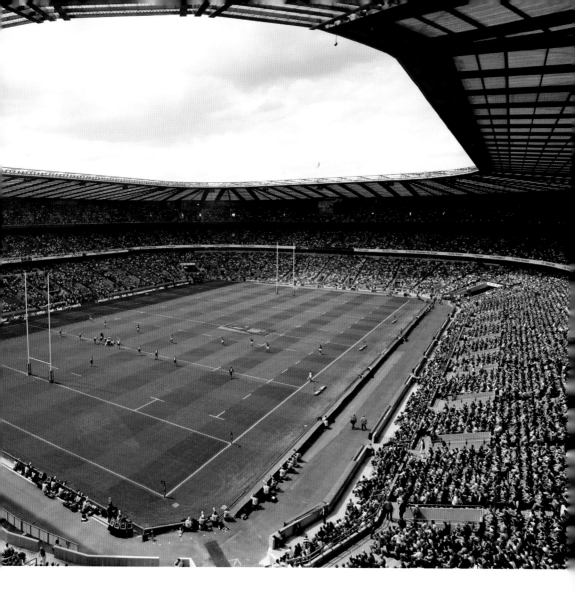

Great River Race

A variety of boats of all sizes head towards London Bridge as they take part in the Great River Race, from Docklands to Richmond in Surrey, a marathon distance of 35km (21½ miles). The race was inaugurated in 1988 and is open to all-comers in traditional-style coxed vessels with a minimum of four oars or paddles, each having to carry a passenger. The race attracts approximately 300 crews from around the world.

London Bridge, SE1

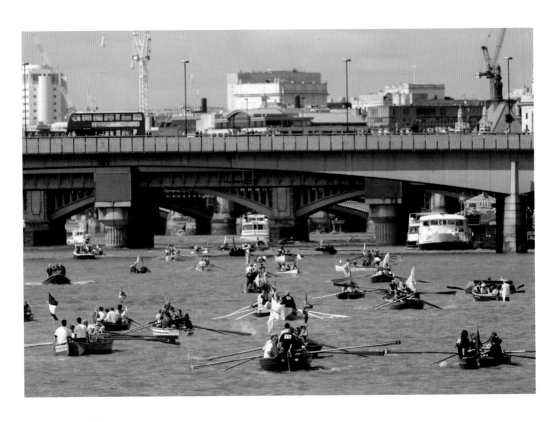

Serpentine

On a mild spring day in April, people enjoy the sun by taking to the waters of the Serpentine Boating Lake in pedalos and rowing boats. The lake boasts a fleet of 110 such vessels as well as a swimming area. The Serpentine gained its name from its curved shape, which snakes through the Hyde Park.

Hyde Park, W2

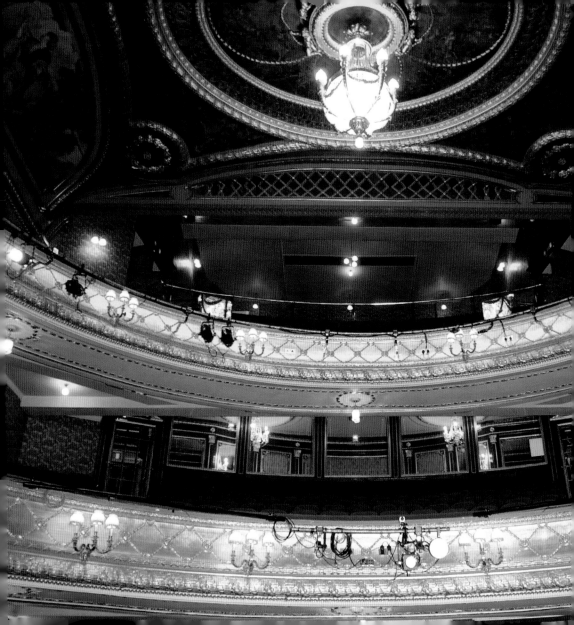

Theatre Royal, Haymarket

Dating to 1821, the Theatre Royal Haymarket was designed by John Nash as a replacement for a previous theatre bearing the same name, but located slightly further north in the same street. The 888-seat theatre was the first to introduce scheduled matinée performances, in 1873; six years later, the stage was enclosed in the first use of the now common picture-frame proscenium.

Haymarket, SW1

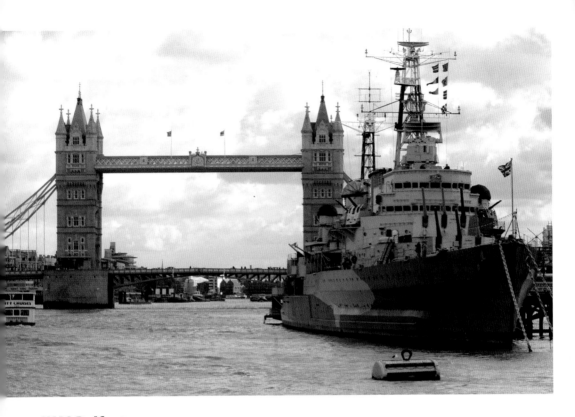

HMS Belfast

The museum ship HMS *Belfast*, permanently moored on the River Thames upstream of Tower Bridge. The former Royal Navy light cruiser is operated by the Imperial War Museum and took part in a number of actions during the Second World War, including the Normandy landings in 1944. The ship also saw service during the Korean War.

Morgan's Lane, SE1

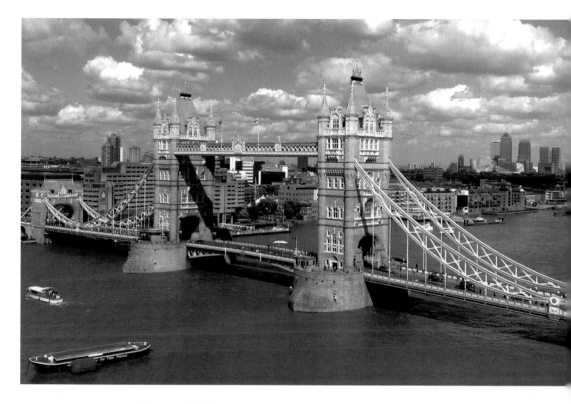

Tower Bridge

The iconic Tower Bridge seen from City Hall. In the background are the skyscrapers of Canary Wharf. Despite its Gothic appearance, Tower Bridge was not completed until 1894, its design having been chosen to complement the nearby Tower of London. In fact, the stonework of the two massive towers is only cladding, added to conceal the steel framework within. The central span of the bridge can be raised to allow the passage of tall vessels on the river.

Tower Bridge Road, SE1/Tower Bridge Approach, E1

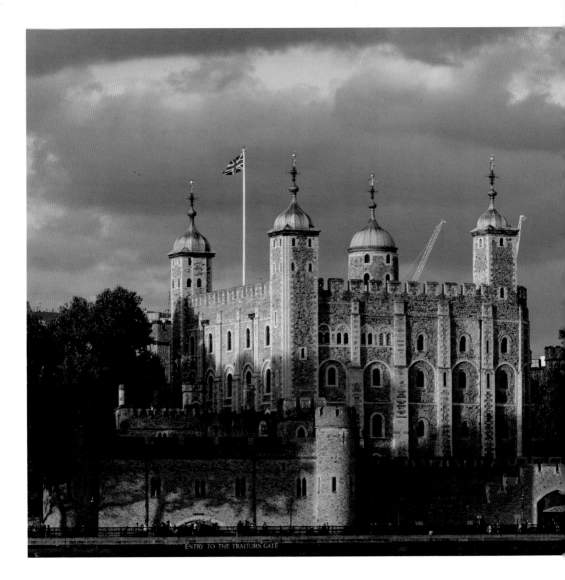

ENTRY TO THE TRAITORS GATE

Tower of London

Standing on the north bank of the River Thames, close to Tower Bridge, this historic castle was founded towards the end of 1066 during the Norman Conquest. The central White Tower, which gives the castle its name, was erected on the orders of William the Conqueror in 1078. For many years a Royal residence, subsequently it has served a number of roles, including as an armoury, a treasury and as the home of the Royal Mint. During the First and Second World Wars, the Tower of London was used to hold prisoners of war, particularly spies, and during both conflicts men convicted of espionage were executed there by firing squad. Today, the Tower houses the Crown Jewels and is open to the public.

Tower Hill, EC3

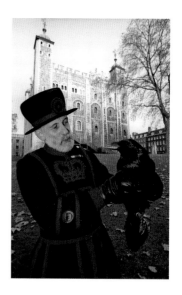

Raven and Yeoman

The Ravenmaster at the Tower of London introduces a new member of the castle's raven population. According to legend, the kingdom and the Tower shall fall if the resident ravens should ever leave the Tower of London. According to tradition, therefore, around six of these large birds are kept at the Tower, their wings being clipped to prevent them from flying away.

Tower of London, Tower Hill, EC3

Trafalgar Square

Trafalgar Square at Christmas always features a large illuminated Christmas tree, which is donated every year by the people of Norway in gratitude for the assistance shown to them by the British during the Second World War, when Norway was invaded by the Germans.

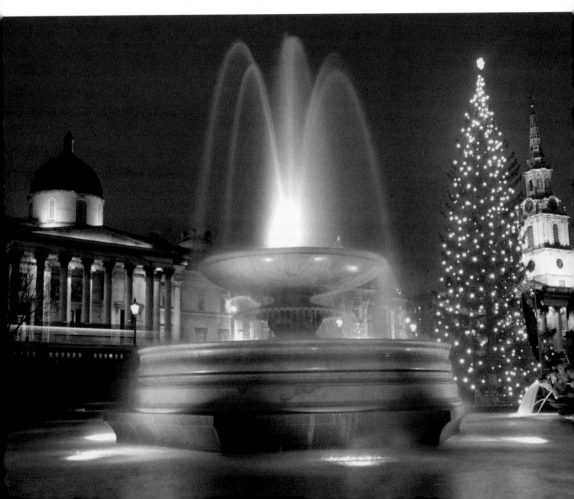

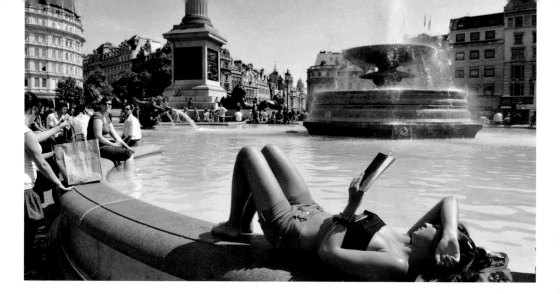

Above: During a hot sunny day in June, crowds enjoy the summer weather around the cooling fountains of Trafalgar Square. Named to commemorate the Battle of Trafalgar, a British naval victory of the Napoleonic wars, the square attracts tourists and office workers alike in large numbers.

Right: The fountains in Trafalgar Square are bathed in colour as night falls. Fountains were included in the design of the square in 1845, not for aesthetic purposes, but to reduce the area available for riotous assembly. Originally, they were powered by a steam engine, but in the late 1930s, a new pump and fountains were installed to a design by Sir Edwin Lutyens. In 2009, the pump system was replaced and an LED lighting arrangement added, reducing energy consumption.

Trafalgar Square, WC2

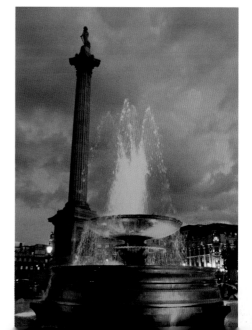

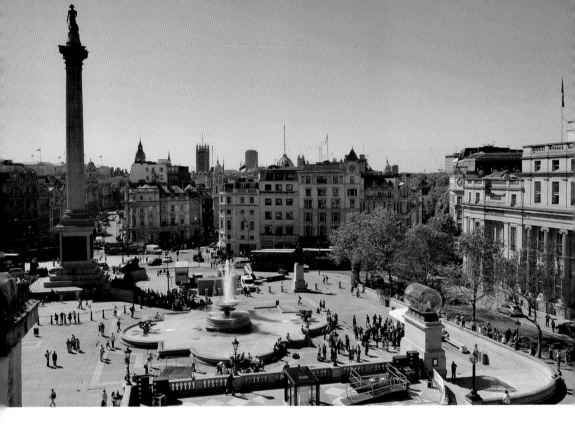

Trafalgar Square

Under a deep blue sky, Trafalgar Square basks in the early summer sunshine. Crowds gather to watch the unveiling of the latest artwork to grace the fourth plinth, Yinka Shonibare's *Nelson's Ship In A Bottle*. Unused for many years, the fourth plinth is now employed for an ongoing series of temporary art exhibitions.

Trafalgar Square, WC2

Chinese New Year

Right: The acrobatic Chen brothers perform the Lion Dance on high poles in Trafalgar Square during celebrations to mark the Chinese New Year. London has a substantial Chinese community, and their vibrant decorations for the New Year bring a welcome splash of colour during the drab winter months.

Trafalgar Square, WC2

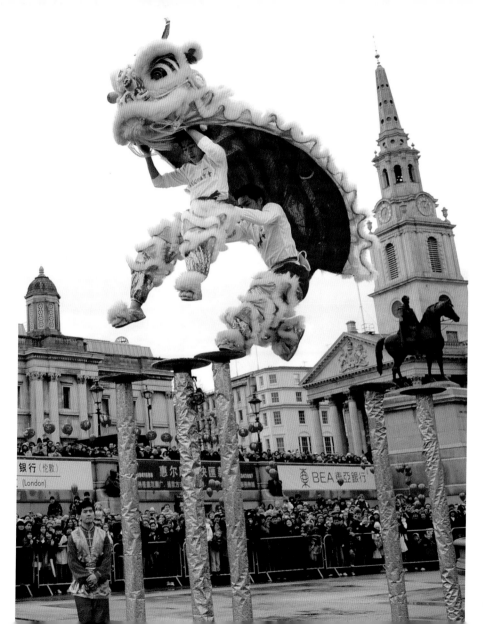

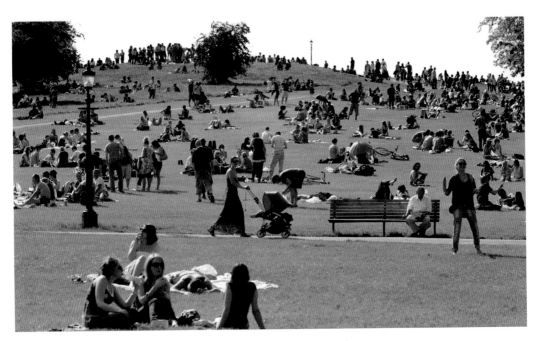

Primrose Hill

Above: On a sunny weekend in late May, people enjoy the warm weather on London's Primrose Hill. This area was once part of a large hunting chase appropriated by King Henry VIII. In 1842, it was turned into a public park. The area around the park is very popular with celebrities, who are drawn to live there because of its Bohemian feel.

Left: A girl plays guitar as people enjoy the sunshine on Primrose Hill. Below can be seen the netted roof of the Snowdon Aviary in London Zoo.

Primrose Hill Road, NW3

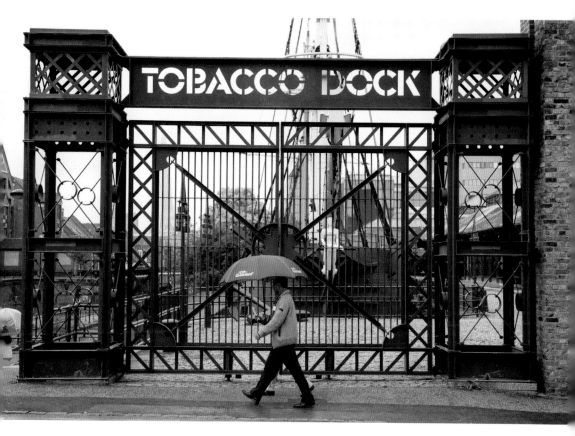

Tobacco Dock

A Grade I listed warehouse in Docklands, east London, Tobacco Dock was built in 1811 as a store for imported tobacco. The brick vaulted building boasts some fine ironwork (such as the entrance gate shown) and is now used for large corporate and commercial events, such as dance events that host up to 5,000 people.

Wapping Lane, E1

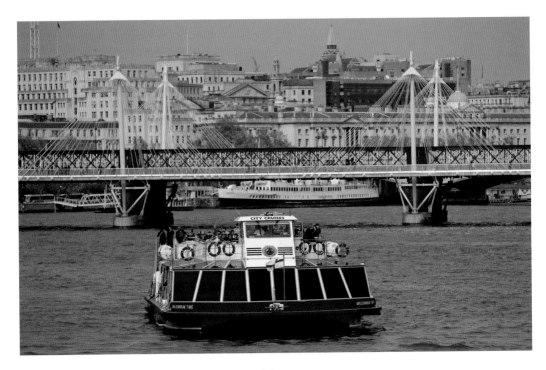

Thames Cruiser and Hungerford Bridge

A sightseeing cruiser heads upstream on the River Thames, away from Hungerford Bridge, a railway bridge that links Charing Cross and Waterloo stations. The bridge is sandwiched between two modern cable-stayed pedestrian bridges, known properly as the Golden Jubilee Bridges in honour of Queen Elizabeth II's 50 years on the throne.

Hungerford Bridge, Embankment, WC2/South Bank, SE1

Charing Cross Hospital

Established in 1823, Charing Cross Hospital is a tertiary referral centre for neurosurgery. In addition, it acts as the serious injury centre for west London, houses the Kennedy Institute of Rheumatology and the West London Neuroscience Centre, and is home to the largest and oldest gender identity clinic in the UK.

Fulham Palace Road, SW6

St Martin-in-the-Fields Church

St Martin-in-the-Fields Anglican church, Trafalgar Square. According to recent archaeological excavations, a place of worship has stood on this site for over 1,000 years. The present church was built by James Gibbs between 1721 and 1726. It is known for its work among the homeless of central London, and for its concerts, many performed by the Academy of St Martin-in-the-Fields, which was co-founded in 1959 by Sir Neville Marriner and John Churchill, the then Master of Music at St Martin's.

The interior of St Martin-in-the-Fields. In 2008, a £36m refurbishment of the church was completed, following ten years of planning, fund raising and painstaking work by an army of craftsmen. The earliest reference to a church on the site dates back to 1222. This was rebuilt by Henry VIII in 1542 and survived the Great Fire, but was replaced by the present building, which was completed in 1726.

Trafalgar Square, WC2

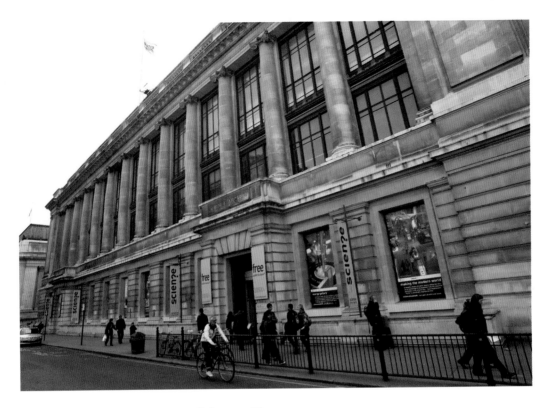

Science Museum

The Science Museum in South Kensington. The museum has some of the most famous items of scientific discovery and endeavour on display, such as Charles Babbage's Difference engine (a very early form of computer), the first ever jet engine and 'Puffing Billy', the world's oldest surviving steam locomotive. The building contains seven floors of galleries.

Visitors to the Science Museum study an electric car with a cabin
that can rotate through 360 degrees. Part of the National Museum of
Science and Industry, the museum was established as an independent
entity in 1909, having previously been amalgamated with the art
collection that became the Victoria and Albert Museum. It holds
a collection of over 300,000 items, including many interactive exhibits.

Exhibition Road, SW7

New Scotland Yard

New Scotland Yard, the headquarters of London's Metropolitan Police. The name of the building was taken from the Met's previous headquarters overlooking Victoria Embankment, which dated from the late 19th century. This, in turn, had gained its name from the police service's first headquarters at Great Scotland Yard in Whitehall. The Metropolitan Police outgrew the Embankment site and moved to the present building in 1967. Over time 'Scotland Yard' has become synonymous with the Metropolitan Police, and it is frequently referred to in crime fiction.

Broadway, Westminster, SW1

Lord's Cricket Ground

In this aerial view, the pristine green oval of Lord's Cricket Ground dominates the foreground. A number of other notable landmarks can also be seen, including the London Central Mosque, with its golden dome and minaret, and the lush vegetation of Regent's Park. The train shed of Marylebone Railway Station is in the middle ground (*right*). Further in the distance are the London Eye, the BT Tower, and St Paul's Cathedral and the skyscrapers of Canary Wharf.

St John's Wood Road, NW8

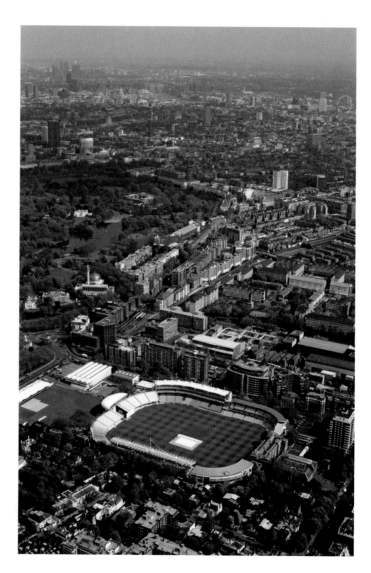

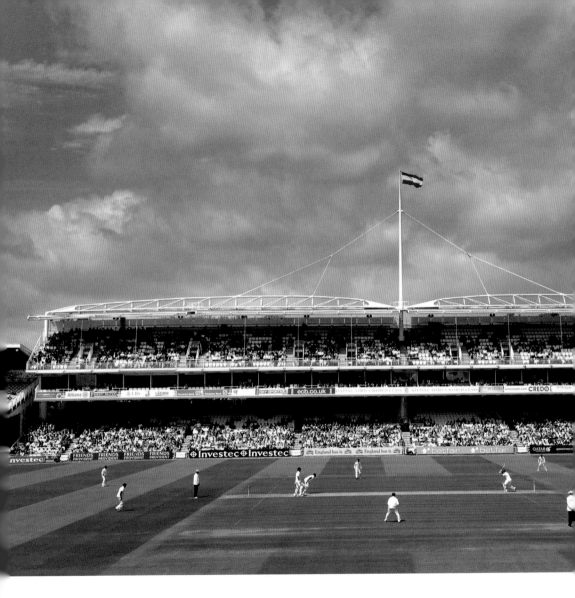

Lord's Cricket Ground

The grandstand during a Test match at Lord's Cricket Ground in St John's Wood. Lord's was named after its founder, Thomas Lord, and is owned by the Marylebone Cricket Club. It is the home of Middlesex County Cricket Club. The venue is the third of three grounds established by Lord, and it is known as the home of cricket. The MCC museum is also on the site and is the oldest sports museum in the world. Among its exhibits are The Ashes.

St John's Wood Road, NW8

Changing the Guard

Right: Drummers from the Grenadier Regiment take part in the Changing the Guard ceremony outside Buckingham Palace. This colourful event takes place every day through the summer at 11.30 am. The new guard marches to the palace from the nearby Wellington Barracks to take over the duties of the old guard, who then march back to the barracks.

Facing page: Guardsmen of the Scots and Coldstream Guards take part in the Changing of the Guard ceremony in the forecourt of Buckingham Palace. The guard is changed every morning between April and August, and every other morning at other times. Although the guard is often mounted by members of the Foot Guards, other regiments of the British Army and even Commonwealth units have taken part on occasion.

Buckingham Palace, SW1

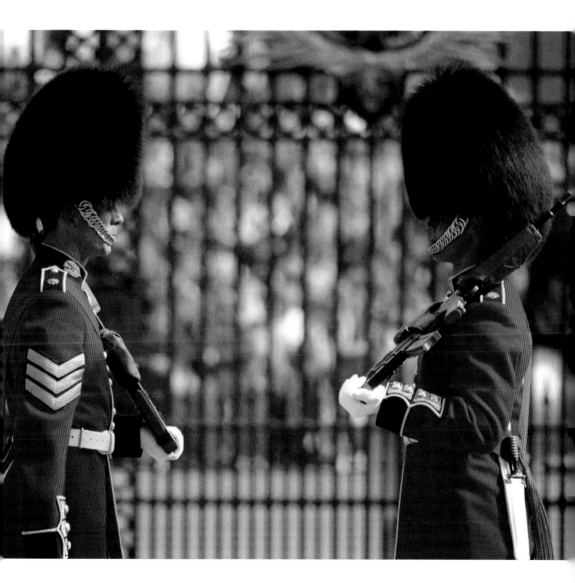

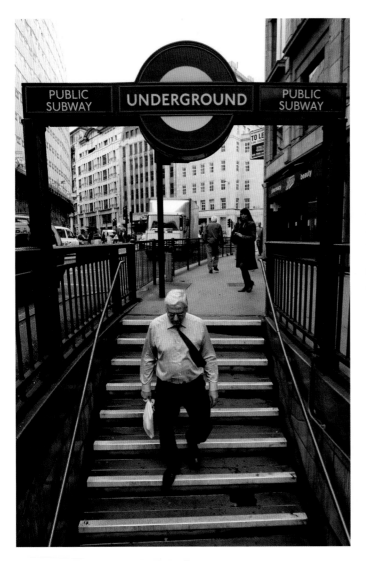

Monument Underground Station

The entrance of the Monument tube station, which displays the classic roundel logo with a blue bar across a red circle. The roundel was first used on the Underground in 1908 as a means of highlighting station names on platforms. It was also used on London's buses and, more recently, on other forms of transport in the city, such as taxis and the Docklands Light Railway.

King William Street, EC4

Kensington Roof Gardens

The Kensington Roof Gardens were created between 1936 and 1938 on top of what was then the Derry and Toms department store. Today, the venue is a private members' club owned by Sir Richard Branson, although the gardens are open to the public on certain days and are accessible through an entrance on Derry Street.

Kensington High Street, W8

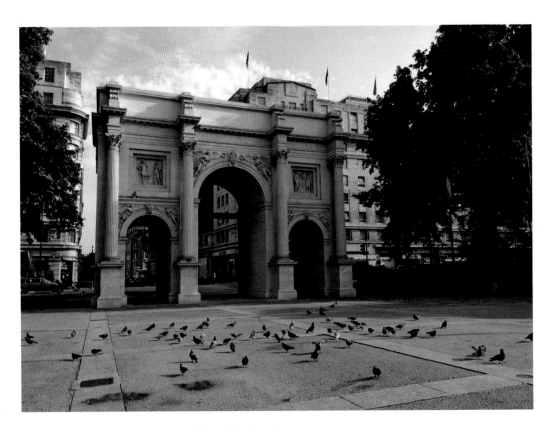

Marble Arch

Built originally as a gateway to Buckingham Palace, Marble Arch
was designed by John Nash in 1828, using the triumphal arch of
Constantine in Rome as inspiration. When the flat east front was added
to the palace in 1851, the white Carrera marble structure was moved to
its present location on a traffic island at the junction of Oxford Street,
Park Lane and Edgware Road.

Fountains at Marble Arch, which were restored in 2009. The three fountains, which are opposite the famous monument, had fallen into disuse a decade before and had been converted to planters. Now they operate automatically, switching off in high winds, and are equipped with lights that alternate red, white and blue.

Park Lane, W1

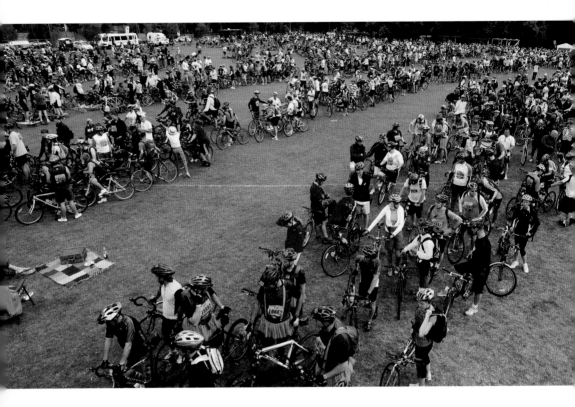

London to Brighton Bike Ride

Keen cyclists gather on Clapham Common before setting off on the annual British Heart Foundation 87km (54-mile) London to Brighton Bike Ride. The charity event regularly attracts around 30,000 entrants and is a tough test of stamina.

Clapham Common, SW4

Rathayatra Festival

The Rathayatra cart festival, part of the Hare Krishna Festival, makes its way along Piccadilly. Hundreds of pilgrims and faith leaders from all over world pull the three 12m (40ft) high colourful wooden chariots bearing the deities Sri Jagannatha, Srimate Subhadra and Sri Balarama, along the route from Hyde Park to Trafalgar Square. The festival has its roots in Jagannatha Puri on the east coast of India and dates back over 5,000 years.

Piccadilly, W1

7/7 Memorial

The striking monument in Hyde Park to the 52 people killed in London on 7 July 2005, when terrorists exploded bombs on three Underground trains and a double-decker bus. The memorial, which cost nearly £1m, and was created by architects Carmody Groarke, comprises 52 stainless-steel columns, each 3.5m tall. In addition to those killed by the co-ordinated attack, around 700 were injured.

Hyde Park, W1

Portcullis House

Standing opposite Big Ben, Portcullis House has a profile of tall chimneys reminiscent of the Victorian Gothic design of the Palace of Westminster. The chimneys do not expel fumes, but are part of an unpowered air conditioning system. The building opened in 2001 as offices for 213 Members of Parliament and staff, augmenting limited space in the Palace of Westminster. Designed by Michael Hopkins and Partners, it incorporates Westminster tube station below. Aluminium bronze was used for exposed metal on the roof and walls, and the structure includes Cornish granite and columns between the windows of Birchover Gritstone from Derbyshire. Inside, the building was designed to look and feel like a ship. Offices and passages have bowed windows and light oak finishing. Metallic 'sails' are suspended over the courtyard. The first floor is open to the public for attending Committee sessions.

Bridge Street, SW1

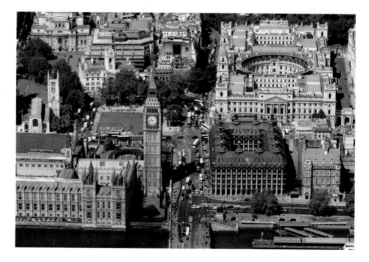

Herding Sheep on London Bridge

A flock of sheep is herded across London Bridge, as Freemen of the City of London take part in the annual Great Sheep Drive of London Bridge, exercising their long-established right to drive sheep over London's oldest river crossing. The ancient privilege dates back to the 11th century.

London Bridge, SE1

Victoria and Albert Museum

Named after Queen Victoria and her husband, Prince Albert, the Victoria and Albert Museum (V&A) was founded in 1852. It is the largest museum in the world dedicated to the decorative arts and design, and has a permanent collection of over 4.5 million items spread through 145 galleries. One of the museum's ten Medieval and Renaissance Galleries is shown, *left*.

Cromwell Gardens, SW7

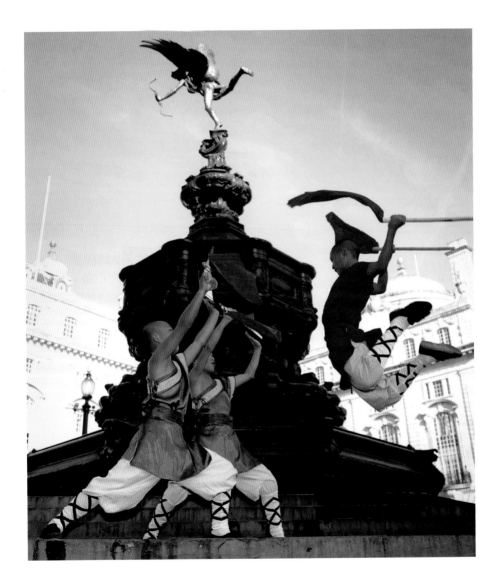

Piccadilly Circus

Left: Chinese acrobats perform Kung Fu moves beneath the statue of Anteros in the centre of Piccadilly Circus to publicise a West End show. Although commonly known as Eros, the statue is actually of his brother and was the work of Alfred Gilbert. It was one of the first statues to be cast in aluminium.

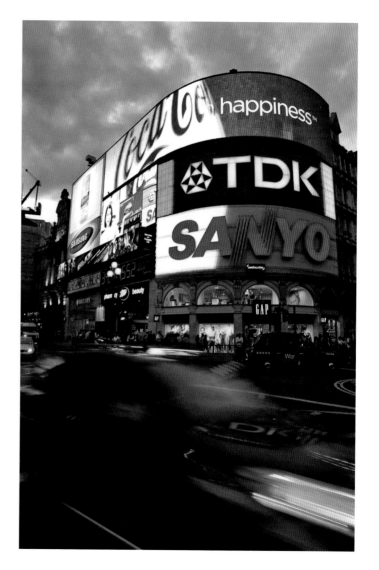

Right: Huge illuminated advertisements at Piccadilly Circus. The famous road junction, which connects Regent Street with Piccadilly, Shaftesbury Avenue, Coventry Street and Haymarket, is renowned for such video displays, along with the statue of the archer Anteros, the god of requited love.

Piccadilly Circus, W1

Sewer Network

Thames Water Catchment engineer Rob Smith works to clear a blockage of fat from part of London's sewer network. Most blockages are caused by cooking fats and oils, which congeal in the sewer and form a thick layer around the pipe. Although much of the original Victorian sewer system has been improved over the years, major expansion of the system is required to cope with the growth of population in London.

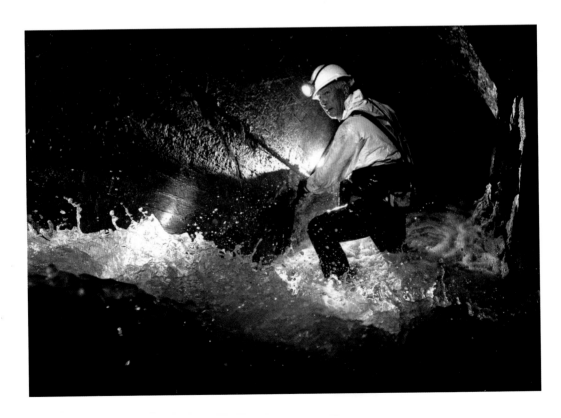

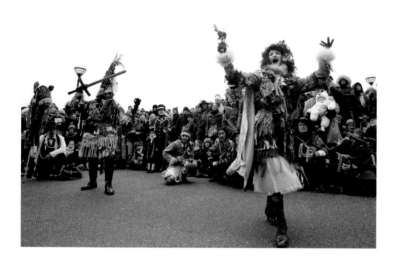

Twelfth Night Celebrations

Twelfth Night at Bankside is a New Year celebration involving ancient aspects of the season, now in its 25th year. The Holly Man, bedecked in greenery, arrives by boat to the accompaniment of wassailers and mummers, who perform a traditional hero/combat play featuring St George. After the play, cakes are distributed and those who find the concealed bean and pea in their cakes are crowned King and Queen for the day; a procession then makes its way to the George Inn on Borough High Street for more dancing, the Kissing Wishing Tree and storytelling. The event is always held close to Twelfth Night/6 January, near Shakespeare's Globe Theatre.

Bankside, SE1

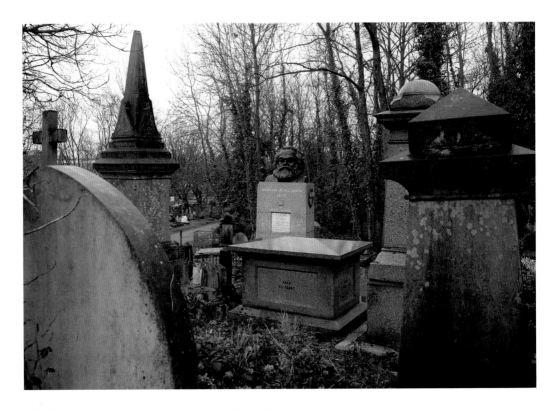

Highgate Cemetery and Karl Marx Tomb

Through the jumble of stones in Highgate Cemetery East can be seen the grave of philosopher Karl Marx (1818–83), who was instrumental in the development of modern communism and socialism. Although German, Marx moved to London in 1849 and remained there for the rest of his life. Both Highgate East and West cemeteries contain the graves of famous people, including William Friese-Greene, Douglas Adams and Beryl Bainbridge.

Swain's Lane, N6

Ennismore Garden Mews

Ennismore Gardens Mews, Knightsbridge. Mews were originally used as coach houses for nearby grand houses, with stabling for horses below and accommodation for staff above. When horse-drawn carriages fell out of favour, many were turned into motor garages, but today they are sought-after housing in fashionable parts of town. Invariably, they line quiet cul-de-sacs.

Ennismore Gardens Mews, SW7

Museum of London Docklands

A member of staff examines nineteenth-century casts of Yoruba busts in the London, Sugar & Slavery gallery at the Museum of London Docklands. The replicas were taken from original sculptures dating to 1100–1400, which demonstrate the skill and art of a sophisticated culture predating the arrival of Europeans in West Africa. The gallery, set in a former sugar warehouse built to store produce from the Caribbean plantations, reveals London's involvement in the slave trade.

West India Quay, E14

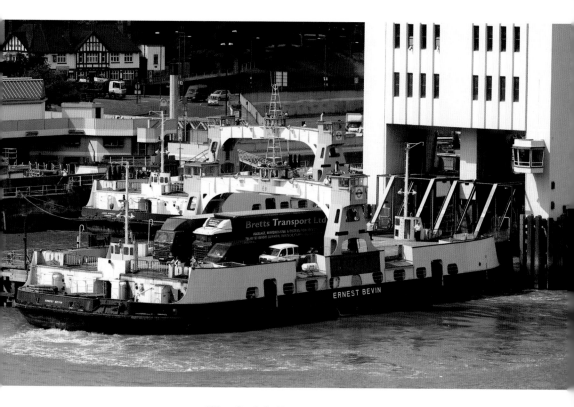

Woolwich Ferry

One of the three-vessel fleet of the Woolwich Ferry prepares to make a crossing of the River Thames. There has been a ferry at Woolwich since at least the 14th century, but the present free service dates to 1889 and was instigated by Sir Joseph Bazalgette, chief engineer of London's Metropolitan Board of Works. The ferry, linking Woolwich on the south bank with North Woolwich on the north bank, carries both vehicles and pedestrians, operating seven days a week.

Ferry Road, SE18/Pier Road, E16

Wimbledon Greyhound Stadium

Enthusiasts follow the action at Wimbledon Greyhound Stadium during the Blue Square Greyhound Derby. Greyhound racing regularly attracts an annual attendance of around three million, and £2.5bn is wagered each year. In London, there are three tracks, at Crayford, Romford and Wimbledon. Wimbledon also hosts regular stock car racing events.

To the thrill of the punters, a group of greyhounds races after the 'hare' at Wimbledon Greyhound Stadium in south-west London. Since the closure of Walthamstow dog track, Wimbledon is probably the best-known greyhound racing stadium in the UK.

Wimbledon Stadium, Plough Lane, SW17

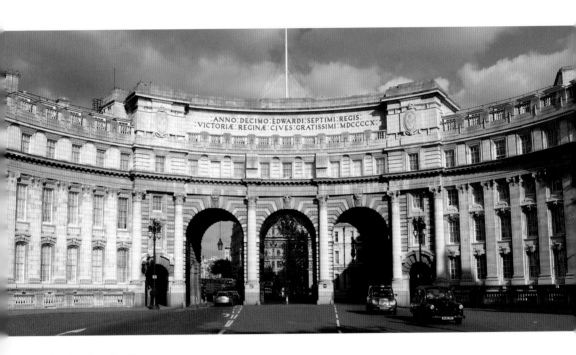

Admiralty Arch

Admiralty Arch, which forms the entrance to The Mall from Trafalgar Square. It was constructed in 1910 in memory of Queen Victoria. On the wall of the northernmost arch, the shape of a human nose has been carved in the stone. Tradition has it that this is in honour of the Duke of Wellington, who had a large nose and was known to his troops as 'Old Hooky'.

The Mall, SW1

Paternoster Square

The eye-catching vent structure by Thomas Heatherwick in Paternoster Square. The structure was required for an underground electricity sub-station below the public space near St Paul's Cathedral. The square was the subject of substantial redevelopment in 2003, following years of criticism of its previous grim architecture.

Paternoster Square, EC4

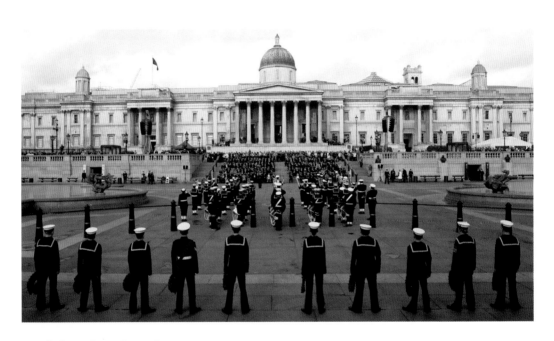

Trafalgar Day Parade

Over 400 Sea Cadets from across the UK take part in the National Trafalgar Day Parade in Trafalgar Square. The parade commemorates Britain's famous victory over the French and Spanish fleets at the Battle of Trafalgar, off the coast of Spain, on 21 October 1805, and also the death of Vice Admiral Horatio Nelson, who led the British fleet.

Trafalgar Square, WC2

Epping Forest

On a mild day in early November, people and geese take to the water at Hollow Pond in Epping Forest. The area is a remnant of ancient forest that contains woodland, grassland, heath, rivers, bogs and ponds. When visiting the area in 1882, Queen Victoria dedicated this "beautiful forest to the use and enjoyment of my people for all time."

Manor Park, E12

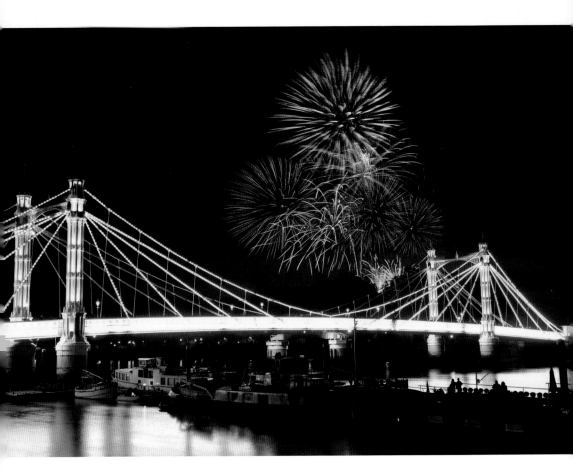

Albert Bridge

Brilliantly coloured fireworks burst above the illuminated tracery of Albert Bridge during Battersea Park's annual Bonfire Night display, held every November. The bridge dates from 1873, with later additions.

Battersea, SW11

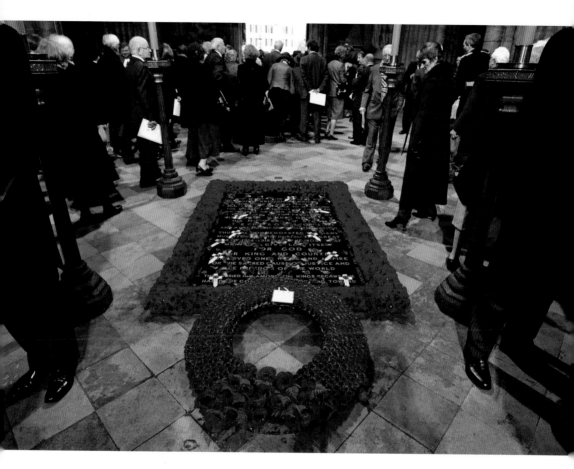

Tomb of the Unknown Warrior

Poppies decorate the Tomb of the Unknown Warrior at Westminster Abbey. The unidentified British soldier from the First World War symbolises all the nation's unknown dead, no matter where they fell.

Westminster Abbey, SW1

International Boat Show

People observe the British-built Sunseeker luxury yacht range, on the first day of the London Boat Show 2014, at the ExCel centre, Docklands in east London. The purpose-built facility was opened in 2000, and hosts numerous trade shows each year. A recent £164m expansion programme increased the centre's event space by 50 per cent.

Western Gateway, E16

Royal Artillery Memorial

Standing at Hyde Park Corner, the Royal Artillery Memorial was dedicated in 1925 to honour the many men of the Royal Regiment of Artillery who died during the First World War. The combined work of architect Lionel Pearson and sculptor Charles Sergeant Jagger, the memorial depicts a BL 9.2-inch howitzer on a large plinth of Portland stone with stone reliefs depicting the reality of war. Four bronze figures of artillerymen are set around the base. In 1949, bronze panels were added to the memorial to honour the artillerymen who lost their lives in the Second World War.

Hyde Park Corner, SW1

Victoria Railway Station

The spacious concourse of Victoria railway station, the second busiest railway terminus in London. Victoria provides mainline access to the south-east, throughout the counties of Kent, Surrey, East Sussex and West Sussex, including a direct link to Gatwick Airport. There is also an Underground station serving the Circle, District and Victoria lines.

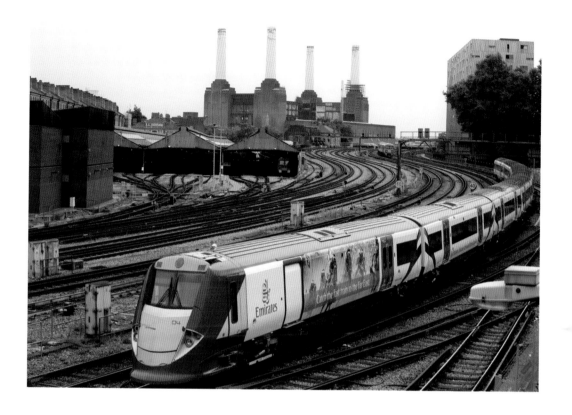

A Gatwick Express train on the approach to Victoria station. In the background can be seen the distinctive shape of Battersea Power Station. The railway station itself is effectively divided into two mainline terminuses: the eastern side caters for services to the south-east and Kent; the western side for those to and from the south, Surrey and Sussex (including Gatwick Airport).

Victoria Station, Terminus Place, SW1

Wembley Stadium

The all-seater interior of the new Wembley Stadium. The venue was built at a cost of £798m, and there has been an ongoing problem with the pitch, which has attracted much criticism from players and team managers alike. It was relaid ten times between the stadium opening in 2007 and 2010.

Right: The new Wembley Stadium seen from the air. Opened in 2007, it replaced the previous stadium, which had been built in 1923. The second largest stadium in Europe, it has a capacity of 90,000 and is the home venue for the England football team. In keeping with many modern stadiums, it has a retractable roof to prevent adverse weather from stopping events.

Left: Snow highlights the statue of Bobby Moore at Wembley Stadium in early April. Created by the sculptor Philip Jackson, the statue of England's 1966 World Cup winning captain was unveiled in 2007 as a tribute to the player, who had died from cancer in 1993. Moore won 108 caps for England and captained the team 90 times.

Empire Way, Wembley, Middlesex

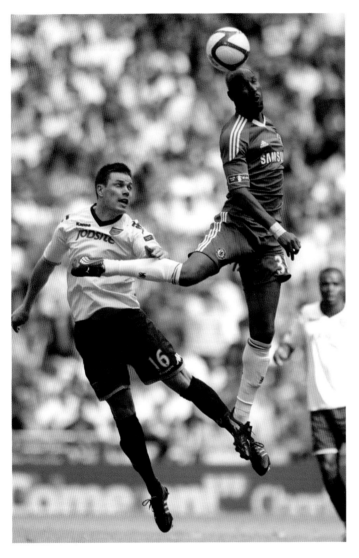

FA Cup Final

Left: Portsmouth's Steve Finnan and Chelsea's Nicolas Anelka leap for the ball during the 2010 FA Cup Final at Wembley Stadium. Chelsea would win the match 1–0, the team's second victory in two years.

Wembley Park Underground Station

Below: The dramatic entrance to Wembley Park Underground station, which was rebuilt at the same time as the new Wembley Stadium was constructed. The original station was opened in 1894 and then rebuilt for the 1948 Olympic Games held at the stadium. Recent improvements allow the station to cope with 37,500 people every hour.

Bridge Road, Wembley

Above: Chelsea's goalkeeper, Petr Cech, saves a penalty from Portsmouth's Kevin Prince-Boateng during the 2010 FA Cup Final at Wembley Stadium. Traditionally played at Wembley, the match is the last in the annual Football Association Challenge Cup series, a knockout competition among English and Welsh clubs, although Scottish and Irish clubs also participated in the early years.

Wembley Stadium, Empire Way, Wembley, Middlesex

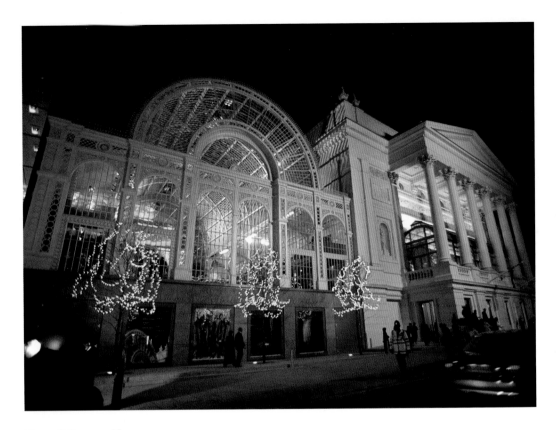

Royal Opera House

There has been a theatre on the site of the Royal Opera House since 1732, and the present building is the third incarnation, following disastrous fires in 1808 and 1857. The large glazed structure next to the main building was once part of Covent Garden flower market, but it became part of the theatre complex during the 1990s.

Bow Street, WC2

University College

Created as a secular alternative to the religious universities of Oxford and Cambridge, University College was founded in 1826. Today, it is one of the most prestigious universities in the world, and the largest in London, with campus buildings and sites across the city. UCL was the first university in the UK to admit women on an equal basis to men.

Gower Street, WC1

University of West London

The Paragon campus of the University of West London at Brentford. In addition, the university has sites at Slough, Reading and Ealing. Formerly known as Thames Valley University, the establishment was formed by the merging in 1990 of the Ealing College of Higher Education, Thames Valley College of Higher Education, Queen Charlotte's College of Health Care Studies and the London College of Music. At that time, it was known as the Polytechnic of West London, but it became a university in 1992. In 2004, Reading College and School of Arts and Design was also absorbed.

Boston Manor Road, Brentford, Middlesex

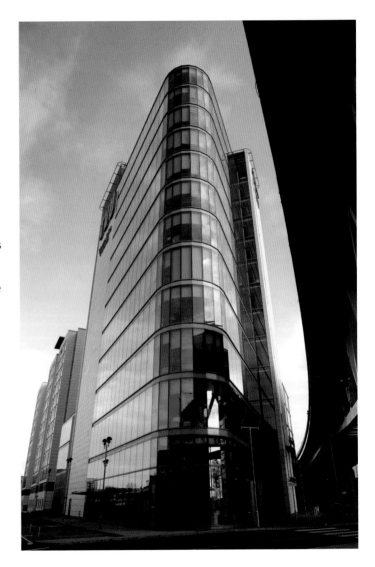

London Central Mosque

The golden dome and minaret of the London Central Mosque rise above the trees of Regent's Park. In 1969, an international competition was held to find a suitable design for the mosque. The winning architect was Sir Frederick Gibberd. Construction began in 1974 with funding from King Faisal bin Abdulaziz Al-Saud and Sheikh Zayed bin Sultan Al Nahyan of Abu Dhabi. The mosque opened in 1978.

Park Road, NW8

Abbey Road Studios

Established in 1931 by the Gramophone Company, Abbey Road Studios is owned today by Universal Music. Originally, the building was a nine-bedroom Georgian townhouse dating from the 1830s, and to celebrate its opening as studios, Sir Edward Elgar conducted the London Symphony Orchestra in recordings of his music. The studios were made famous during the 1960s when The Beatles used them to develop a range of innovative recording techniques.

Abbey Road, NW8

Hampton Pool

Steam rises from the heated outdoor pool in Hampton on a snowy January day as one hardy soul enjoys a dip. The pool is open 365 days a year, allowing swimmers to take the plunge in the tropical blue water regardless of the weather. The pool was built in 1922, but was faced with closure by Richmond Council in 1980 until the local community raised over £60,000 to keep it open.

High Street, Hampton, Surrey

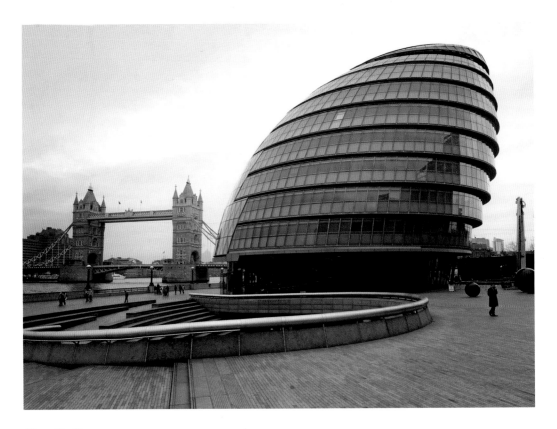

City Hall

City Hall, headquarters of the Greater London Authority and the Mayor of London. Often referred to as 'the Onion', the building was designed by the renowned architect Sir Norman Foster and was built at a cost of £65m, being opened in July 2002. Its striking shape was conceived to reduce its surface area and thus improve energy efficiency.

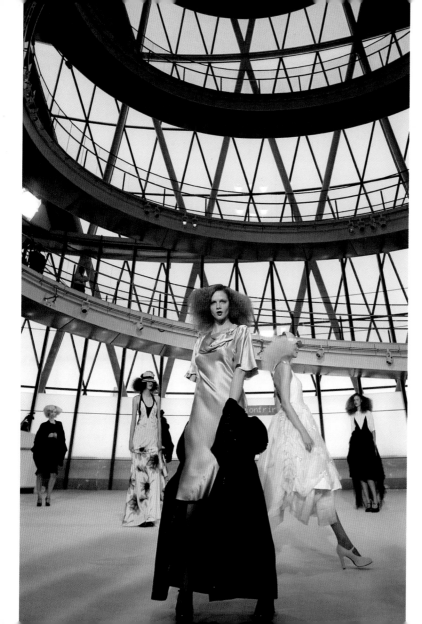

With the dramatic helical staircase of City Hall as a backdrop, models showcase the work of eminent new UK designers during a show for the London Fashion Week Spring/ Summer Collections.

The Queen's Walk, SE1

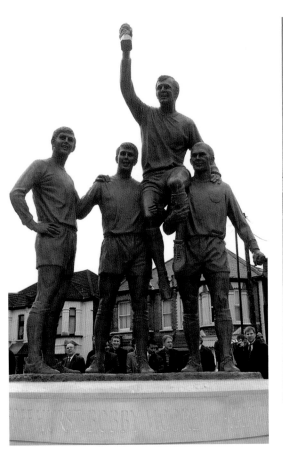

A bronze statue outside West Ham's Upton Park ground in east London, commemorating England's 1966 World Cup victory over Germany. The statue depicts (*left to right*) Martin Peters, Geoff Hurst, captain Bobby Moore (holding the trophy) and Ray Wilson. Moore, Hurst and Peters were all West Ham players at the time of the famous victory. Unveiled in 2003, the 5m (16ft) high statue was the work of renowned sculptor Philip Jackson.

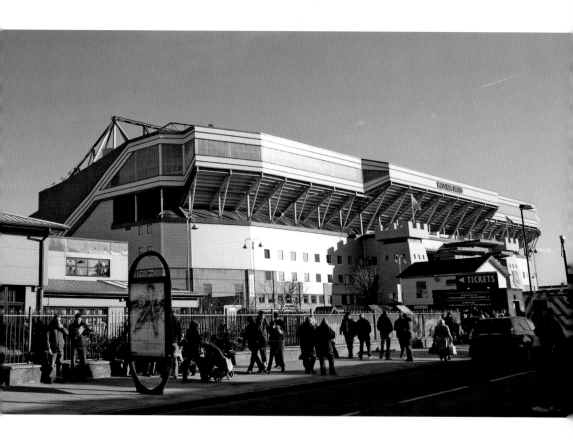

Upton Park Football Stadium

Upton Park, officially known as the Boleyn Ground, was the home of West Ham United Football Club since it first opened its turnstiles in 1904. The ground is being redeveloped after West Ham's 2016 move to the Olympic Stadium.

Green Street, E13

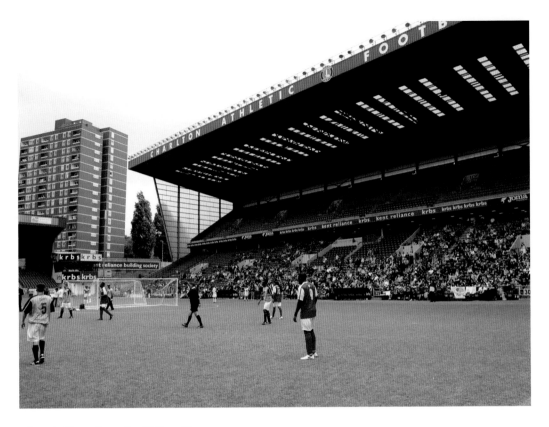

The Valley Football Stadium

A celebrity football tournament at the Valley, home of Charlton Athletic F.C. in south London. The ground was created by the club's supporters in 1919, but in 1984, following bankruptcy, Charlton was forced to leave the Valley and share Selhurst Park with Crystal Palace F.C. In 1988, however, the club was able to return, its supporters rallying once more to refurbish the site.

Floyd Road, SE7

Telephone Boxes

A row of classic public telephone boxes, designed by Giles Gilbert Scott, who won a competition to design a kiosk held by the Post Office in 1924. The iconic K2 box, deployed in 1926, was made from cast iron painted red for high visibility (although Scott had specified mild steel, painted silver with a greenish-blue interior). Today, more utilitarian designs are common, but many of the much-loved red boxes still survive.

Broad Street, Covent Garden, WC2

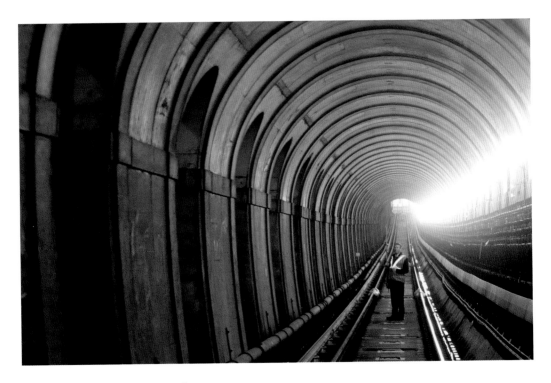

Brunel's Thames Tunnel

Completed by Isambard Kingdom Brunel in 1843, the Thames Tunnel provided a pedestrian link between Wapping on the north bank and Rotherhithe on the south. Trains began running through it in 1869, and it is now part of the London Overground rail network. The tunnel was the first in the world to have been built beneath a navigable river.

Wapping High Street, E1/Railway Avenue, SE16

Battersea Reach

The redevelopment of defunct warehouses along the River Thames in central London into upmarket apartments has led to a high demand for riverside accommodation, which is being met by many developers. These modern apartment blocks are at Battersea Reach, on the south bank of the Thames.

Battersea Reach, SW18

New Routemaster Bus

London's iconic red double-decker bus gets twenty-first century update. Manufactured by Wrightbus, the New Routemaster is a hybrid diesel-electric vehicle that retains the original's hop-on hop-off rear open platform, but updated to meet modern requirements. The bus has doors at front, centre and rear, and two staircases. Internally, there is LED lighting, air-conditioning, and text displays and audio announcements advise on route number, destination, the name of the next stop, and that the bus is stopping.

Above left: The rear hop-on hop-off platform can be closed when a conductor is not on board.

Above right: Unlike the original Routemaster, the new bus has a conventional full front end, rather than the protruding, bonneted 'half cab' design. The bus can be operated by one person at off-peak times.

Piccadilly, W1

South Bank

People promenade along the South Bank, a strip of riverside land whose name was adopted during the 1951 Festival of Britain over the less attractive Lambeth Marsh. It encompasses County Hall and the Sea Life London Aquarium, the London Dungeon, the Jubilee Gardens and the London Eye, the National Theatre, and the Southbank Centre, which comprises the Royal Festival Hall (*shown*), the Queen Elizabeth Hall, and the Hayward Gallery.

South Bank, SE1

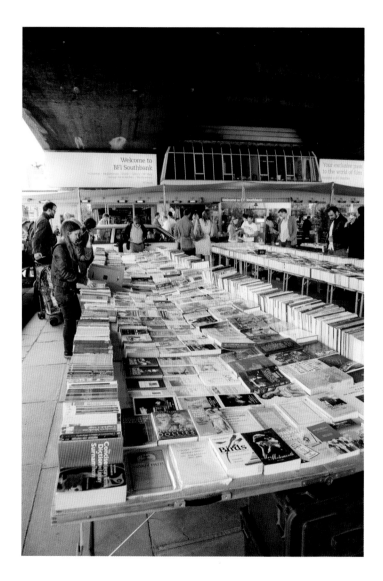

Southbank Centre Book Market

People browse through books at the Southbank Centre Book Market, tucked under the arches of Waterloo Bridge on Queen's Walk. It is one of the few outdoor second-hand and antique book markets in southern England, and is open daily, rain or shine.

Queen's Walk, SE1

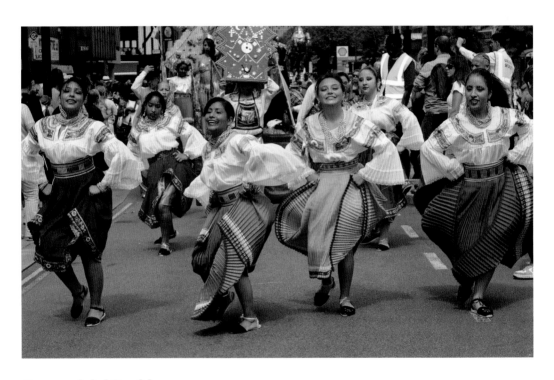

Carnaval del Pueblo

Dancers and floats fill Walworth Road, south London with a riot of colour and sound during the annual Carnaval del Pueblo, which showcases Latin American culture. A festival of dance and music, the event is the biggest Latin American celebration in Europe, with a parade that winds its way from Elephant and Castle to Burgess Park, Camberwell, where the party continues throughout the day.

Walworth Road, SE17, Albany Road & Burgess Park, SE5

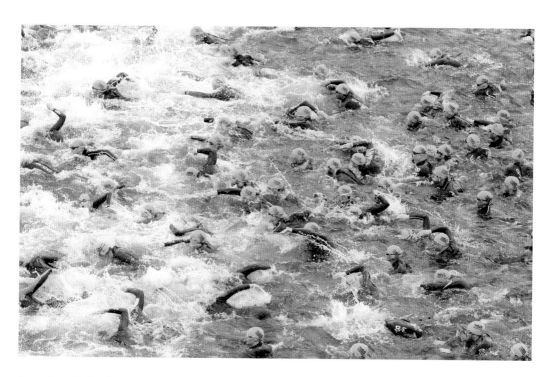

London Triathlon

The water in Docklands is churned up by a mass of flailing arms as the London Triathlon gets under way near the ExCel centre. Competitors in the gruelling event undertake an arduous swim followed immediately by a tough cycle race and finally an energy sapping run through the streets of the capital. Over 13,000 triathletes regularly take part, raising around £3m for charity.

North of Thames, E1, EC3, EC4, WC2 & SW1

Eleanor Cross Monument

The Eleanor Cross monument, in front of Charing Cross railway station. The monument was erected in 1865 to replace a cross that had stood at the top of Whitehall and had been destroyed during the English Civil War. The original cross was one of several erected across the country to mark the 12 nightly resting places of the body of Queen Eleanor of Castile, wife of King Edward I, during her last journey from Lincoln Cathedral to Westminster Abbey.

Strand, WC2

Fashion and Textile Museum

Founded by famed British fashion designer Zandra Rhodes, the Fashion and Textile Museum exhibits contemporary fashion, textiles and jewellery in a series of permanent and changing exhibits. The museum, which is operated by the Newham College of Further Education, is housed in a striking building designed by Mexican architect Ricardo Legorreta.

Bermondsey Street, SE1

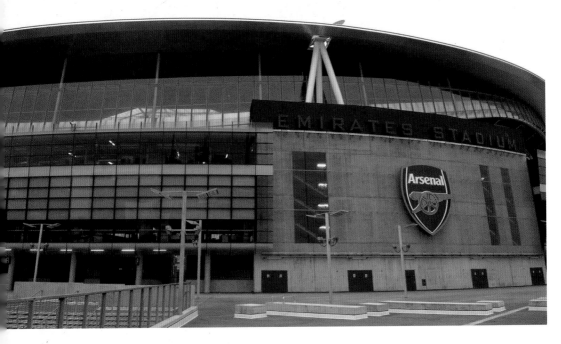

Emirates Football Stadium

Home to Arsenal Football Club, the Emirates Stadium was completed in 2006 and has an all-seater capacity of 60,355. It is the second largest football club stadium in England after Manchester United's Old Trafford. Originally, it was known as Ashburton Grove, but a naming rights deal was signed with the Emirates airline in 2004. The stadium takes the form of a four-tiered bowl with roofing over the stands.

Right: Arsenal Football Club fans pack the stands at their home ground, the Emirates Stadium, in anticipation of an exciting international match against AC Milan. The London team would hold the Italians to a 1–1 draw. The massive Emirates Stadium was built at a cost of £390m.

Ashburton Grove, Holloway, N5

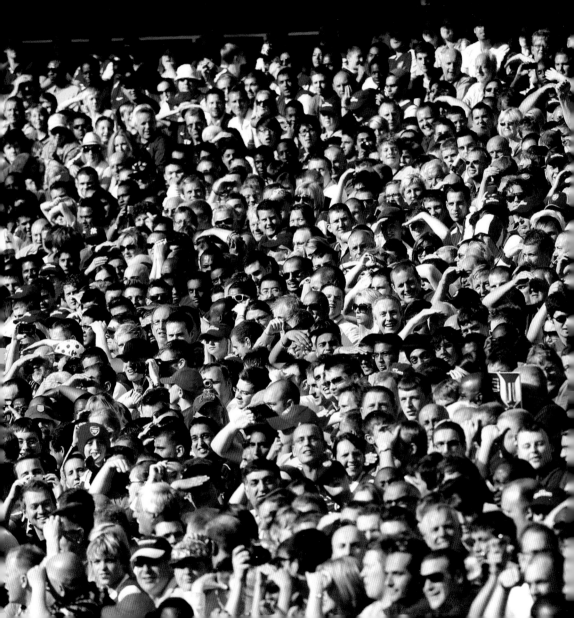

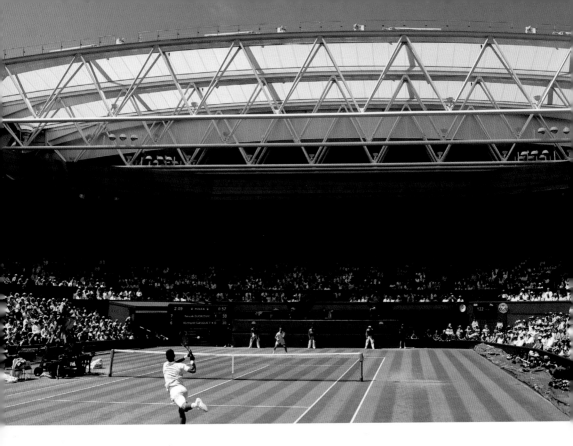

Wimbledon Tennis Championships

Action on Centre Court as Novak Djokovic (*foreground*) plays against Richard Gasquet during day eleven of the Wimbledon Championships at the All England Lawn Tennis and Croquet Club. The retractable roof had been installed in time for the 2009 championship, ensuring that rain would no longer stop play.

Statue of Fred Perry

A statue of Fred Perry at the All England Lawn Tennis and Croquet Club, Wimbledon. Perry, born in Stockport in 1909, was a three-time Wimbledon champion and World Number One player for five years, four of them consecutive, between 1934 and 1938. He is one of only seven men to have won all four Grand Slam events.

All England Lawn Tennis and Croquet Club, Church Road, SW19

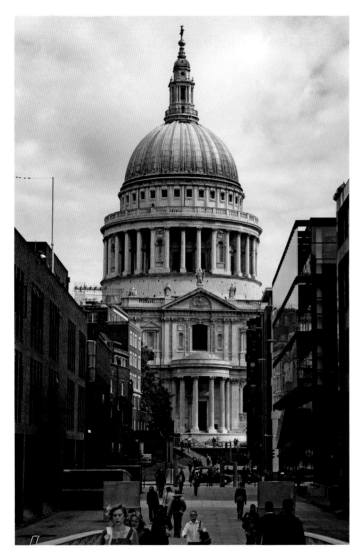

St Paul's Cathedral

Seen from Ludgate Hill, St Paul's Cathedral rises majestically against the backdrop of a cloudy sky. Designed by Christopher Wren, the building dates from the 17th century, although it is thought to be the fifth cathedral to stand on the site, the first dating from AD 604. At 11m (365ft) high, the cathedral was the tallest building in London until 1962.

St Paul's Churchyard, EC4

Polo at the Hurlingham Club

Team London (red) takes on Team Moscow (green) during Polo in the Park at the Hurlingham Club in south-west London. The exclusive sports club, which was founded "as an agreeable country resort" in 1869 by Frank Heathcote, is set in 17 hectares (42 acres) by the Thames in Fulham. It offers its members tennis, cricket, croquet, bowls, golf, squash and swimming, in addition to a fitness centre and gymnasium.

Ranelagh Gardens, SW6

Duke of York Column

Topped by a bronze statue by the sculptor Sir Richard Westmacott, the Duke of York column is a monument dedicated to Prince Frederick, Duke of York, the second son of King George III and commander of the British Army during the French Revolutionary Wars. The duke is remembered in the nursery rhyme, *The Grand Old Duke of York*. When he died in 1827, the entire Army forfeited a day's wages to pay for the monument. Completed in 1834, the pink granite column is over 37.5m (123ft) high, which caused some to suggest at the time that the duke was trying to escape his creditors; he had died £2m in debt.

Carlton House Terrace, SW1

National Theatre

Situated on the South Bank, the National Theatre, or more properly the Royal National Theatre, contains three separate auditoria: the Olivier Theatre, the Lyttelton Theatre and the Cottesloe Theatre. Its striking concrete architecture has attracted praise and criticism in equal measure, often being called 'brutalist'. It is home to the publicly funded National Theatre Company.

South Bank, SE1

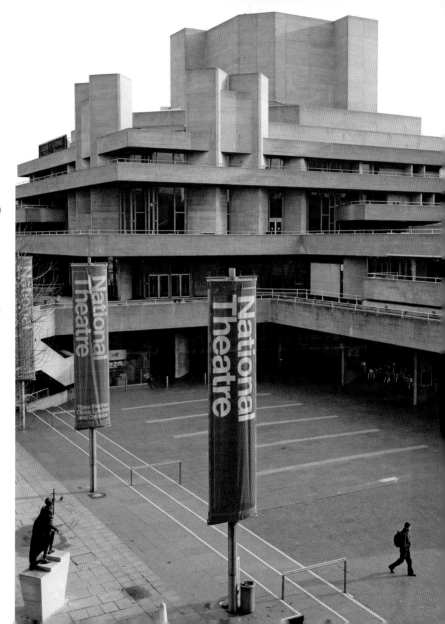

Hilton London Paddington Hotel

Formerly the Great Western Royal hotel, the Hilton London Paddington is actually part of the Paddington Railway Station complex. Built between 1851 and 1854, the hotel forms the main façade of the station. The design was the work of Philip Charles Hardwick, in the Second Empire style that he pioneered for buildings of this type. Owned by the Great Western Railway and then British Rail, the hotel was eventually sold off in 1983, following the privatisation of Britain's railways.

Praed Street, W2

Pie, Mash and Eel Shops

Hungry fans queue at the Pie & Mash kiosk at the Valley
Football Stadium, Charlton. Pie and mash is a traditional
London working-class food that originated in East
London in the 19th century. Minced beef and cold water
pastry pies, or steamed or jellied eels, are served with
mashed potato and a parsley sauce called 'liquor'.

Charlton, SE7

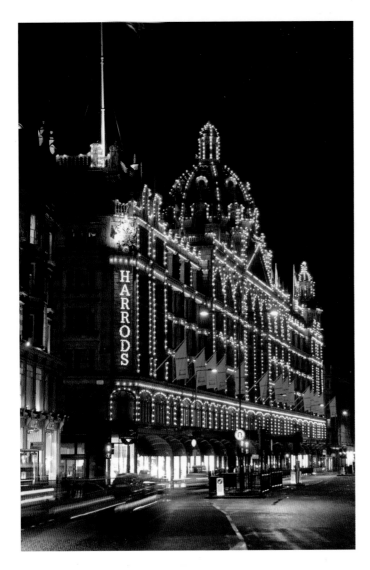

Harrods

The illuminated façade of Harrods department store. Charles Henry Harrod first opened a shop on the site in Knightsbridge in 1849, encouraged by the prospect of plenty of trade stemming from the Great Exhibition of 1851. His son, Charles Digby built the business into a thriving retail store, selling medicines, perfume, stationery, fruit and vegetables. The present building, designed by Charles William Stephens, was completed in 1905.

Brompton Road, SW3

Harrods Boxing Day Sales

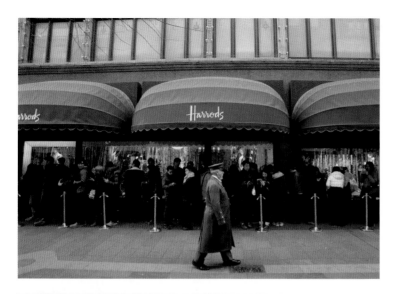

Left: Uniformed in Harrods livery, a doorman inspects the queue of shoppers awaiting the start of the Boxing Day sales. Up to 300,000 customers visit Harrods on peak days, comprising the highest proportion from non-English speaking countries of any department store in London. More than 5,000 staff from over 50 countries work at the iconic store.

Left: Shoppers are entertained by Harrods 'waiters' while they eagerly await entry into the store, for the Boxing Day sales.

Brompton Road, SW3

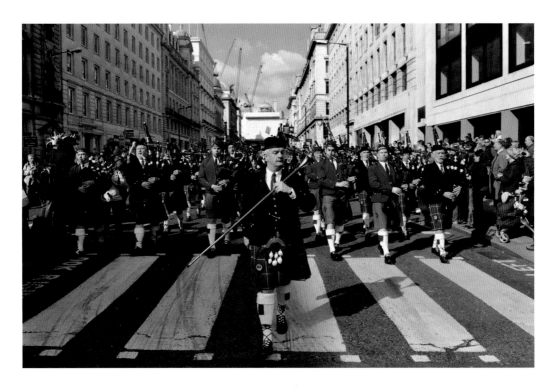

St Patrick's Day Parade

A pipe band leads The Mayor of London's St Patrick's Day Parade through central London on its way to Trafalgar Square and Whitehall.

Piccadilly, W1 to Whitehall, SW1, via Trafalgar Square, WC2

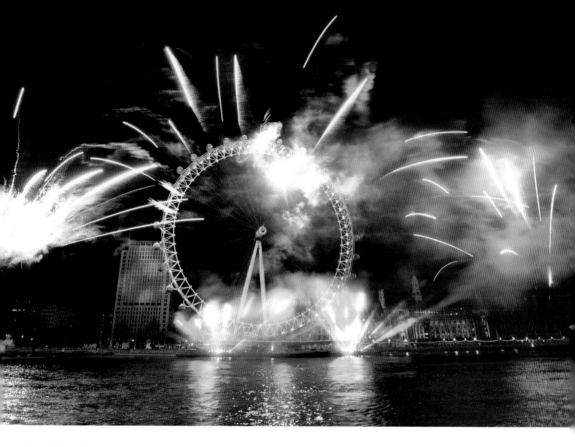

London Eye

The sky is filled with a kaleidoscope of colour, reflected in the waters of the River Thames, during a massive New Year fireworks display centred on the London Eye. Such displays have become a traditional means of celebrating the arrival of the New Year in London and regularly draw many thousands of onlookers.

Belvedere Road, SE1

Index

AMMONITE
PRESS

PRESS
ASSOCIATION
Images